THE IMPRESSIONIST REVOLUTION

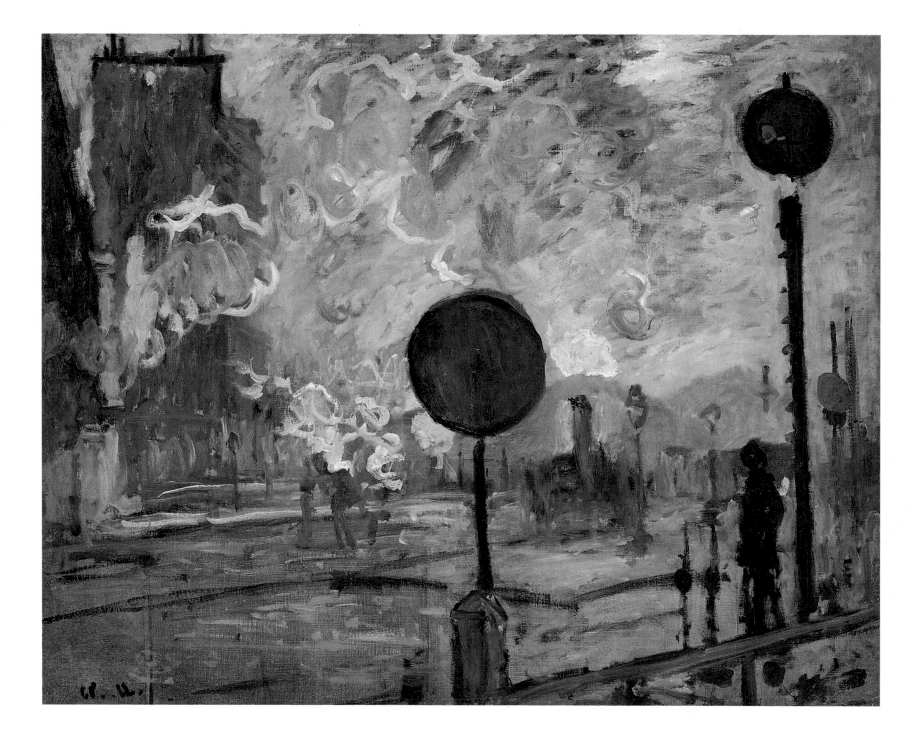

Monet: The Signal, Gare St. Lazare,
1876. 65 × 81.5 cm. Musée Marmottan,
Paris.

THE IMPRESSIONIST REVOLUTION

EDITED BY BRUCE BERNARD

ORBIS · LONDON

A MACDONALD ORBIS BOOK

© Opus Publishing Limited

First published in Great Britain in 1986
by Macdonald & Co (Publishers) Ltd
London & Sydney

A member of BPCC plc

British Library Cataloguing in Publication Data

The Impressionist Revolution.
 1. Painting, French 2. Impressionism (Art)–
 France.
I. Bernard, Bruce
759'.4 ND547. 5 14/
ISBN 0-356-12877-6

Filmset by Balding + Mansell Limited

Printed and bound in Spain by Cayfosa, Barcelona

Dep. Leg. B-30028-1986

Design Consultant: Derek Birdsall RDI

Designer: Graham Bingham

Macdonald & Co (Publishers) Ltd
Greater London House
Hampstead Road
London NW1 7QX

CONTENTS

INTRODUCTION

T his book is intended to offer a concise account, by means of seven biographical studies, of the only occasion in recorded history when a group of painters have taken on the cultural machinery of a state and the entrenched prejudices of most of its leading citizens in order to establish the validity of their way of looking at the world and their right to determine the proper course of their art.

They were indeed revolutionaries and were referred to during their most combative decade, the 1870s, as 'The Intransigents' (more damning than in modern usage). The official Salon had probably feared the emergence of an avant-garde or splinter group ever since it had been obliged to keep its doors open to Gustave Courbet because of the right of access established by his award of a gold medal in the Salon of 1848. It was similar to the right that Turner had taken advantage of in England during his last two decades to show paintings that would never have been granted admission by the selection committee of the Royal Academy. Courbet's *hors concours* must have seemed to some almost equivalent to a licence granted to a terrorist to enter and leave a country freely while planting bombs there and in a sense that is just what he was doing. It was he who made the first significant cracks in the edifice that were necessary for the eventual destruction of the Salon's virtual dictatorship of public taste. This was accomplished in the end largely by the seven men to whom this book is devoted, their comrades in arms and their few supporters and patrons. The incursions made earlier into the Salon by Corot, Millet and the Barbizon school proved of little use to their successors. Though their work was a very necessary inspiration to all except Manet and Degas, the niche they had been granted was a conditional one – conditional on knowing their place as landscape or genre painters – a place far below the virtuoso celebrators of Napoleonic myth, the smooth pedlars of Oriental fantasy and those who recycled the legends of antiquity to provide voluptuous causes for bourgeois complacency. Where Daubigny was acceptable despite his inelegant impasto, Manet was much less so, let alone any of the others, unless their work proved sufficiently inoffensive

through early modesty or occasional moderate compromise.

Any analogy with political revolution can of course be taken too far. These painters were not seeking to replace the ruling class of the Salon and dictate the future course of art. Their aspirations were radical but they were peaceful ones. Although few generalisations apply to all of them, they were possessed of an inner conviction derived from their passion for art as a continuous living process rather than a respectable profession or (except for Manet's touching weakness) a source of public honours, and they thought they had a right to assert it in the only place where they would be paid any public attention or be offered any chance of a livelihood. Three of them (Monet, Pissarro and Sisley) were concerned to establish the sufficiency of recording their immediate sensations in front of nature, while Manet and Degas were determined to affirm the propriety of painting the realities of modern urban life in any of its aspects. Renoir was interested in the more pleasurable manifestations of both, and Cézanne stood apart. Except for a brief though vital confluence with Pissarro, Cézanne's goal lay in the future, only known to himself. But the Impressionists believed in their different ways that they had found the only possible path for the development of painting and that they held the key to the progress in the broader tradition that was being impeded in high places for less than worthy motives.

As in most great sagas, there were minor heroes and tragedies as well as great ones, along with a host of supporting actors. There was Bazille, the exemplary young enthusiast who was killed at the very start in the Franco-Prussian War. Sisley, of the major figures, was dogged by ill-fortune until the very end of his life. There were the kind of people who seem heaven-sent, like the collectors Victor Chocquet and Gustave Caillebotte, the latter a highly talented painter who cared more for his friends' success than his own. There was Paul Durand-Ruel, a man of commerce who became possessed of a faith befitting a saint and probably saved the ship from foundering completely, while an eccentric left-wing colour-grinder known as Père Tanguy was one of the first to value the lofty aims of Paul Cézanne and acquire his work. There were also mistresses and wives who were asked to bear considerable burdens and did so with minimum complaint, and a heroine in the form of Berthe Morisot, the sister-in-law of Manet, and also an American, Mary Cassatt, who persuaded even Degas that a woman might draw well.

Today it is almost impossible to imagine anyone going to an exhibition of work that they despise in order to laugh and to be seen to be laughing at it with cruel inanity – but many did on the occasions of the Impressionist exhibitions held between 1874 and 1886 in Paris. And the so-called writers, who were deferred to in a way that must arouse the envy of a few of their descendants, made the later sneering in print at Cubism, Surrealism and modernism in general seem like polite dissent. Witness Albert Wolff: 'Tell [Monsieur Degas] that in art there are such qualities as drawing, colour, execution, control … or try to explain to Monsieur Renoir that a woman's torso is not a mass of flesh in the process of

decomposition with green and violet spots which denote the state of complete putrefaction of a corpse!'

Yet the less venomous arbiters of taste were insufferably condescending when they occasionally bestowed faint praise. Their 'could do better' reports make perhaps even more distasteful reading than the calculated hysteria of Wolff. Happily, however, there were Baudelaire, Astruc, Castagnary, Silvestre, Duret and others who provided the encouraging words that were so vital to the painters, as well of course as Zola, the most redoubtable of champions at the outset even though he felt unable to sustain his enthusiasm.

We end our story in the 1880s because, although the struggle was not quite over, victory was assured and the wartime coalition was naturally breaking up. The painters had proved to themselves and their detractors that they were an irresistible force and would continue to be so whatever happened. Manet had been sadly struck down, but had worn his Légion d'Honneur at last. Monet was beginning to prosper in the way he had always considered his due and some of his greatest achievements lay ahead of him. Degas commanded almost universal respect, however grudgingly from some, and was about to use colour as boldly as any of the younger generation. Pissarro was still humbly learning at the feet of the young Seurat, though he would soon return to his well-tried methods. Renoir, after his curiously academic reaction against his most radical achievements, would soon find new ways of depicting his Arcadia, and Cézanne was using his father's fortune to conduct his lonely search for the order he craved after his own natural passions and the liberties granted by Impressionist methods had failed to satisfy him. Only Sisley pursued his aim to the very end and so emphasised that those who had been closest to each other now had less in common as artists as well as no further need for public displays of solidarity. But like soldiers who have served in a victorious campaign against a common enemy, they had become blood brothers of a kind and remained fundamentally loyal to one another and the memory of 1874. There are ways in which Degas, for instance, owed as much to Monet as to Manet or to Ingres. To suggest that Impressionism was simply a fortuitous and uncertain camaraderie of convenience is surely to miss the point. The completeness of the revolution they effected came from their talents and temperaments being forced by history into a much closer and more creative contact than most of them would have desired or would even admit to. The Renaissance that they embodied, for such it was, changed the whole course of painting because of their united stand against the meretricious art that the heedless public were being misled by.

Much of the heritage of Impressionist painting lies on the surfaces of the canvases for all to see – the broken strokes and touches of the brush, the purity of colour, the type of composition. The subject-matter of Impressionism was also significant because of its categorical assertion that the depiction of everyday modest scenes and events was more

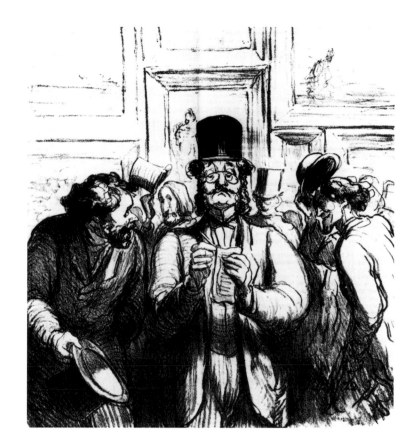

Daumier: THE IMPORTANT CRITIC WALKS THROUGH, 1865. Daumier mocks the abject attention paid to leading art critics.

valuable than the fabrication of portentous or banal fantasies that history painting had become. And it is sometimes difficult, when looking at much of contemporary art, to realise that the most recent developments in painting as well as those that immediately followed the work shown in this book were made possible only by the 'Impressionist Revolution' and that the freedom in which artists now luxuriate and that they sometimes abuse was created by the seven men described in this book, who were undoubtedly the first 'avant-garde'.

A great many of the 100-year-old pictures are now evidently the most easy to enjoy ever painted, but if they are enjoyed too easily they are surely not enjoyed to the full. And if the relationships between the individual painters is not sometimes considered, an adequate understanding of the pictures' presence in the world cannot be attained. They are not only among the most beautiful of any paintings, they represent the most conscientious exploration ever undertaken by any association of artists.

The Impressionists found a new way of looking at the world and several closely or subtly related ways of painting it. It is this combination that made them such a potent force and a century later a still far from exhausted source of inspiration.

BRUCE BERNARD

ACKNOWLEDGEMENTS

The compilation of this book has been possible only through the efforts of several hard-working people apart from the very capable providers of the main texts – Kathleen Adler, Anthea Callen, Charles Harrison, Richard Kendall, Christopher Lloyd and Nicholas Mirzoeff. Christopher Lloyd has also been indispensable as a consultant, vetting the notes on the pictures and the captions. His suggestions have been invaluable and I feel deeply indebted to him. Derek Birdsall, the book's distinguished consultant designer, has been admirably served by Graham Bingham who made the lay-outs and who, like Derek Birdsall, is one of those surprisingly rare book designers who love and understand paintings. Reg Grant and Sue Leonard have been very capable and patient text editors. Ann Davies, Barbara Heller and Deborah Pownall have also been of considerable service, as have Graham Mason, Graeme Dewar and in particular Cherry Jaquet. Robert Gordon has helped both with his beautiful book on Monet (in collaboration with Andrew Forge) and as a friendly consultant. I have grateful memories of the friendly reception and valuable advice I received· from two distinguished curators of Impressionist painting, Richard Brettell in Chicago and Charles Stuckey in Washington, and I hope they will have no cause to regret it. My debt to the publisher Martin Heller is as considerable as that I still owe him from our two previous ventures.

No book on Impressionism could be compiled without reference to John Rewald's *History of Impressionism* and this one has been no exception to that rule. The writers of the main texts would no doubt nominate very many helpful books but in the writing of captions and notes perhaps the most important have been the catalogue of the great Manet exhibition at the Metropolitan Museum in New York and the Grand Palais in Paris in 1983, the catalogue of the Impressionist exhibition held at Washington and San Francisco in 1986 (*The New Painting: Impressionism 1874–1886*), and also the Pissarro and Renoir catalogues of the exhibitions which were at the Hayward Gallery in London in 1980 and 1985 respectively. *Degas, His Life, Times and Work* by Roy McMullen has also been of great value.

PORTRAITS OF THE ARTISTS

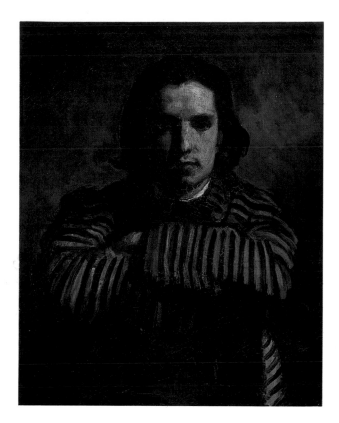

MONET - THE ESSENTIAL IMPRESSIONIST

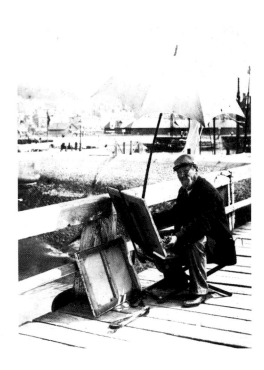

Eugène Boudin.
The minor master who encouraged
Monet to look at nature and set him on
the road to greatness.
Musée Boudin, Honfleur.

Claude Oscar Monet was born in Paris on 14 November 1840. When he was five, his parents moved to the bustling port of Le Havre on the Normandy coast, where his father joined the large firm of wholesale grocery and ship's chandlers owned by Monet's uncle, Jacques Lecadre. Monet never showed any inclination to follow in his father's footsteps. According to his own later account, he was an undisciplined child who regarded school as little better than prison and escaped whenever he could to the cliffs and beaches around Le Havre. Nevertheless, it was at school that he first learned to draw, and his artistic talent soon revealed itself in an exceptional gift for caricature.

Monet's witty drawings of his teachers and other local personalities were widely admired in Le Havre, and by the age of 15 he was receiving commissions to do caricature portraits. Monet revelled in his fame and fortune – the sums of money he earned through his drawings were small but significant for a boy of his age. However, he was soon to make a fateful encounter that would change the course of his life.

Among the residents of Le Havre who noticed Monet's caricatures was the painter Eugène Boudin. Born of a seafaring family in 1824, Boudin had made his first sketches as a cabin boy on his father's trading ship. He ran a framemaker's shop in Le Havre until 1851, and then devoted himself to a full-time career as a painter. He loved the sea and the vast expanses of sky visible from the coast, and in his work he concentrated on seascapes and port scenes. He was committed to painting out of doors and to recording the changing face of nature under varied weather conditions. In 1856 the dedicated open-air painter Boudin met the caricaturist Monet.

Boudin saw Monet's drawings exhibited in the shop window of the framemaker's which he had himself once run. Convinced of the youth's talent and eager to help him, Boudin tried to persuade him to come on open-air painting trips around Le Havre. At first Monet rejected the older man's offers of advice and companionship, and it was not until the summer of 1858 that he responded to Boudin's invitation. The result was akin to a religious revelation. Monet later recalled: 'My eyes were finally opened and I understood nature; I learned at the same time to love it.' It was to be a lifelong passion.

Boudin taught Monet two fundamental principles: that it was vital to retain 'one's first impression, which is always the right one' and that 'whatever is painted directly on the spot always has a strength, a power, a vividness of touch that can never be recaptured in the studio'. These two beliefs – in the first 'impression' and in the vitality of painting done out of doors – were to form the basis of Monet's work as a landscape painter. In particular, Boudin encouraged him to finish oil paintings out of doors, a rare procedure at this period when even the most adventurous open-air landscapists tended to return to the studio either to complete their oil sketches or to transfer a study to a new larger canvas in a more finished style. Monet later wrote in glowing terms of the effect Boudin had upon him: 'I had seen what painting could be simply by the example of this painter working with such

independence at the art he loved. My destiny as a painter was decided.' But if he was to become an artist, he knew he must leave Boudin and the provincial narrowness of Le Havre for the artistic and intellectual centre of Europe – Paris.

Monet's father was not entirely opposed to his son adopting an artistic career, and another relative in Le Havre, Monet's aunt Madame Lecadre, was herself an amateur painter and encouraged the young artist. When Monet left for Paris in May 1859, however, he quickly revealed an independent temperament which rejected the kinds of formal art training available in the capital. It was the start of a long-running battle with his family who insisted that, if he was going to be an artist, he should set about it in the manner that they considered proper. Monet later regarded his first years in Paris as a wasted period of his life, but he certainly did some painting at the very informal Académie Suisse, and explored the complex Parisian world of studios, exhibitions and artists' cafés.

In the spring of 1862, Monet was called up for national service and enrolled in the Chasseurs d'Afrique, a glamorous regiment which took him to Algeria for about a year; he later claimed the vivid experience of colour and light in North Africa as a major influence on his work. As a conscript he should have served seven years, but because of a bout of typhoid he was repatriated, and his aunt, Madame Lecadre, taking pity on his condition, agreed to buy him out of the army if he promised to follow a proper course of art study in Paris. The compromise was accepted, and in the autumn of 1862 Monet went to Paris in search of art training.

France's highly centralised system of formal academic art training was dominated by one major school, the Ecole des Beaux-Arts in Paris. The Ecole was run by members of the Academy, an honorary body of established artists whose role was to advise the government on artistic matters, and who also dominated the jury for the annual Salon exhibition. These men thus controlled most of the Paris art world, and it was against their monopoly that radical artists like Courbet, Manet and the Impressionists were to battle. Students who failed to gain admission to the Ecole or who chose to study elsewhere were effectively on the fringe, excluded from the accepted ladder to a career as a professional artist.

But this was the difficult path that Monet chose. He stayed outside the academic system, enrolling at the studio of the Swiss-born artist Charles Gleyre. Gleyre was a successful Salon painter, but he was neither a professor at the Ecole nor a member of the Academy. Unlike the Ecole professors, Gleyre remembered his own struggles as a student and charged nothing for his services. His students merely paid 10 francs a month towards the cost of the studio and models. Naturally, penniless young artists were attracted by this most economical form of training, and the independent-minded were drawn by Gleyre's noted respect for the ideas of others. Classes at Gleyre's studio were held every weekday from eight in the morning until late afternoon, with a break for lunch which consisted of bread and soup and a chop. Gleyre himself attended twice weekly to discuss each student's work.

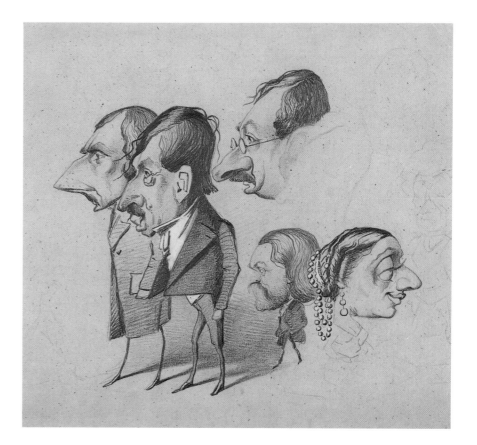

Monet: THEATRE PEOPLE (detail), c.1858.
A profitable gift for caricature that the young Monet willingly set aside thanks to the influence of Boudin.
34 × 48 cm. Musée Marmottan, Paris.

Monet: CORNER OF THE
STUDIO, 1861.
The artist's outstanding natural gifts are
clearly established in this large early
work achieved at only 21.
182 × 127 cm. Musée du Louvre, Paris.

An artist who worked at Gleyre's around this time, the writer George Du Maurier, gave a vivid description of the students in his novel *Trilby*: 'a mixture of greybeards who had been drawing and painting there for 30 years or more and . . . younger men, who in a year or two, or three or five, or ten or twenty, were bound to make their mark . . . others as conspicuously singled out for failure and future mischance – for the hospital, the garret, the river, the morgue or worse . . . the idle and the industrious apprentice, the good and the bad, the clean and the dirty (especially the latter) – all more or less animated by a certain *esprit de corps*, and working very happily and genially together . . .' It was among this disparate collection of students that Monet met three aspiring young artists with whom he would soon be close friends – Frédéric Bazille, Auguste Renoir and Alfred Sisley.

Bazille had come up to Paris from Montpellier in the south of France. His well-off parents had agreed to support him as long as he divided his time between the study of art and the study of medicine. Sisley, Paris-born but of English parents, was also from a moneyed background, but Renoir, the son of a poor family from Limoges, had had to make his own way, earning enough money through his own efforts to fund his arts studies. From diverse backgrounds, Monet, Renoir, Sisley and Bazille were also contrasting characters. Monet was the natural leader of the group – proud, self-confident and independent. He would have no truck with the academic system; he was determined to follow his own path. Renoir had none of Monet's almost brutal single-mindedness. Lively and extrovert, he had a sheer joy in painting which soon attracted the not uncritical attention of his teacher Gleyre: 'I suppose you're dabbling in paint just to amuse yourself?' the professor asked. 'Why, of course,' Renoir replied, 'if it didn't amuse me, you can be sure I wouldn't do it.'

Sisley was a genial, good-humoured figure, with a certain timidity in his nature, while Bazille stood out by his refined manner and distinguished appearance, which went with an essential loyalty of character that made him an excellent friend. What united such diverse personalities was their intense dedication to their new approach to art.

Although many unkind things were later said and written about Gleyre – especially by Monet who had a strong tendency to propagate myths about his own past – he was in fact an excellent teacher for the four young artists. He taught drawing and painting from the nude, and composition – he set his students test subjects to compose into preparatory oil sketches for a large-scale canvas. He hated slickness, but he did not approve of lack of finish in students' work. He expected carefully worked paintings of the nude model and well-thought-out compositional exercises. This must have been of great value to young apprentices in the art of painting.

Monet later claimed to have spent only a brief period at Gleyre's studio, but in fact he appears to have studied there for about two years. Still, his love of painting in the open air never faltered. The most famous centre for open-air painting in France was the

Fontainebleau forest southeast of Paris. In summer the area was dotted with the parasols of landscape artists – both famous and obscure – and not surprisingly from 1863 Monet and his friends became frequent visitors. The area around Chailly where they worked had been made famous by the Barbizon school of landscapists, but the young painters soon shook off any imitation of their elders. Where the Barbizon artists had mostly filled their paintings with subdued colours and dark shadows, Monet painted studies brimming with sunlight – spacious scenes captured on bright pleasant days.

The visits to Chailly alternated with spells on the Normandy coast, where Monet renewed his unbroken friendship with Boudin. His younger artist friends also came to stay either at Le Havre or nearby Honfleur, and Monet's letters of the time express all the excitement he found in stimulating companionship and the daily struggle to render in paint the landscapes and seascapes around him. 'Every day I discover more and more beautiful things,' he wrote in July 1864. 'It's enough to drive one mad: I have such a desire to do everything, my head is bursting with it!'

But like all aspiring artists, Monet wanted not only to work as he wished, but also to achieve recognition and – most importantly – to make a living from his painting. In order to make a name, and therefore a living, in the mid-1860s, an artist had to gain acceptance at the Salon, the annual major art exhibition in Paris. The first hurdle was the tough Salon jury, dominated by academics, which approved or rejected paintings. Then came the all-important visit of the art critics, whose opinions could make or break an artist's career. Among the thousands of entries at the Salon, large pictures attracted attention, but those with a 'licked' surface (showing no hint of brushwork) and with a good storyline were often preferred.

Despite the teaching of his mentor Boudin, Monet started out by preparing entries for the Salon in the traditional manner – painting a finished canvas in the studio from the studies done out of doors. In the Salon of 1865 he exhibited two sea-paintings completed in this manner which enjoyed a considerable success. The only person to express annoyance at Monet's work was the artist Edouard Manet, who thought that the exhibition of paintings by an unknown artist with an almost identical name was some sort of joke at his expense.

When Monet turned to the preparation of large-scale figure paintings for the Salon, however, he was to encounter a wall of hostility, because his pictures did not conform to accepted ideas about finish or suitability of subject matter. Far from having a smooth 'licked' surface, Monet's paintings were broadly handled with a loaded brush, giving a rough surface texture and clearly visible brushstrokes, and sacrificing detail to overall effect. What is more, Monet's paintings were of modern everyday life. This was a direct insult to the academics who considered that large-scale painting was appropriate only for grand heroic subjects that told a moral story. The unconventional combination of large canvases

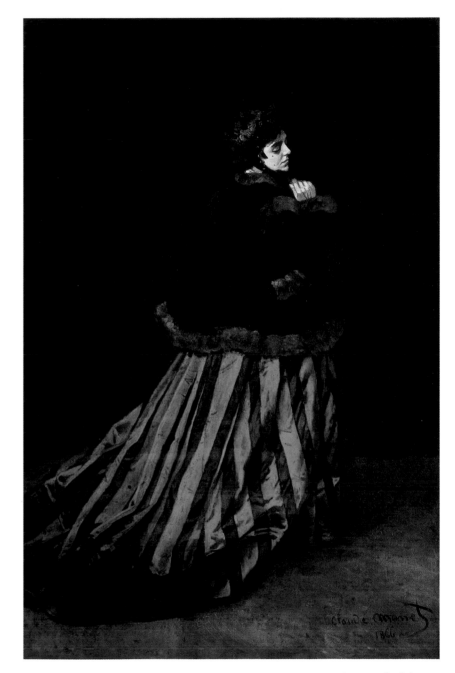

Monet: CAMILLE, OR THE WOMAN IN THE GREEN DRESS, 1866.
Monet's mistress, later his wife, posed for this impressive essay in a traditional form. It was completed in four days expressly for the Salon, to which it was admitted. It clearly shows that Monet could have continued to find favour there had he so chosen.
231 × 151 cm. Kunsthalle, Bremen.

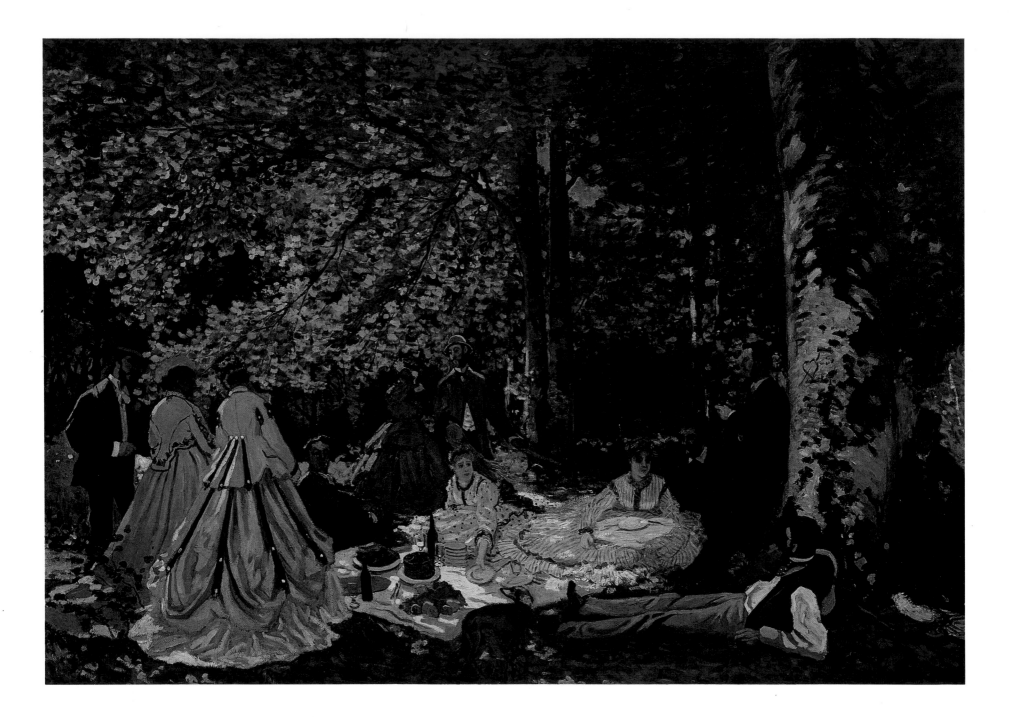

Monet: STUDY FOR
LUNCHEON ON THE GRASS,
1865.
Of the huge picture that resulted only

two fragments survive. Bazille posed for
at least two of the figures.
130 × 181 cm. Pushkin Museum,
Moscow.

and modern-life subjects had been pioneered by the arch-realist Gustave Courbet and taken up by Edouard Manet. Both had encountered public rejection and ridicule – as well as gaining widespread notoriety and a following among younger artists.

Monet's first attempt at a large-scale figure painting was *Luncheon on the Grass* – a deliberate reference to Manet's painting of the same name which had caused a scandal at the Salon of 1863. Conceived in May 1865, this ambitious project obsessed Monet until the following spring. Preparatory studies – both drawings and oil – for this 460 × 610 cm canvas were made in the Fontainebleau forest in the summer of 1865. Difficulties slowed his progress – an accident laid him up in bed and wet weather prevented work outside – but a large oil study (page 18) painted indoors was complete by September. It is more successful than the final version, with a lively directness of brushwork capturing the dancing sunlight as it plays through the fresh greens of the foliage, dappling the lounging figures with patches of direct and reflected light. Monet transferred this large study to the huge final canvas in Paris studios in the winter of 1865–66. Far from the source of inspiration, it was a more mechanical picture and betrayed Monet's lack of formal training as a figure painter, as well as his inexperience in working on such a scale. As a result, Monet could not complete the picture in time for the 1866 Salon. It was abandoned unfinished to rot, and only fragments survive today.

Monet was undaunted by this major setback. He still exhibited two paintings at the 1866 Salon, a Fontainebleau landscape and *Camille*, or *The Woman in the Green Dress* (page 17). This portrait of Monet's new model, the 19-year-old Camille Doncieux, was apparently painted in four days as a last-minute Salon entry. It was regarded as 'safe' by the jury and was a considerable public success. Encouraged, Monet embarked on another large canvas, *Women in the Garden* (page 127), for presentation the following year.

Monet started the picture in the summer of 1866, when he moved to Ville d'Avray (made famous by the landscapist Corot) southwest of Paris. It was painted almost entirely out of doors in the garden of Monet's house, with Camille, now his mistress, posing for at least two of the figures. Courbet, a regular visitor that summer – and a man who had a vast experience of large-scale figure paintings – could not understand the difficulties that Monet created for himself. Monet would only paint when the sunlight was falling correctly on the subject. Courbet suggested that, when the figures were not correctly lit, he could spend the rest of his time working on the foliage. But Monet was committed to an equally accurate portrayal of each part of the subject before him. As he explained to Courbet, when the light effect changed he could not continue working on *any* part of his picture without losing the overall unity. In order to maintain a fixed position in front of his subject, Monet even dug a trench and lowered his canvas into it so that he could reach the upper section. His alternative – using a stepladder, as was customary in academic studios – would have forced him to change his point of view and look down on the subject from above. This would

Monet: CAMILLE WITH A SMALL DOG, 1866.
Camille's character is conveyed here with a singular poignancy, while the dog's pleasing absurdity is summarised in masterly fashion.
73 × 54 cm. Bührle Collection, Zurich.

Monet: QUAI DU LOUVRE, 1867.
Monet, Renoir and Pissarro favoured
cityscapes seen from above street level.
Here, though the elements are defined
quite separately, one can already sense

the fusion of space, light, substance and
colour Monet was pursuing.
65 × 93 cm. Gemeente Museum, The
Hague.

have made the composition (the relation of the parts to the whole) inconsistent, and again destroyed the picture's unity.

Although Monet was forced to complete *Women in the Garden* in his Le Havre studio the following winter, it retains the freshness and authenticity of his first impression. Not entirely to Monet's surprise, however, the 1867 Salon jury rejected the painting. The combination of large scale with life-size modern-life figures, and of naturalism with bold brushwork in bright colours, ensured a hostile reaction.

Monet was still expanding the range of his painting. In the early summer of 1867 he, like Renoir, worked on Parisian scenes – views of garden squares and the tree-lined quays of the Seine – all painted from high up on the colonnade at the east end of the Louvre. But the difficulties of his life were accumulating. He was virtually penniless, dependent on the support of better-off friends – notably Bazille – and of his family. What is more, his mistress Camille was now pregnant. Monet's aunt, Madame Lecadre, offered him the chance to spend time at her summer residence at Sainte-Adresse near Le Havre, on condition that he did not bring Camille with him. Thus Monet left Camille behind in Paris, in the care of a medical student, and was at Sainte-Adresse when their son Jean was born on 8 August.

Yet little of Monet's hardship or family tensions shows in the paintings he executed that summer. In his *Terrace at Sainte-Adresse* (page 128), his respectable family are depicted enjoying the sea and the summer afternoon sunlight. Only the artist's high viewpoint – he painted from above the terrace looking down – may suggest his feeling of exclusion as an onlooker from this pleasant family scene. *Terrace* was one of Monet's most carefully composed pictures of the 1860s. He called it his 'Chinese' painting, by which he meant that it showed the influence of the newly discovered Japanese woodblock colour prints, of which he was an ardent collector. The composition is almost abstract, the flamboyant colours held in place by the taut pattern of horizontals and verticals created by the superimposed strips of sky, sea and land across the painting and the uprights of the two flagpoles. This grid-like framework draws our attention to the flat design on the canvas surface, undermining the illusion of depth so important to traditional landscape painting. For contemporaries this was novel and hard to follow; Monet did not exhibit the painting until 1879.

Through 1868 and 1869 the artist's fortunes fluctuated. He found his first patron, a Le Havre businessman called Gaudibert who commissioned a series of family portraits. Guaranteed temporary financial security, Monet settled for the winter with Camille and Jean at Etretat near Le Havre. Here he painted some superb seascapes like that of the Porte d'Amont, a local beauty spot.

Yet Monet was never careful with money and extreme poverty was soon his lot again. Even at Etretat, he was forced to re-use canvases because he could not afford new ones, scraping off and painting over previous studies which may themselves have been

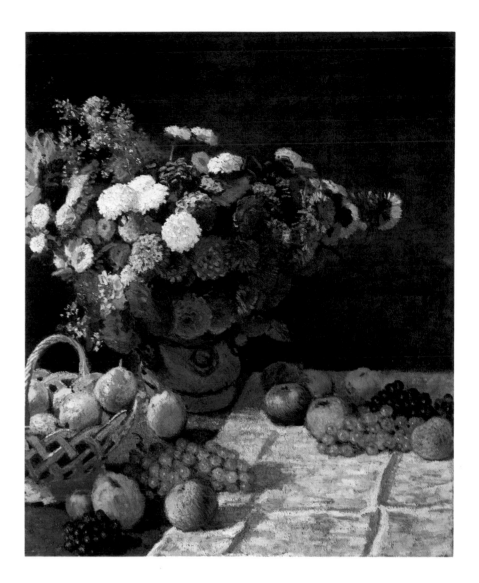

Monet: STILL LIFE WITH FLOWERS AND FRUIT, c.1869. A marvellous sense of freedom in handling and colour gives us a foretaste of the great flower pieces of the 1880s. 106 × 81 cm. J. Paul Getty Museum, Malibu.

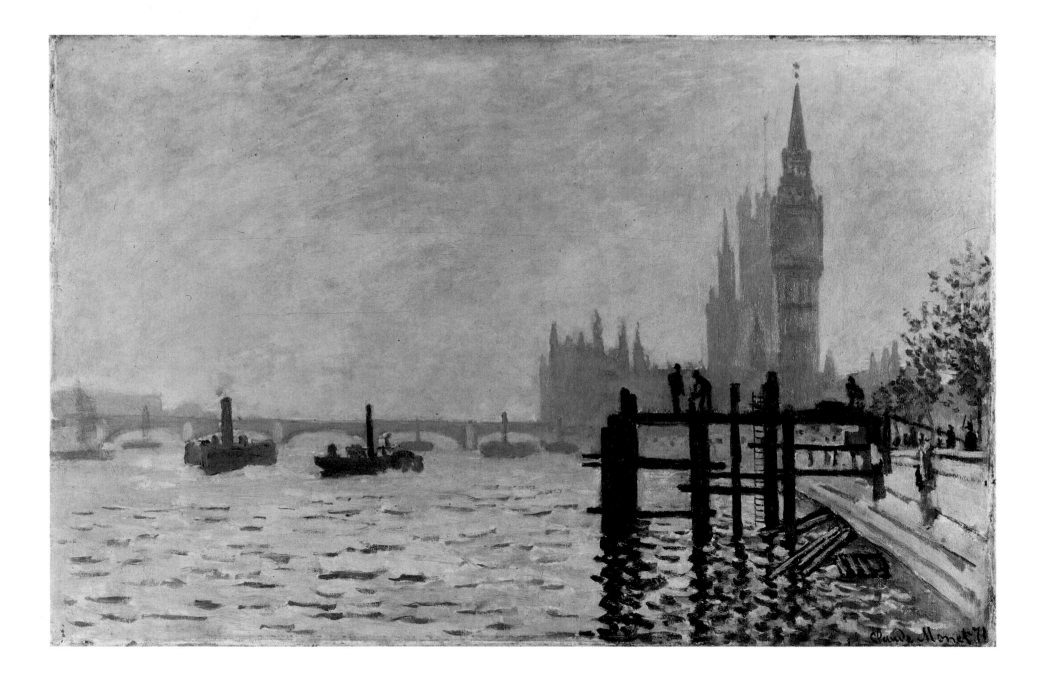

Monet: THE HOUSES OF
PARLIAMENT, LONDON, 1871.
The Thames and the Houses of
Parliament captivated Monet during his
exile and he was to return over 30 years
later to paint Waterloo Bridge and the
Houses of Parliament in series. In
comparison with the later works this
view is cool, calm and judiciously
composed.
48 × 73 cm. National Gallery, London.

masterpieces – the stunning snow-scene *The Magpie* (page 131) is one picture known to be painted over another. Other pictures were left with landlords to cover unpaid bills or auctioned off at pitifully low prices to satisfy creditors.

During the first seven months of 1869, Monet almost ceased work because he had no money to buy paints. He moved to Bougival, west of Paris, and from there wrote begging letters to Bazille describing his plight: 'For a week no bread, no kitchen fire, no light – it's appalling.' But in the autumn an intensive working partnership with Renoir produced a series of pictures that were to change the course of landscape painting. They came closer in feeling to the Impressionist painting of the 1870s than anything either man had done before. At the popular Seine riverside resort of La Grenouillère, on the Isle of Croissy near Bougival, Monet and Renoir set up their easels side by side. They made studies of almost identical views of the bathers, boats and strollers in the sunny landscape (page 132). Monet intended to use his La Grenouillère studies – 'some bad sketches' he called them at the time – for a larger picture, but none was ever painted. In fact, this marks the end of the period in which Monet regularly made preparatory oil studies with larger works in mind. The La Grenouillère studies are really successful as paintings in their own right, and are typical of Monet's loosely brushed 'unfinished' paintings that were to rock the art establishment in the 1870s.

The winter of 1869–70 saw Monet working at Bougival and at nearby Marly, but new problems were looming, this time political. In July 1870 war broke out between France and Prussia. Since Monet had married Camille on 28 June, he was freed from the first call-up of single men, but, anxious to avoid any further call-to-arms and determined to continue painting, he retreated with his family to Trouville on the Normandy coast, where Boudin often worked. There Monet painted a delightful series of open-air beach scenes (page 133) which give no hint of the war. By the autumn, Paris was under siege and France was on the path to revolution. While many of his friends remained in Paris, Monet followed Boudin's example and left the country, taking a boat to London, where his family joined him.

Monet took lodgings in the artists' quarter of Kensington at 1 Bath Place (now 183 Kensington High Street – the actual house no longer exists). His landscapist friend Charles Daubigny had lodgings nearby, and the two exiles soon made contact – Daubigny is said to have come across Monet painting on the banks of the Thames in November. Daubigny undoubtedly gave Monet entrée to the artistic circles with which he, a regular visitor to London, was already familiar.

One person to whom Monet was introduced was Durand-Ruel, the Parisian art dealer who had fled France in September 1870, sending most of his stock of paintings on ahead. On 10 December 1870, he opened a gallery in London at 168 New Bond Street – curiously called the German Gallery – having formed a Society of French Artists, under

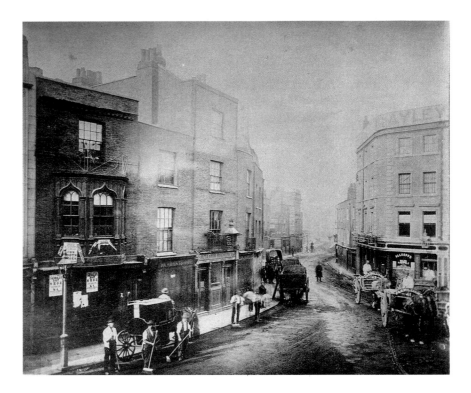

Monet: KENSINGTON HIGH STREET, c.1870.
Monet knew a very different Kensington from ours. In the end he valued London's fog more than anything else he found there.
Kensington Public Libraries.

J. Andrieu: THE DESTROYED
RAILWAY BRIDGE AT
ARGENTEUIL, 1870–71.
When this bridge was rebuilt after the
war, Monet painted it several times. The
idyllic Argenteuil where Manet, Renoir
and Sisley also worked in the 1870s
seems very remote from this evidence of
national disaster.
Photographic Collection, National
Gallery of Canada, Ottawa.

whose banner he was to hold regular exhibitions in London until 1875. Monet had clearly
met Durand-Ruel by the beginning of December, for the dealer showed at least one of his
pictures, an *Entrance to Trouville Harbour* brought with him from France, in his first
exhibition. Durand-Ruel was delighted to meet Monet, having already admired his work
in the 1860s and even given the artist a warm appraisal in his *Revue internationale de l'art et de
la curiosité* of 1870 – despite the fact that Monet's paintings had been excluded from the
Paris Salon. The meeting was a vital one for Monet. Not only did Durand-Ruel
immediately exhibit his work, he soon also began purchasing from the artist: two
landscapes, including a *Trouville*, were sold to the dealer in June 1871 for 300 francs apiece.
It was the beginning of a lifelong association, which brought Monet crucial support
during the 1870s, when he was still struggling for recognition and a regular income.

It was through Durand-Ruel that Monet made contact with another artist who had
taken refuge in London, Camille Pissarro. Monet and Pissarro had become close friends in
the late 1860s, sometimes painting together, and meeting in the artists' circle which
gathered around Manet at the Café Guerbois. Pissarro and his family had settled well out
of central London in Upper Norwood, a still semi-rural part of the rapidly expanding
southern suburbs. While Monet concentrated on painting the urban landscape – the
Royal Parks, the *Houses of Parliament, London* (page 22) and the *Pool of London* – Pissarro,
several miles away, worked in a more rural environment. Pissarro and Monet apparently
never painted side-by-side in London, but they did visit museums and exhibitions
together. It was an opportunity to study English painting, and especially the works of
Turner and Constable.

In 1870 the Turner Bequest was in the hands of the National Gallery, and over 100 oils
and watercolours were always on view, including *Rain, Steam and Speed* and the *Fighting
Temeraire*. A dozen Constables, among them the *Hay Wain*, were also hanging there, and
more at the South Kensington Museum (now the Victoria and Albert) not far from where
Monet was staying. But none of Constable's freely executed sketches and studies were on
view at the time, and neither were Turner's most 'impressionistic' works. Monet's
recollections of London in 1871 expressed an abrupt scepticism about the influence of
these British artists on his own work. His friends recalled that Turner's painting was
antipathetic to Monet 'because of the exuberant romanticism of his fancy'. In 1918 Monet
admitted that he had at one time admired Turner greatly, but added: 'Today I like him
much less . . . he did not organise colour enough, and he used too much of it.'

Monet submitted two paintings to the Royal Academy exhibition in March 1871 but
both were rejected. One of his entries was probably an important interior study of Camille
called *Repose* or *Meditation* – a strangely literary title for Monet, perhaps geared to his
English audience. The painting certainly confirms the presence of Monet's wife in
London, where the picture was executed. The artist had more success at the International

Exhibition at South Kensington in May. The French section included *Repose*, a Trouville seascape and *Camille* – a small-scale version of Monet's Salon success of 1866.

By the end of May 1871, with the war between France and Prussia ended and the revolutionary uprising of the Paris Commune repressed, Monet was free to return from his voluntary exile. But, unlike the homesick Pissarro, he chose instead to remain abroad, leaving England for Holland probably at the invitation of Daubigny, who painted there in 1871 and 1872. Drawn by the picturesque potential of this new environment, Monet settled in the pretty village of Zaandam, near Amsterdam – a choice which enabled him not only to paint, but to visit the Rijksmuseum in Amsterdam to study the Dutch Masters, and also the Frans Hals Museum.

The flat Dutch landscape with its cool northern light and varied greys provided Monet with a refreshing contrast to the more colourful urban and suburban motifs which dominated his subject-matter in the 1860s. Reminding him of the Seine and the Normandy coast, the many Dutch waterways allowed Monet to continue his research into the effects of light on water. This theme encouraged his use of pale blond hues to suggest the overwhelming presence of the sky and its reflection in the water's surface. The long, low horizons were often emphasised in Monet's choice of unusually elongated canvases. These odd-shaped canvases he had bought in London expressly with his Dutch trip in mind.

An echo of Monet's Paris scenes painted in 1867 can be seen in his townscapes of Zaandam, although his work there was done at ground level to complement the characteristic Dutch landscape. It is unlikely that his paintings of Amsterdam itself date from this visit. He may have returned in 1872, but on stylistic grounds it is considered much more probable that the second visit was made in early 1874.

By mid-November 1871 Monet was back in Paris, renting a studio at 8 Rue de l'Isly near the Gare St. Lazare, which he kept until 1874. The artist always maintained a pied-à-terre in the city, to store canvases and materials, and sometimes to live and paint. He always chose a spot in the new 'Europe' district, close to the station which was the terminus for the railway line to Normandy. The same line took him through all his favourite haunts, including Argenteuil and Vétheuil, where he would live in the late 1870s. By the end of 1871, Monet was installed with his family at Argenteuil, renting a property with its own studio, close to the Seine. Although Monet did not limit himself to working in the town and its environs, Argenteuil did provide him with the majority of his motifs over the next few years.

In the summer of 1872, Monet and Renoir renewed their working partnership, out together painting landscapes around Argenteuil in which their brushstrokes became smaller and more broken, their colours lighter, brighter and more prismatic. Monet also worked alongside Sisley that year, both artists depicting Argenteuil's Boulevard Héloïse in a plunging perspective, although Monet's version was predictably the more daring of the

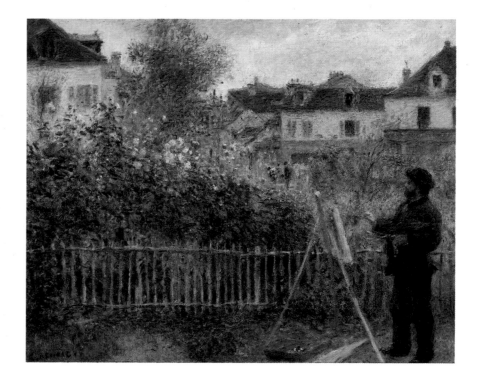

Renoir: MONET WORKING IN HIS GARDEN AT ARGENTEUIL, 1873.
Painted during a period when Monet and Renoir were very close, both personally and in painting technique. 50 × 106 cm. The Wadsworth Atheneum, Hartford, Conn. (Bequest of Anne Parrish Titzell.)

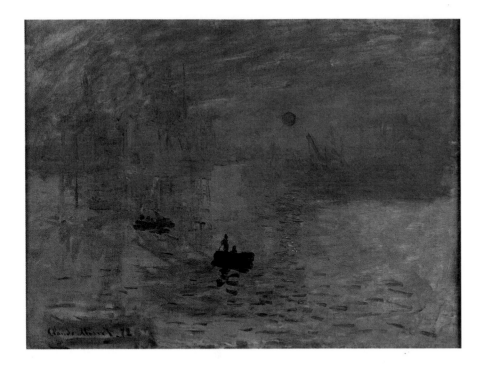

Monet: IMPRESSION, SUNRISE,
1873.
A picture that has become a leading
emblem of the movement to which it
fortuitously gave its name. Asked for a
title to put in the historic 1874 catalogue,
Monet later explained: 'It couldn't really
be taken for a view of Le Havre and I
said: "Call it Impression." . . . From
that came Impressionism and the jokes
blossomed.'
48 × 63 cm. Musée Marmottan, Paris.

two. All three painters worked together in different pairs during 1873, when Renoir
portrayed Monet executing a study of colourful dahlias in his garden (page 25). It was
during his Argenteuil period that Monet's love of gardening – which was to culminate in
his creation of the magnificent Giverny garden – first had the opportunity to emerge.
Almost a decade later he was to record his Vétheuil garden (page 139), with its luxuriant
growth of sunflowers on the bank rising to his house. Flowers – either growing in colourful
profusion outdoors or as cut flowers for studio still lifes – were to provide the artist with a
wealth of subjects for experimentation, and were a continual source of inspiration
throughout his career.

It was probably in 1873 that Monet adopted Daubigny's idea for more mobile outdoor
work – notably a floating studio. Monet may well have converted his boat with the help of
a neighbour at Argenteuil, the engineer Gustave Caillebotte, himself a painter, an avid
gardener, and an important patron and supporter of the Impressionists. The boat's
protective cabin and awning allowed Monet to carry a considerable bulk of materials and
to work in all weathers. As with Daubigny, the craft stimulated Monet to even freer
experiments with composition in which, for obvious reasons, water often dominated the
immediate foreground, giving maximum scope for recording colourful reflections.

It was the Seine and the long stretch of its valley from Paris to Le Havre that absorbed
most of Monet's artistic interest during the 1870s. Around Argenteuil, he frequently
painted the river's road- and rail-bridges, which provide startling geometrical frameworks
for his compositions. These bridges – and the presence of steamers on the river – give the
only hint of industrial modernity in Monet's landscapes at this time. Unlike Pissarro, he
expressly excluded any direct reference to nearby factories and new industrial
developments, with the exception of the reconstruction of the Argenteuil highway bridge
after its devastation in the Franco-Prussian War. Yet even these oblique symbols of
modernity point to Monet's faith in the post-war economic recovery of France, a recovery
upon which his own livelihood depended. Monet's one direct portrayal of industrial
labour – *Men Unloading Coal* of 1875 – uses the Asnières highway bridge (on the outskirts
of Paris) as a frame for the rhythmic pattern of coal-haulers on gangplanks between barge
and riverbank, unloading fuel for the Clichy gasworks.

Painting trips away from Argenteuil included regular visits to the inland port of Rouen
– on the Seine about 100 miles east of Le Havre – where Monet's brother Léon lived. A
number of shipping scenes and seascapes were inspired by Rouen, whose Cathedral façade
was to be the subject of one of Monet's 'series' of paintings in the 1890s. The artist also
returned to Le Havre, and it was there that he executed (probably in 1873) his famous
study *Impression, Sunrise* (page 26), which was to give its title to the new movement at the
first group exhibition in 1874.

The idea of group exhibitions independent of the Salon and free of the whims of its

traditionalist jurors had been broached as early as 1867, but lack of funds had prevented it coming to fruition. The continuing difficulty experienced by artists exploring new techniques and subject-matter – men such as Monet himself, Renoir, Pissarro, Sisley, Manet, Degas and Cézanne – in getting their work exhibited at the Salon kept the issue alive, however. By the early 1870s, Monet had stopped submitting paintings to the Salon jury at all, and he seems to have been the guiding force behind the formation of the *Société Anonyme des Artistes Peintres, Sculpteurs, Graveurs, etc.* in May 1873. The declared aim of the Société Anonyme was to promote 'independent art', and it was intended that it should be run on the model of the bakers' union. A joint-stock company was founded with regulations, shares, articles of partnership and monthly subscriptions. An exhibition was planned for April 1874, a fortnight before the official Salon, and a gallery was found on the second floor of 35 Boulevard des Capucines in the heart of fashionable Paris – the former studios of the photographer Nadar.

There was to be one striking absentee from the exhibition. Manet, regarded by the critics and public as the head of what they termed 'the school of daubers', refused Monet's invitation to join the group, maintaining that the Salon ought to be reformed from within. This left at the core of the exhibition nine professional artists: Monet, his friends from Gleyre's studio Renoir and Sisley (the third friend, Bazille, had been killed in the Franco-Prussian War), Pissarro, Cézanne, Degas and Manet's friend Berthe Morisot. The numbers were made up by associates or acquaintances, ranging from artists who had frequently exhibited at the Salon to complete amateurs. Monet himself contributed 12 of the 165 works to be shown.

Sadly, the excitement of the weeks of preparation for the exhibition was followed by an awful anticlimax on the day of the opening, 15 April. Only 175 people turned up – a figure which was to drop to 54 on the last day. On one evening (it was an innovation to remain open from eight until ten for passers-by who might want to 'drop in' after dinner) only two visitors turned up. Compared to the Salon, which attracted 400,000 visitors in the first month alone, overall attendance remained low: 3500 paid their one franc entrance fee, and the average daily attendance was only 117.

The problem for conservative viewers was the fact that the pictures exhibited were 'unfinished' sketches of the type not normally shown to the public as complete works of art. There were no 'finished' pictures in sight. Such behaviour seemed an affront to academics and serious art-lovers alike: were they being taken for a ride? And, if not, how could artists hoping for public recognition expect patrons to pay good money for such slapdash paintings which showed little evidence of hard work and seemed no more than mindless imitations of unadorned reality?

It was in his review of 25 April that the critic Louis Leroy – friend of the caricaturist Daumier and of the Goncourt brothers, and himself a poet and artist – first coined the

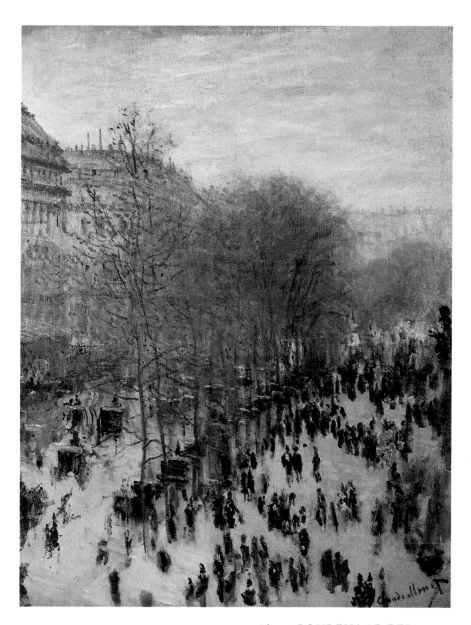

Monet: BOULEVARD DES CAPUCINES, 1873.
The view from Nadar's studio where the First Impressionist Exhibition was held the following year. This painting, or a similar one now in the Pushkin Museum, Moscow, was included in the exhibition.
79.4 × 59 cm. The Nelson-Atkins Museum of Art, Kansas City, Missouri.

Berthe Morisot: HIDE AND SEEK,
1873.
Lent by Manet to the 1874 exhibition.
Morisot was one of the staunchest of the
Impressionists and showed several
pictures there, to the deep disquiet of her
mother.
45 × 55 cm. Collection Mr. and Mrs.
John Hay Whitney, New York.

name 'Impressionists'. Writing of Monet's *Impression, Sunrise*, he describes the marine view as even less finished than 'wallpaper in its embryonic state'. But his review was for the satirical magazine *Le Charivari*, and despite a hectoring style, his views were much less negative than popular opinion now assumes.

The term 'impression' was not a novel one, having been in regular use since the early 19th century to describe a rapidly executed sketch which recorded the artist's initial response to a subject. As such, it was already part of the technical vocabulary employed by artists to distinguish the various preparatory stages in the printing process. Critics had for some time also used it — sometimes perjoratively — to characterise the 'finished' work of the more radical landscapists like Corot and Daubigny. Théodore Rousseau had spoken of his desire to record his 'virgin impression of nature', and both Corot and Boudin are often quoted as stressing the importance of the first impression — always the strongest. Manet linked this approach with honesty and sincerity, and in 1867, on the occasion of his first one-man show, he spoke of his intention to 'convey his impression'. Even a critic essentially hostile to the Impressionist group show was forced to admit that Monet caught 'admirably the first impression of nature'.

The Impressionists' landscapes of this period were superbly described in the review of the show by Armand Silvestre. He noted that the canvases were 'of modest dimensions' since they were intended to be hung in intimate settings rather than cavernous public buildings. The paintings were bathed in a 'blond light' and 'everything is joyousness, clarity, feasts of spring, golden evenings or blooming apple trees'. Their pictures seemed to 'open windows on a gay countryside, on the river carrying hasty boats, on the sky streaked with light vapours, on cheerful and charming outdoor life'. The critic Jules Castagnary commented that their novel way of understanding nature was 'neither boring nor banal . . . It is lively, sharp, light; it is delightful.'

One of the few criticisms in Armand Silvestre's review was directed specifically at the Impressionists' apparent lack of selection of their subjects, whereas the 'ancient masters' had composed their studio landscapes from fragments of nature chosen for their beauty. The Impressionists rejected such preconceptions of 'the beautiful'. Their idea that everything in nature was equally beautiful was, Silvestre maintained, 'artistically wrong', reinforcing 'the manual aspect of their technique'. Castagnary, too, found fault in what he considered their anti-intellectual stance. 'A school lives on ideas and not on material means,' he wrote, and 'distinguishes itself by its doctrines and not by a technique of execution.' He condemned their style as 'a manner and nothing else'. Yet it was precisely this rejection of established artistic conventions which gave their work originality. Academically acceptable landscape painting was thought to show not simply the manual dexterity of the artist in copying raw nature, but to demonstrate the artist's genius through tasteful selection and polished artifice.

Despite many reservations, all the reviewers expressed some admiration for the new painting. However, the conservative press (to avoid any publicity for a movement judged subversive to 'the moral order') in general abstained from comment, and their silence was decisive. Collectors were undoubtedly discouraged from investing in the Impressionists' work. By the time the show closed after its one month's run, Monet had sold only 200 francs worth of paintings (the actual transactions are not recorded). Moreover, income from tickets, the sale of catalogues and commission on sales of paintings was insufficient to cover costs, leaving the group deep in the red. The participants were asked to contribute a further 184 francs each to cover the deficit. On 17 December 1874, a final general meeting was held at Renoir's studio, when it was decided to put the group into liquidation, and the cooperative was dissolved.

Yet despite the failure of the First Impressionist Exhibition to secure financial or popular success, 1874 marks a high point of Impressionism, because it was the year in which the artists involved were closest to each other – a bond created by work, style and artistic aims. Even Manet, despite his refusal to join the Exhibition, came close to them in style under the influence of Monet, with whom he worked outdoors at Argenteuil that summer.

Monet and his colleagues were in no way deterred by the fate of their 1874 exhibition, but events in 1875 forced them to postpone a second show until 1876. A financial slump discouraged patrons and dealers – even Paul Durand-Ruel – from investing in painting, and the studio sales after the deaths of Corot and Millet in 1875 soaked up what meagre resources there were. In an attempt to gain publicity and raise funds, Monet, Renoir and Sisley organised a sale of their work on 24 March 1875 at the Hôtel Drouot in Paris, where all auction sales were conducted under government supervision. Berthe Morisot, though not in need of money, staunchly joined in with the others. In fact, it was her participation which resulted in a public brawl at the sale-rooms, when an irate spectator called her a 'whore' and was promptly punched by Pissarro. Ironically, Morisot's pictures claimed the highest prices, and, surprisingly, Renoir's the lowest – averaging only 100 francs. Monet's varied between 165 and 325 francs, but he had to buy back several paintings on which the bidding was too low.

Although auction sales were an important path to public recognition at that time – giving visibility and publicity (however notorious) to artists' work – this one was badly timed because, as Cézanne remarked, 'all the bourgeois are unwilling to part with their money'. Among the jeering crowds and the loyal supporters, however, was a new face – Victor Chocquet. He soon introduced himself to Renoir, and then to Cézanne who, in February 1876, introduced him to Monet. Not a wealthy man, Chocquet was nevertheless an enthusiastic collector, and bought several small things from Monet. Both Monet and Renoir (who painted several portraits of Chocquet, as did Cézanne) painted views of the Tuileries gardens from the windows of his splendid apartment on the fifth floor at 198 Rue

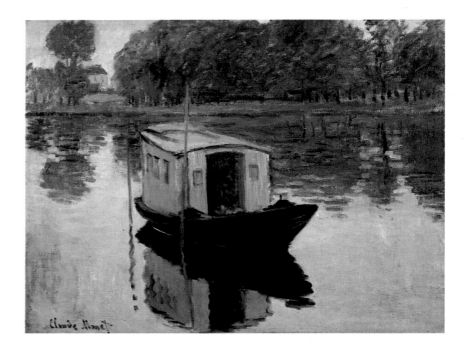

Monet: THE ARTIST'S FLOATING STUDIO, 1874. Monet adopted the Barbizon painter Daubigny's idea of painting from a small boat which naturally affected the resulting pictures by reason of the viewpoint and the proximity of the moving water. Turner had painted from a boat on the Thames in 1806–7. 50 × 64 cm. Rijksmuseum Kröller-Muller, Otterlo.

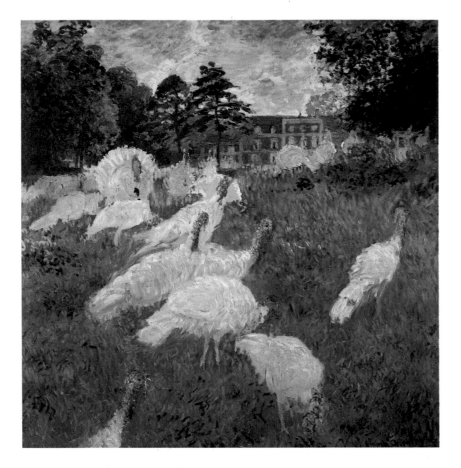

Monet: TURKEYS, 1877.
This is one of four decorative panels
commissioned by Ernest Hoschedé for
his country house, the Château de
Rottembourg at Montgeron. He bought
several pictures by Monet but went
bankrupt in 1878. His wife Suzanne
later became Monet's mistress and in
1892, after Ernest's death, the artist
married her. This panel seems unique in
Monet's oeuvre and gives us a glimpse of
the versatility that his single-mindedness
as a painter has tended to conceal.
72 × 75 cm. Musée d'Orsay, Paris.

de Rivoli in Paris.

In general, patrons and dealers like Chocquet and Durand-Ruel ensured Monet high earnings during the 1870s – between 10,000 and 12,000 francs a year, a substantial income for the period that placed him in the 'good bourgeois' class. His problem was not that his paintings failed to sell, but that he lived consistently above his means. Thus, the begging letters to friends and collectors continued. That to Manet in June 1875 – admittedly the artist's worst year of the decade – is typical: 'It's getting more and more difficult. Since the day before yesterday, not a cent left and no more credit, neither at the butcher nor the baker. Although I have faith in the future, you see that the future is very painful.' The background to Monet's working life remained, as in the 1860s, one of constant financial difficulties.

Between 1876, the year of the Second Impressionist Exhibition, and 1878, Monet painted regularly in Paris. In addition to his views of the Tuileries, he painted in the Parc Monceau and – most importantly – executed a series of studies of the Gare St. Lazare. It was in early 1877 that Monet, immaculately dressed, arranged for himself the official permission to set up his easel inside the station itself, along the railway tracks. At the same time he rented a small apartment at 17 Rue de Moncey, as a base for his work at the station.

In most of Monet's Gare St. Lazare paintings, the iron and glass canopy spanning the tracks gives compositional structure, an elegant architectural frame to contain the floating effects of steam, light and colour (pages 136 and 137). From his positions under this protective awning, Monet looked out towards the huge new Europe Bridge which crossed the railway lines, and up to the modern apartment buildings of the district. The cool, filtered light where he stood contrasts with the brilliant daylight beyond the canopy – in some paintings a golden afternoon sunlight, in others the neutral luminous grey of an overcast sky. Although different in conception from his later work, these paintings do look forward to Monet's 'series' paintings of the 1890s.

Already by the spring of 1877 Monet had sufficient completed canvases to exhibit several of his Gare St. Lazare paintings at the Third Impressionist Exhibition, held in April. Three had previously been sold – two to his patron Hoschedé, a third to Dr. de Bellio, another valiant supporter – and were loaned back to Monet for the show. Sadly for Monet, Hoschedé was in financial difficulties by this time. In the summer and autumn of 1876, Monet had spent some time at the Hoschedés' château at Montgeron, beginning four large decorative panels, including the stunning *Turkeys* (page 30), which remains unfinished. The lower two-thirds of this startling composition show a vivid green bank interrupted by the dramatic shapes and colours of these strange birds, the whole freely and vigorously painted. But Hoschedé was living far beyond his means and, in June 1878, was forced to dispose of his entire collection. It was another disaster for the Impressionists, who again saw their works sold for miserably little: Monet's 16 canvases averaged only 150

francs, and his *Impression, Sunrise* (which Hoschedé had bought in May 1874 for 800 francs) was knocked down to de Bellio for only 210 francs.

During the summer of 1878, under pressure from creditors, Monet left Argenteuil and, as he described it, 'pitched his tent' on the banks of the Seine at Vétheuil, further out from Paris. He was in 'a ravishing place' on a point jutting out into the winding river where it was dotted with wooded islets, and all around were superb motifs very different in feel from the Argenteuil landscape. In September, he and his family began sharing their house with the Hoschedé family – partly from mutual financial need, partly to assist Monet, whose wife was ill. Camille had been unwell since 1875, but the birth of their second son, Michel, in March 1878 was the final blow to her health. She died in September 1879 and Monet, in a subtle painting which mingles sorrow and guilt, recorded her face on the morning of her death (page 32). He later recalled that he had been horrified to find his eye continuing mechanically to analyse the colour effects on his wife's features even as she lay dying.

During that summer, preoccupied by Camille's declining health, Monet had painted far less than usual. Painting again that autumn and winter must have helped his loss, of which he wrote to Pissarro: 'You more than anyone must know the sorrow I bear. I am prostrate, not knowing where to turn, nor how to organise my life with my two children. I am sorely to be pitied.' Madame Hoschedé – who had six children of her own and who was, much later, to become Monet's second wife – came to the rescue.

Poor weather in the autumn of 1879 meant that Monet worked little out of doors, concentrating instead on still lifes of fruit, flowers and game birds. That winter was one of the coldest ever known in the Paris region, and the Seine iced over completely. Despite such inhospitable conditions, Monet painted several views of the frozen river. At the beginning of January 1880 the thaw came, and with it the most dramatic scenes of ice-floes which threatened the property of all living close to the banks. Beginning at five on the morning of Monday, 5 January, the thaw on the Seine lasted four days, although the freezing weather and snow continued until mid-February. With daylight from eight in the morning till four in the afternoon, Monet cannot have had sufficient time to complete the 20-odd canvases that depict the various stages of the thaw from different viewpoints on the riverbank. Some were executed on the spot, while others were studio recreations of the scene, painted using the *plein-air* studies for inspiration (page 143), and certain canvases were finished as late as March 1880.

Describing himself as working 'at full force' at this time, Monet prepared another major studio painting from several outdoor studies. *Lavacourt* was to be the artist's first Salon acceptance for over a decade: his last attempt had been in 1870. Monet had been impressed by the success of Renoir's *Portrait of Madame Charpentier and her Children* (page 67) at the Salon of 1879 where, thanks to the sitter's influence, the picture had been well hung and warmly received. In addition, the influential dealer Georges Petit – a rival of Durand-Ruel

Monet. CORNER OF AN APARTMENT, 1875.
An over-preponderance of blue was most noted in this intimate and tender painting at the 1877 exhibition. The figure in the background may or may not be Camille – paintings of family life would virtually cease after her death in 1879.
81.5 × 60.5 cm. Musée d'Orsay, Paris.

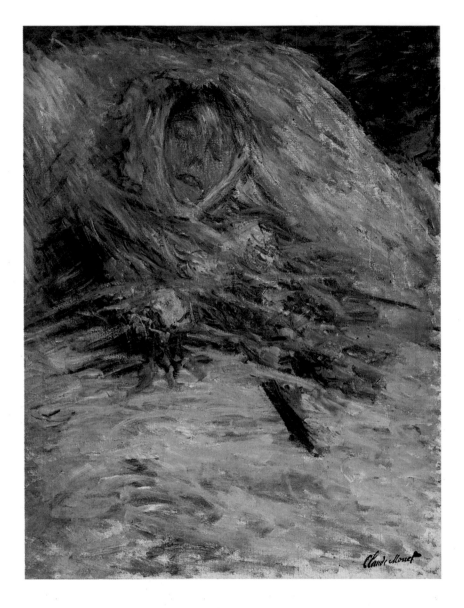

Monet: CAMILLE ON HER
DEATHBED, 1879.
A unique document and a truly
remarkable picture which shows just
how relentlessly compulsive a painter
Monet was. He later described his
painfully mixed emotions as he painted
this picture to a close friend.
92 × 70 cm. Musée d'Orsay, Paris.

— had tempted Monet with the offer of purchases, on condition that he gain acceptance at the Salon. Of his two entries, only *Lavacourt* — a large-scale riverscape executed in a self consciously conservative style — met with the jury's approval. Even so, it was hung six metres up, on the highest row, packed in 'like soldiers in a cattle-truck'. The critic Burty complained that, as a result, 'all the delicacy of his palette evaporates without benefit to himself, nor to the public, which is beginning to develop a taste for his subtle notations'.

An anonymous leak to the press in January 1880 had alerted Monet's colleagues to his intention to submit to the Salon. Couched in the most scurrilous terms, it satirised Monet's 'desertion' of the Impressionist camp to throw himself 'body, soul and paintbrush . . . at the maternal bosom . . . of M. Cabanel' — his arch-enemy in the conservative academic stronghold. Monet suspected that his patron Dr. de Bellio was behind this treacherous article, but could prove nothing. His friends at first refused to believe that Monet (like Renoir, Cézanne and Sisley before him) was renouncing his commitment to exhibit only with the independents, and Degas was openly hostile when it turned out to be true.

Monet justified his action in terms of potential sales — he needed the money. In March 1880 he wrote in explanation to the critic Duret, a friend who had encouraged his submission: 'It's not by choice that I do it, and it's appalling that the press and the public have not taken our little exhibitions more seriously, so preferable are they to this official bazaar.' The ex-Director of Fine Arts, Philippe de Chennevières, wrote favourably of Monet's picture, commenting that its 'light, clear atmosphere makes all the neighbouring landscapes look black'. Even Zola, whose review that year was critical of his former favourites, complained of its bad position, remarking that it 'sets up an exquisite note of light and open air up there'. *Lavacourt* was Monet's last ever entry to the official Salon.

Although out of favour with Degas, Monet rediscovered his alliance with Renoir through his attempt at official recognition. As a result, Renoir introduced him to his patron Charpentier, who held exhibitions at the offices of his publishing house for *La Vie Moderne*, a weekly illustrated review. An interview with Monet was published in June, in which the artist maintained he had 'never had a studio' and that he failed to understand painters 'locking themselves up in rooms. To draw, yes. To paint, no.' This partial view was reinforced by Duret, who wrote the introduction for the catalogue of Monet's one-man show at *La Vie Moderne* that year: 'With him, no more accumulated preliminary sketches, no more crayons or watercolours to be used in the studio, but oil painting entirely begun and finished in front of the natural scene, directly interpreted and rendered.' Monet's desire to present himself exclusively as the archetypal open-air Impressionist resulted in him over-emphasising that important aspect of his work to the exclusion of all actual studio practice — at least as far as the public was concerned.

Nevertheless, Duret's description of Monet's *plein-air* methods — gleaned directly from the artist himself — provides vital information on his approach in the 1870s: 'On his easel

he placed a white-primed canvas, and he began to cover it with patches of colour which corresponded to the coloured patches the natural scene presented to him.' At the first sitting, he often got no further than a rough block-in before the light effect changed, and this was pushed further on subsequent days' sittings. In addition to canvases primed with white, Monet frequently used other pale tints as a basis for his paintings: cream, grey, pale brown and biscuit colours were common. Duret's record omits the frustrations of unfinished studies and vanished light effects, problems Monet resolved by working indoors and completing pictures from memory or from previous studies. Gradually, during the 1880s, another solution would present itself to the artist, that of working in series – with a large number of canvases on a single motif under execution at any one time.

In March 1881, Monet wrote to Zola concerning his next move: 'I must shortly leave Vétheuil, and I am on the lookout for a pretty site on the banks of the Seine . . . I've thought of Poissy.' In December of that same year, he was installed at Poissy, where Alice Hoschedé joined him. Not surprisingly, her husband objected strongly to this arrangement, and the emotional tension resulting from this conflict may have contributed to Monet's dislike of his new residence, although it did not impair his creative energy.

In 1882 Monet exhibited for the last time as a member of the Impressionist group. Having declined to participate in the independent exhibitions of the two previous years, it was only at the insistence of Durand-Ruel that he agreed to take part. With Renoir, Sisley and Pissarro also participating, the Seventh Impressionist Exhibition was perhaps the purest representation of essential Impressionism of all the group shows. But the movement was beyond resuscitation, and Monet was far more enthusiastic for Durand-Ruel's plan to hold a series of one-man exhibitions.

In May 1883 Monet moved to Giverny, which was to be his home for the rest of his life. There was to be no clear break with the friends he had met at Gleyre's studio, and no sharp fissure in the evolution of his art, but Monet no longer stood at the centre of an artistic revolution. Young artists were coming forward who would pose their own new challenge to orthodoxy. Much of Monet's greatest work still lay ahead of him, but it was to be the expression of his individual genius, isolated from any movement or school.

At first Monet used Giverny as a base for energetic forays to the Normandy coast, and further afield to the Mediterranean and to the valley of the Creuse in the Massif Central. Wherever he travelled, he obsessively sought every effect of light and colour that he could possibly record on canvas, at times enduring the most acute discomforts of cold, wind and rain – he was once nearly pulled out to sea and drowned by a huge wave when he had mistaken the tide.

The Manneporte, Etretat (page 34) and the Ravine of the Creuse (page 146) capture the quality of his passionate assault on his subject-matter and the intense scrutiny of his unblinking eye. The

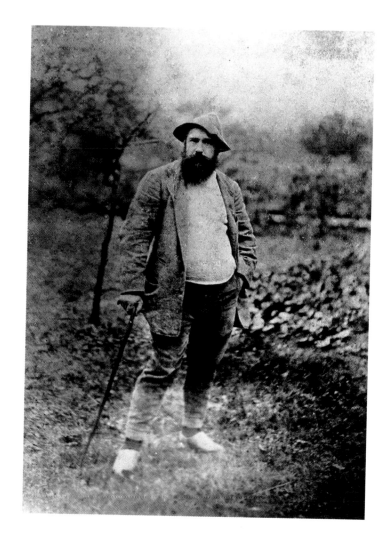

Monet c.1880.
An engaging image of the robust and unstoppable painter. He faltered a little after Camille's death, but was soon working again with a prodigious energy which was only to flag once more (temporarily) in his seventies.
Collection Robert Gordon.

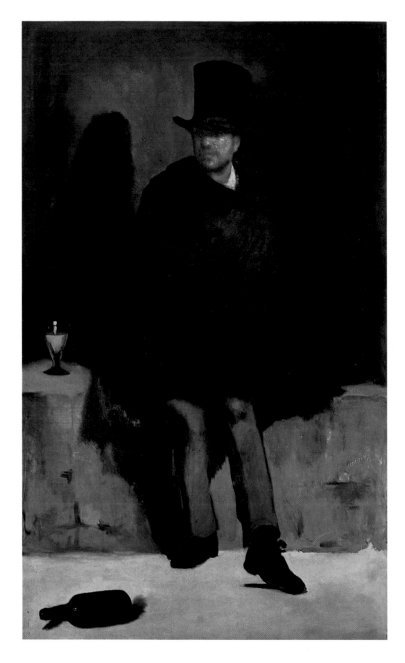

Manet: THE ABSINTHE
DRINKER, 1859.
Already under the spell of Spanish art,
Manet makes a bold though awkward
attempt at a low-life subject.
181 × 106 cm. Ny Carlsberg
Glyptothek, Copenhagen.

In the middle of the 19th century, French art was dominated by large-scale oil paintings of scenes from the Bible, classical antiquity, or French history. The modern urban world was almost totally absent from the walls of art exhibitions. The most eloquent protest against this state of affairs came from the poet and influential critic Charles Baudelaire, who called for an artist who would reveal the 'heroism of modern life' – the characters and hidden dramas of the contemporary world – in paintings on the scale of the great masters of the past. The artist who was to come closest to fulfilling this particular ideal of 'modernity' in art was Edouard Manet.

For an artist, Manet had an unlikely background. He was born in Paris in 1832, the son of Auguste Manet, a prominent civil servant and jurist. His mother was Eugénie Désirée Fournier, whose father moved in the highest political circles. As a result, unlike many of the Impressionist artists, Manet never had to paint for a living. As a young man, he hoped to follow his father in the law, but he failed his exams and so decided to try a career at sea instead. In December 1848 he enrolled in the merchant marine and set sail for Rio de Janeiro on board *Le Havre et Guadeloupe*. He returned in June 1849, only to fail more exams, this time for the navy. Finally, in 1850, his parents allowed him to join the studio of Thomas Couture.

Couture was one of the most prominent painters of his day. His monumental work *The Romans of the Decadence* had been the great success of the Salon of 1847, and his fame was now at its height. Manet spent six years in Couture's studio and it is clear that he was strongly influenced by the experience. Although Couture was in some ways a conventional teacher, following the state-run Ecole des Beaux-Arts in his insistence on drawing, he also recognised the importance of colour. Moreover, he told his students to carry a sketchbook at all times to capture 'action, movement, light, passion, thought – follow all these marvels of life as a hunter follows his prey'.

Despite this invigorating advice, Couture's practice in the studio did not always meet with Manet's approval. The lighting of subjects from high on one side to produce dramatic but unnatural effects especially disgusted him. Manet's friend and biographer Antonin Proust recalled him saying of the studio: 'I don't know why I'm here. Everything in front of our eyes is ridiculous. The light is false, the shadows are false. Whenever I enter the studio, I feel as if I'm entering a tomb.'

Manet was eventually to find his subjects in contemporary life, rather than in traditional historical narrative or scenes from antiquity. But although in his choice of subject he was undeniably modern, Manet had a deep respect for the masterpieces of the past. He not only learned from them but openly referred to them in his work. When he left Couture's studio in 1856, he did not immediately take up painting full-time, but instead made two long journeys around Europe, visiting museums and art galleries, where he copied the works of the masters. He was to be especially influenced by two great Spanish artists, Goya and

Velázquez, whose presence can be felt in most of his early paintings.

On his return to Paris in 1859, Manet produced his first major work, *The Absinthe Drinker* (page 36). It was refused for the Salon of that year, but did secure the support of the ageing Eugène Delacroix, the illustrious leader of the Romantic school. The picture provoked the final split between Manet and his former teacher when Couture observed that it must have been the artist who had consumed too much absinthe in producing such a work. It was not so much Manet's technique that offended Couture as the subject-matter, taken from the low street-life of contemporary Paris.

At this time the French capital was an overcrowded maze of winding streets, a breeding ground for disease and discontent. The population was rising alarmingly, fuelled mostly by people migrating from the countryside in search of work. As recently as 1848, the city had been convulsed by revolution, and the imperial government of Napoleon III, which had imposed itself in 1852, regarded the capital as a powder-keg that might at any time explode into popular upheaval.

Baron Haussmann, the governor of Paris, responded to the capital's acute problems by producing a plan for redevelopment. His solution was to demolish and rebuild large areas, thereby providing work, handsome profits for investors and – not least – making things difficult for any future revolutionary crowds (by creating long, broad boulevards that could be easily swept by cannon fire). But such long-term projects meant that enormous numbers of people found themselves homeless, while whole areas of Paris became desolate building sites. Manet's *The Absinthe Drinker* was a figure out of this disrupted city, a member of what were then known as the 'dangerous classes', depicted amid the ruins of his former neighbourhood. The subject is presented without sentiment or moral comment, with the detached eye of a solitary observer. It was the first of many paintings in which Manet was to disturb his audience by a cool unwavering gaze turned upon the life of Paris.

Public recognition came to Manet not through his fascination with the city, however, but through his enthusiasm for Spain. At the Salon of 1861, his *The Spanish Singer* was so popular with the public visiting the exhibition that it was subsequently moved to a more prominent position and earned the artist an Honourable Mention. Manet would not actually visit Spain for another four years, but during that period he was to paint a series of portraits in his studio – using a small number of Spanish props he had at his disposal – which were closely modelled on Goya or Velázquez in technique and pose.

When not painting, Manet devoted himself to a routine of social engagements with such friends as Edgar Degas, who also avoided the more Bohemian circles of the art world. The two painters became firm companions, although it was often a stormy relationship. Lunch would find Manet at the fashionable Café Tortoni, dinner at the Café de Bade, and it was at such venues that his admirers would seek him out. On the death of his father in 1862, the artist had come into a considerable inheritance. He was also free to marry his mistress

Fantin-Latour: EDOUARD MANET, 1867.
Fantin-Latour, a more than talented painter of portraits and still lifes, perfectly captures Manet as an elegant stroller of the boulevards. Manet's predilection for top hats and dark suits shows itself in several of his paintings. 117 × 89 cm. Art Institute of Chicago, Stickney Fund.

Manet: MUSIC IN THE
TUILERIES, 1862.
Manet here presents fashionable Paris of
the Second Empire parading itself in the
Tuileries Gardens. The painting is in
essence his response to Baudelaire's
invocation to artists to paint modern life.
Most of the figures in the picture can be
identified and include Manet himself
(standing at the extreme left), Astruc,
Baudelaire, Fantin-Latour, Offenbach,
Gautier and Eugène Manet (the artist's
brother). This was the social milieu to
which Manet belonged.
76 × 118 cm. Trustees of the National
Gallery, London.

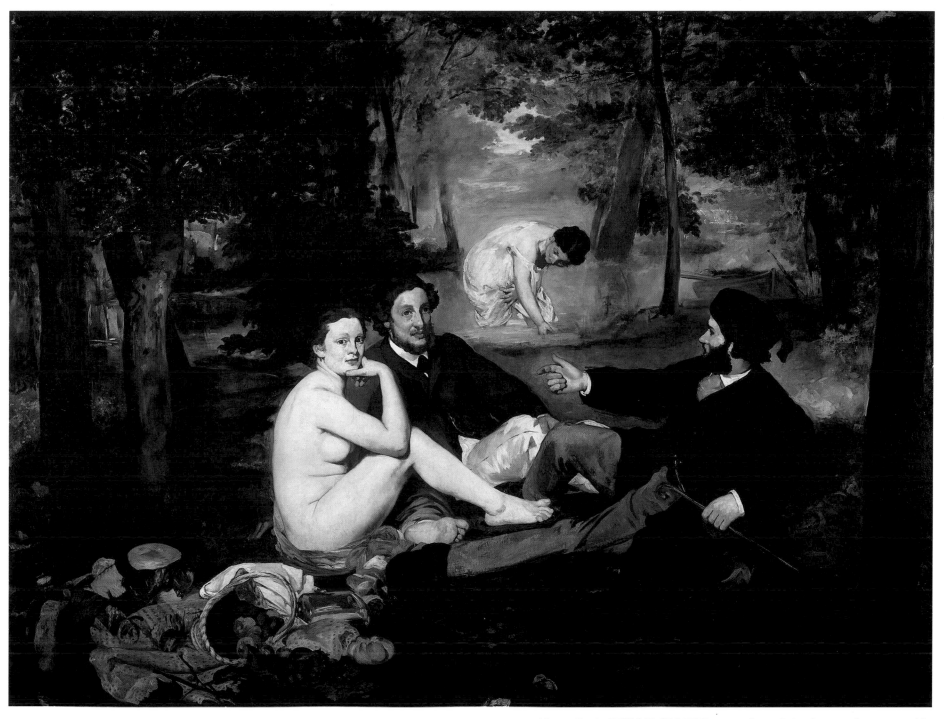

Manet: LUNCHEON ON THE GRASS, 1863.
This picture was exhibited at the Salon des Refusés of 1863 and was savaged by the critics.
208 × 264 cm. Musée d'Orsay, Paris.

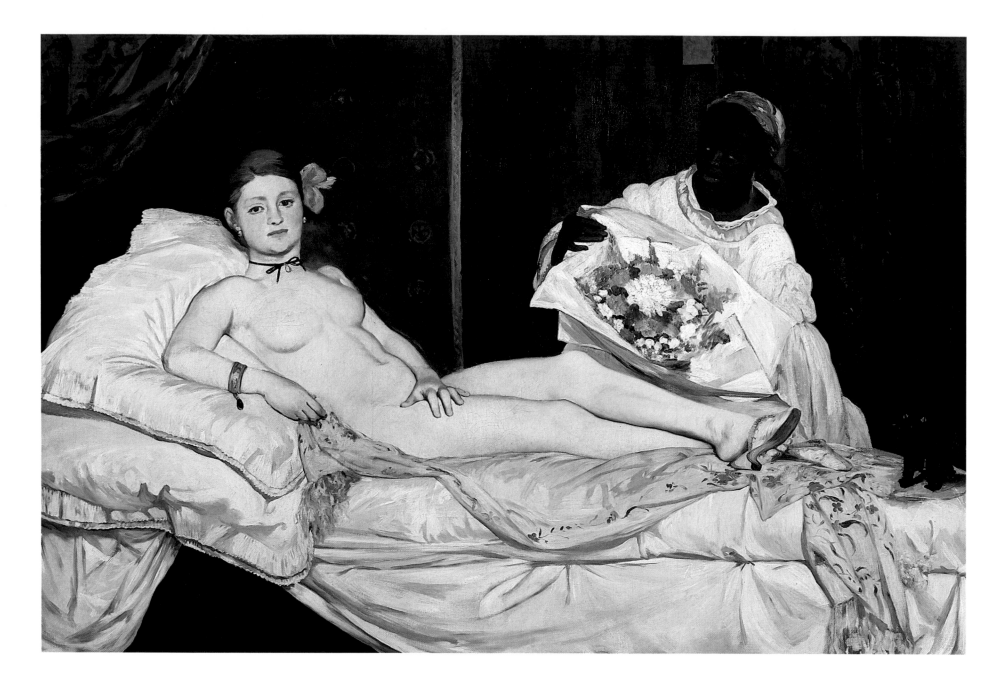

Manet: OLYMPIA, 1863.
Manet's second great challenge to
established opinion, painted in the same
year as *Luncheon on the Grass*, was
thought even more scandalous when it
was exhibited in the Salon of 1865.

Again the subject seemed to ape
tradition, inviting direct comparison
with Titian's *Venus of Urbino* and
Goya's *Naked Maja*.
130.5 × 190 cm. Musée d'Orsay, Paris.

Suzanne Leenhoff – the liaison had been kept discreet ever since it began in 1850, as it might have harmed his father's career. So discreet was Manet about his private life, in fact, that it has never been known for certain whether Suzanne's son Léon, who appears frequently in the artist's paintings, was his son or the product of an earlier liaison.

Manet's style of dress and behaviour was that of an elegant *flâneur*, a leisured frequenter of the Parisian boulevards. He was distinguished by his meticulous appearance on all occasions, wearing a top hat even on his rare visits to the country. Théodore Duret, a close friend, recalled the 1860s as an age when: 'The boulevard was still free from the crush, and in the afternoon the elite could meet there, to walk and to stroll. Manet was one of the last representatives of this way of life.'

The boulevards, however, were not merely a playground for the rich. They were working streets which carried the people of Paris to their jobs and provided the prostitutes with a place to ply their trade. Manet's awareness of such contrasts provides part of the lasting interest in his work. Whereas in *The Absinthe Drinker* he had chosen to depict a member of the poorest class of society, in his *Music in the Tuileries* (page 38), exhibited in a private gallery in 1863, he drew his material from his own elegant world.

Only recently introduced, these twice-weekly concerts in the gardens by the Louvre had become a regular venue for gatherings of Parisian society. They can all be seen in Manet's painting. He appears himself on the extreme left-hand side, and mixed with the crowd we find nobles like Lord Taylor, critics such as Gautier and Champfleury, and the poet Baudelaire, whom Manet had now met and befriended. Fantin-Latour is there to represent the new generation of painters. Manet only made rough sketches of the scene on the spot; all of the painting was done in his studio. The various figures either came to pose for him or were taken from photographs, drawings or prints.

The scene appears to be absolutely modern, but in reality Manet is presenting the latest version of an established theme. Outdoor concerts were a standard subject for 18th-century artists, and it seems clear that Manet borrowed the arrangement for the figures from Velázquez. The new is wrapped up in the old, and our eye flits across the scene as easily as it would across the real gardens.

In the same year, 1863, Manet exhibited a painting which brought him notoriety and public ridicule: *Luncheon on the Grass* (page 39, usually known by its French title *Déjeuner sur l'Herbe*). Rejected for exhibition at the Salon, it was hung in the Salon des Refusés organised on the instructions of Napoleon III as a sop to the outraged victims of the jury's severity. It was very prominently displayed by the Salon authorities in the hope that its dramatic qualities would attract the ridicule they felt it deserved. Manet was undeterred, and said: 'I know it's going to be attacked, but they can say what they like.'

Manet's picture, painted in the studio, shows a naked woman among her discarded clothes while another woman bathes in the background. The scandal arose from the fact

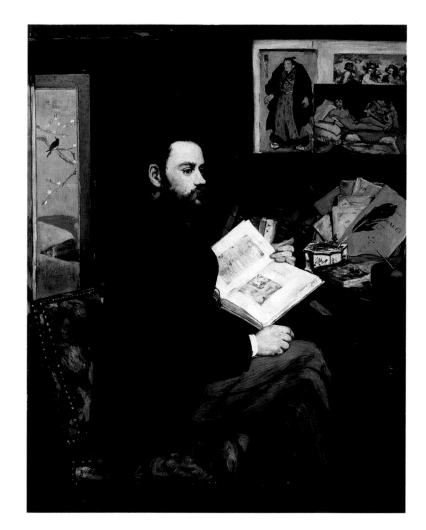

Manet: PORTRAIT OF EMILE ZOLA, 1868.
Zola was a great champion of Manet's and he stoutly defended the generally execrated *Olympia*, a photograph of which Manet put into the background of this solidly painted portrait as a tribute to the writer's moral support. This was sadly not always forthcoming later on. 146 × 114 cm. Musée d'Orsay, Paris.

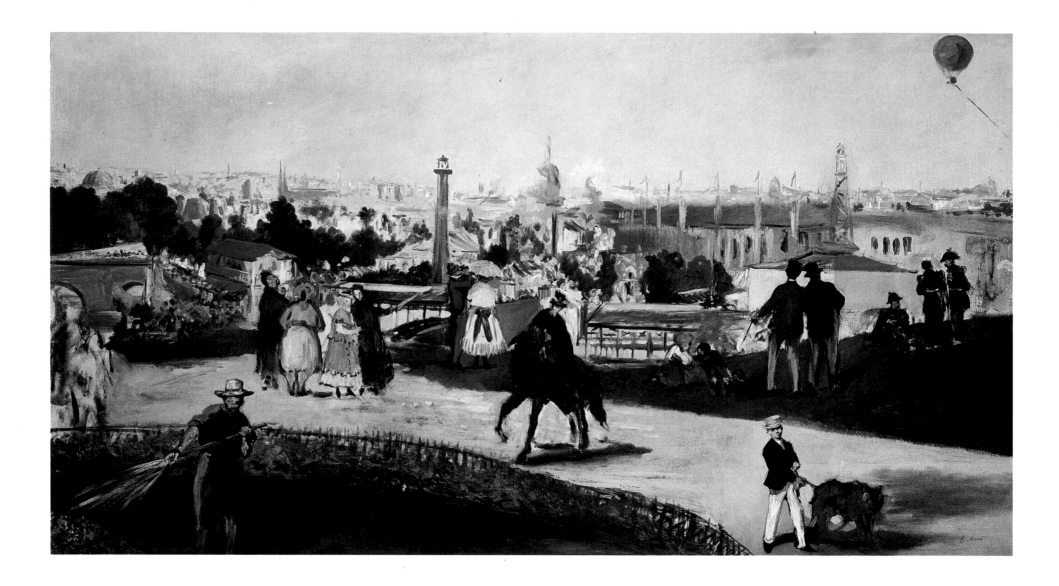

Manet: VIEW OF THE
INTERNATIONAL
EXHIBITION, 1867.
In 1867 this spirited panorama must
have seemed a shockingly direct look at
modern life, and though the occasion it
depicts was intended to glorify the
Second Empire Manet made it glow
with a new democratic spirit. A lady,
various top-hatted gentlemen, a
gardener, some soldiers and a group of
working women are clearly regarded by
the artist as equals. The modern age is
symbolised by the balloon flight of
Manet's friend, the photographer Nadar.
108 × 196 cm. Nasjonalgalleriet, Oslo.

Manet: THE EXECUTION OF
THE EMPEROR MAXIMILIAN,
1868.
Manet painted four versions of this,
perhaps his most deeply felt subject.
Owing much to Goya's *Third of May
1808*, it seems to interpret the Emperor as
a figure of innocent sacrifice analogous to
Christ. He is flanked by two figures and
the sombrero he wears resembles a halo.
The dispassionate quality of the painting
perhaps deliberately provokes unease
rather than sympathetic involvement or
outrage.
252 × 305 cm. Städtische Kunsthalle,
Mannheim.

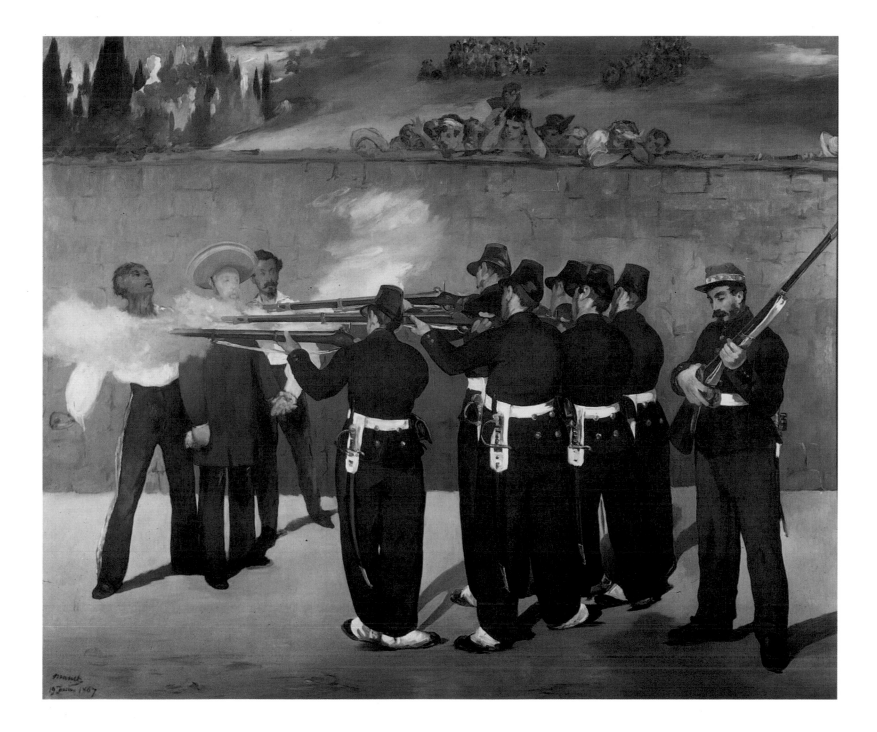

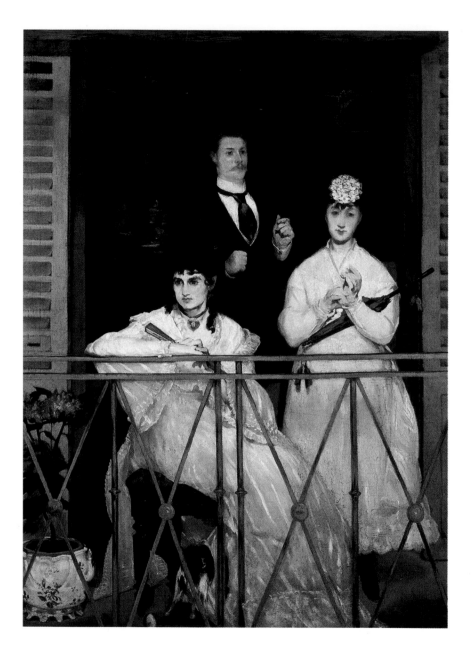

Manet: THE BALCONY, 1868–69.
This group portrait of three friends (with
a boy in the darkness behind) makes
direct reference to Goya's *Majas on a
Balcony*. It shows Berthe Morisot (seated)
and Fanny Claus, a violinist, with
Antoine Guillemet the painter.
169 × 125 cm. Musée d'Orsay, Paris.

that two clothed men were shown next to the naked woman in the foreground. The impact of their close proximity was enhanced by the arrangement of the figures' limbs. As Manet well knew, such a harmonious grouping was traditionally used in what was known as 'history painting'. This included religious subjects, historical incidents and scenes from literature, presented not as an end in themselves, but as an illustration of moral ideals. In *Luncheon on the Grass* no such reading is possible. The licentious air suggested by the woman's discarded clothes is only enhanced by the spilt fruit basket and the empty bottle in the foreground. Above all, the viewer is confronted by the steady gaze of a woman, known to be Manet's favourite model, Victorine Meurent, who would appear to be asking us what we make of all this.

The dislocation produced by this unconventional use of familiar methods is further reinforced by the 'incorrect' perspective that brings the bather in the background directly to our attention. An educated specatator might also have recognised in the composition elements borrowed from the great Renaissance artists Raphael and Giorgione. But what no one could miss, and what still strikes us so forcibly today, is the vividness of Manet's paint and colour. As the critic Duranty wrote at the time: 'In every exhibition at the distance of 200 paces, there is only one painting which stands out from all the others – it is always Manet's.' The respected critic and artistic conservative Paul Mantz recognised this, but could not accept it: 'This art may be strong and straightforward, but it is not healthy.' More typical reaction went like this: 'I search in vain for the meaning of this unbecoming riddle. This is a young man's practical joke, a shameful open sore not worth exhibiting in this way.' Despite himself, this hostile critic seems to have recognised a subversive quality in Manet's work, poking fun at the moral pretensions of French society under the Second Empire.

Also in 1863, completing a remarkable burst of creativity, Manet painted what many regard as his masterpiece – *Olympia* (page 40). But he delayed exhibiting it until the Salon of 1865, knowing the uproar it would cause, and perhaps hoping first to introduce the public more fully to his style. In *Olympia*, Manet brilliantly succeeded in revealing the conflict between the tradition of art built up since the Renaissance and the modern world it now had to depict.

We see a naked woman reclining provocatively on her bed, looking out at us as a black servant offers her a bouquet of flowers. While the *Luncheon* holds a certain mystery as to the activity of the participants, there is no such doubt here. No contemporary could have missed the fact that Olympia is a prostitute. Her very name had been used frequently by playwrights of the period to denote just that. The crumpled bed, her choker, her jewels and the casually dangling slipper are all indicators of her trade. The cat on the right has its hackles raised, for it does not recognise the visitor Olympia is looking at. A visitor has brought flowers, of which – according to popular legend – prostitutes were inordinately

fond. But they are casually wrapped up in paper, scarcely a fitting gift from a lover. Above all, the defiantly flexed pose of the hand conceals from the visitor what he has come for. It was these features of the painting that the scandalised critics returned to over and over again. For the direction of Olympia's gaze makes the viewer into the visitor she is about to receive.

The composition of the painting is clearly derived from Titian's *Venus of Urbino*, which Manet had copied on a visit to Italy. But to understand how different this treatment of the nude was from the traditional handling of the subject, we need only compare it with such a picture as Cabanel's *The Birth of Venus*, exhibited in the same year. Here the soft sensuous female form is presented passively and submissively to the onlooker's gaze. The critics considered Cabanel's work 'wanton and lascivious' but 'not in the least indecent', for the nude 'offers curves that are agreeable and in good taste; the general line is revealed as harmonious and pure'.

It was not possible to consider Olympia as an abstract object in this way, for she was far too clearly an identifiable person. (Victorine Meurent had in fact been the model once again.) But it was not merely artistic convention that Manet had violated. It is a strange fact that, although it was quite proper to comment in detail on a nude in the Salon, it would have been considered obscene in polite circles even to mention the shape of a woman's ankle. And whereas everyone knew that brothels and prostitutes existed, and many frequented them, one certainly did not paint them. The writer Emile Zola was justified in commenting: 'Olympia, she who has the serious fault of closely resembling young ladies of your acquaintance. There, isn't that so? What a strange madness not to paint like the others! If at least Manet had borrowed Cabanel's powder puff and done up Olympia's face and hands a bit, the young lady would have been presentable.' Thus, the outrage resulted from seeing in public what was normally kept private and, just as scandalous, from Manet's attempt to use high art to depict low-life.

Manet was unprepared for the full extent of the storm his painting unleashed. Criticism was couched in the most extreme terms. Théophile Gautier, for example, wrote: '*Olympia* cannot be understood from any point of view, even if you take it for what it is, a puny model stretched out on a sheet.' Jules Clarétie expressed his distaste: 'What is this odalisque with a yellow belly, a degraded model picked up I don't know where?' There were many more such comments. Baudelaire, one of Manet's few supporters, worried about the artist's response: 'Manet has a strong constitution which will stand up to these attacks,' he wrote. 'But he has a weak character. He seems to me dazed and disconsolate from this shock.'

Unsurprisingly, Manet's next works were less challenging. For a while he concentrated on portraits of his friends, such as Emile Zola, Zacharie Astruc and Edmond Duranty. But the old confidence had not entirely gone. In 1867 there was a Universal Exhibition in Paris and, although an official exhibition of painting had been organised, Manet avoided

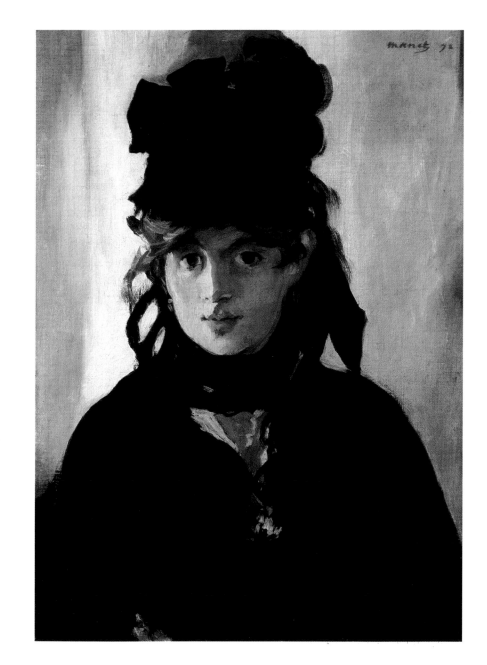

Manet: BERTHE MORISOT, 1872. Without doubt Manet's most inspired and affectionate portrait of his good friend, future sister-in-law and sometime pupil. Perhaps no painter has used dense black to such lyrical effect.
55 × 38 cm. Private Collection.

Manet 45

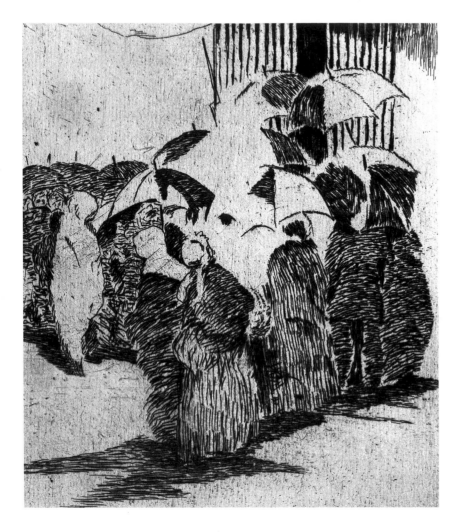

Manet: THE QUEUE AT THE
BUTCHER'S SHOP, 1870–71.
(Etching)
A beautiful etching influenced by
Japanese art but perhaps not a very
powerful evocation of starving Paris.
Only a soldier's bayonet rising above the
umbrellas hints at anything untoward.
As in *The Barricade* (opposite), Manet's
feelings have failed to integrate
themselves into the picture.
17.1 × 14.8 cm. Bibliothèque Nationale,
Paris.

the inevitable rejection by organising his own exhibition outside the official show. There he displayed 50 of his works, including many of the most famous – *Music in the Tuileries, Luncheon on the Grass, Olympia* – and some new paintings not previously exhibited in public, such as *Woman with a Parrot* (page 153), *Portrait of Zacharie Astruc* and *The Fifer*.

His exhibition was not a popular success, even though there were some who recognised its importance. A friend of Cézanne wrote to him describing Manet's work: 'His pictures so amazed me that I had to make an effort to get used to them. All in all these pictures are very fine, very admirable in their exactness of tone. But his work has not yet reached its fullest bloom; it will become richer and more complete.'

Manet produced a pamphlet introducing his work to his visitors, in which he expressed his own position: 'Nowadays the artist does not say: "Come and look at flawless works," but "Come and look at sincere works." It is sincerity which makes works of art seem like a gesture of protest, although the painter has only intended to convey his personal impression – Monsieur Manet has never intended to protest. On the contrary it has been against him, who did not expect it, that there has been protest, because there exists a traditional teaching about forms, methods, viewpoints, painting; because those brought up on such principles do not accept the validity of alternatives . . .'

It was an eloquent statement from a man who had continually sought public recognition in the face of general incomprehension. The hostility he confronted was now to push him into a close relationship with other rejected artists, the future Impressionists, with whom socially and artistically he had little in common. The relationship was to prove a fertile one, and to earn Manet the misleading title of 'the father of Impressionism'.

At first, the younger artists admired Manet from a distance, but in the late 1860s admiration was succeeded by personal friendship. By 1869, Manet had gathered around him a group of artists including Monet, Renoir, Bazille, Sisley, Degas, Pissarro and Cézanne. They met at the Café Guerbois in the Batignolles district, a part of Paris noted for the number of artists' studios, and were known as the Batignolles group. Monet, for one, described the meetings at the Café Guerbois as a constant source of inspiration: 'In 1869 . . . Manet invited me to join him every evening at a café in the Batignolles quarter. Nothing was more interesting than our discussions with their perpetual clash of opinions.' Yet, as Monet here suggests, the differences between the artists were very marked, despite the friendship they felt for one another and their shared hostility to official art. Manet, in particular, always remained in many ways separate from the others, despite the influence he had upon them, and the influence that, in return, they had upon him.

Manet was, for example, the only one of the group to introduce contemporary political events into his art and his ambivalent studies of scenes from modern life often hinted disturbingly at contemporary social issues. The other Batignolles artists naturally had views on politics and society, but they did not bring them directly into their work. As early

as 1864, in *Battle of the Kearsarge and the Alabama* (page 151), Manet adapted the traditional genre of the history painting – normally used to depict scenes from the Bible, antiquity or the Middle Ages – to record a contemporary event. The artist may actually have witnessed this sea battle of the American Civil War – it took place off the French coast near Cherbourg.

In 1867 he returned to the painting of contemporary history with a canvas which focused unwaveringly on a major political happening of the year – *The Execution of the Emperor Maximilian* (page 43). This work represented the tragic climax to Napoleon III's ill-fated attempt at military intervention in Mexico. After establishing their control over part of the country, in the face of stiff resistance from the Mexicans, the French had offered the Mexican throne to Maximilian, the younger brother of the Austrian Emperor Francis Joseph. Under pressure from the United States, however, Napoleon was forced to withdraw his troops from Mexico. He expected Maximilian also to leave, but the politically naive ruler refused to desert his throne. Without French support, Maximilian was soon captured by Mexican forces, and he was executed in June 1867. Manet's painting makes no overt political comment, but the depiction of an event widely regarded as discreditable to Napoleon's government reflects the artist's hostility to the Second Empire.

The Execution of the Emperor Maximilian was evidently a work to which Manet attached considerable importance, for he did no less than four versions of it and a lithograph, which was banned by the government. The influence of Spanish art so often found in Manet's painting is again apparent here, since the treatment of the scene owes much to Goya's *The Third of May, 1808*. The scale of Manet's work shows clearly that it was intended for exhibition at the Salon, but the authorities made it plain to the artist that if it was presented to the jury, the painting would be rejected.

Manet did not follow *The Execution* with other depictions of contemporary history, turning instead to more enigmatic scenes of modern life. Two paintings accepted for the 1869 Salon – *The Luncheon* (page 157), also known as *The Luncheon in the Studio*, and *The Balcony* (page 44) – both show an unusual group of seemingly unrelated people. These canvases baffled both public and critics who expected such large-scale figure painting to in some sense illustrate a story or point a moral. Realists such as Courbet and Millet had not essentially disturbed this assumption: in their paintings, it was generally clear what was happening, who the characters were, and more or less what one was supposed to think of them – the Salon public may not have liked what the paintings were saying, but they could understand them. Manet's works seemed to resist all efforts to 'read' the images.

The Luncheon, painted in a rented studio in Boulogne, has three figures – Manet's son or stepson Léon, a maid and a neighbour – all ignoring each other and looking away in different directions. The critics admired its painterly qualities, but were puzzled by the subject. Théophile Gautier wondered: 'Why these weapons on the table? Is this the

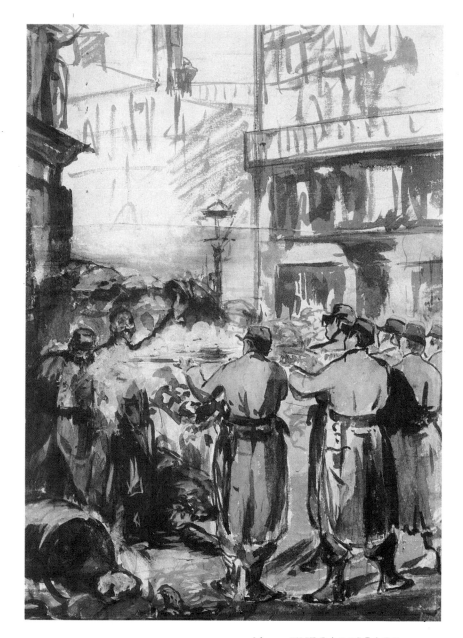

Manet: THE BARRICADE, 1871(?). (Pencil, ink wash, watercolour and gouache)
Manet witnessed the suppression of the Paris Commune and was shocked by its savagery. He based the composition on *The Execution of Maximilian* (page 43). 46 × 32.5 cm. Szépmüvészeti Múzeum, Budapest.

Manet: ARGENTEUIL, 1874.
Manet perhaps came closer here to the
spontaneous Impressionist spirit than
ever before though the composition
shows his usual deliberation. The
picture successfully captures the apathy
that can be induced by glorious weather
and pleasant surroundings.
149 × 115 cm. Musée des Beaux-Arts,
Tournai.

luncheon that follows or precedes a duel?' And Jules Castagnary wrote: 'Manet is a true painter . . . his subjects he takes from poetry or from his imagination, not from the ways of real life. Looking at *The Luncheon*, for example, I see on a table where the coffee is served a half-peeled lemon and some raw oysters . . . similarly, the figures are distributed at random, with nothing of necessity or compulsion to determine their composition.'

The same appears true of *The Balcony*, in which Manet shows us a group of two women, a man and a dog on one of the balconies that Haussmann's reconstructions had made such a common sight in Paris. Although we may detect overtones of a similar work by Goya (*Majas on the Balcony*), the painting has a quality unique to Manet. In part, this derives from the unexplained relationships between the figures. Easily the most striking is the artist Berthe Morisot, seated on the left. Morisot had studied landscape painting with Corot and was to become one of the mainsprings of the Impressionist group, participating in seven of their eight group exhibitions. Manet had met the young artist in the winter of 1868, and here captures her in a moment of dignity and beauty. Next to her, the other figures – the painter Antoine Guillemet, the violinist Fanny Claus, and Léon – seem shadowy and lifeless, making the composition impossible to 'read' as a conventional group portrait.

Morisot became a close friend of Manet and it has indeed often been suggested that his feelings for her were much stronger than mere friendship. From *The Balcony* onwards, his portraits of her emanate a very striking intensity. She was later to become his sister-in-law, marrying his brother Eugène in 1874. Manet also took an interest in another female artist, Eva Gonzalès, who was in fact his only pupil.

In his involvement with female artists, especially Berthe Morisot, who was a professional painter, Manet must inevitably have been drawn into consideration of the general attitude to women in society. The female artist exemplified the growing number of women claiming equality and freedom of expression in the late 1860s. The role of women was a central social question of the time. Liberals felt that there could never be a true Republic in France as long as the clergy held a dominant influence over women and, hence, over the family. On the other hand, people argued that the growing number of women working for a living was producing a decline in moral standards and undermining French society. In 1870 Manet produced portraits of both Morisot and Gonzalès that are revealing of his own attitude in different ways. The portrait of Morisot, finally exhibited at the Salon of 1873, was entitled *Repose*. She rests with her left leg drawn back under her dress once more with a thoughtful, slightly sad expression. Such a close examination of a woman's character was most unusual in previous 19th-century portraiture, which normally concentrated on presenting symbols of ideal attractiveness, beauty or reassurance. The picture subtly alludes to the difficulties of Morisot's position, for she is seen as both a painter – an aspect of her life symbolised by the Japanese print on the wall behind her – and a middle-class gentlewoman, unhappily trapped between her contrasting lifestyles.

In the same year, Manet did two portraits of Eva Gonzalès at work; one was for the exhibition, the other he kept. The difference between them is most revealing: in the Salon version, Gonzalès is seen sitting, reaching awkwardly for the canvas with a brush at arm's length. She is resplendent in a white dress – hardly the most practical garment for painting – since convention demanded that women, even women-artists, be seen in this way. However, in the version he kept, Manet showed her standing close to a canvas, wearing a simple black dress tied at the waist. This image of a woman at work might have offended those who wished to see women as 'angels by the hearth', and Manet does not seem to have been prepared to confront the public with a reality of which he himself was clearly aware. For nothing abated Manet's desire for public acceptance. Berthe Morisot noted in 1868: 'His show, as usual, was little appreciated by the public; but for him this is continually a cause of astonishment.'

Still, the critic Duranty described Manet at this time as 'overflowing with vivacity, always bringing himself forward, but with a gaiety, an enthusiasm, a hope, a desire to throw light on what was new, which made him very attractive'. This spirit was clearly finding expression in his work. But now, in the summer of 1870, Manet became inescapably drawn into events which distracted him from the pursuit of his art. In July the Emperor declared war on a better prepared and better equipped Prussia, in a misguided attempt to bolster up his Second Empire. Instead, the Empire fell after the defeat of Napoleon at Sedan in early September, and a Republic was proclaimed. As a convinced Republican, Manet rallied to the defence of the new regime in the continuing war against Prussia. He enlisted in the National Guard, finding himself to his chagrin under the command of the popular artist Meissonier. On 19 September the Prussian siege of Paris began. Since the enemy made no effort to assault the fortifications around the city, Manet saw little action, but he had to endure the hardships of a bitter winter. Food shortages worsened as the siege dragged on. People ate cats, dogs and even rats; horse and donkey-meat were luxuries; the animals in the zoo were slaughtered for food. One morning, Manet's housekeeper's cat went missing – presumed eaten. To add to the misery, in January 1871 the Prussian guns began to pound the city. All attempts to break the encirclement of Paris failed, and on 28 January an armistice brought hostilities to a close, as France finally admitted defeat.

Once the siege was lifted, Manet went to join his family who had taken refuge near Arcachon in southwest France, and he was thus absent from the capital when the revolutionary Paris Commune was declared in mid-March. Paris was once more besieged, this time by the forces of the French government installed at Versailles. Surrounded by its enemies, the Commune had no chance of survival, but the manner of its destruction was shockingly brutal. On 21 May 1871 the Versailles army penetrated the city's defences and for a week it fought its way across Paris, as the Communards' hastily flung-up barricades

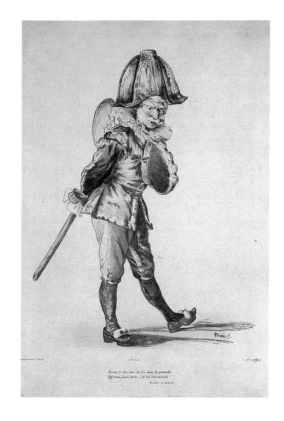

Manet: POLICHINELLE, 1874–76. From the generally temperate Manet, this lithograph constitutes a really hostile caricature of the merciless General MacMahon, suppressor of the Commune.
53.5 × 35 cm. National Gallery of Art, Washington D.C. Rosenwald Collection 1947.

Manet: NANA, 1877.
Painted in anticipation of Zola's
forthcoming novel of the same name,
this was posed for by a notorious demi-
mondaine. Her protector of the moment
is waiting patiently just within the
frame. The Salon refused it on moral
grounds.
154 × 115 cm. Kunsthalle, Hamburg.

were defended to the last. At some time during that week, Manet returned to Paris and
witnessed the fighting on the barricades and the indiscriminate slaughter that accompanied
and succeeded it. The Communards executed some 60 hostages, but this was nothing to
the bloodshed inflicted by government troops, who probably killed as many as 25,000
Parisians. There is no question that Manet felt a deep sympathy for the defeated
revolutionaries and was sickened by the massacres. He recorded the events of 'Bloody
Week', as it is known, in such works as *The Barricade* (page 47) and *Civil War*. Although
produced after the event and based on earlier paintings, these works were fed by Manet's
direct observation and serve as a testament to his radical political beliefs.

In the years immediately following the fall of the Commune, Manet was drawn closer to
Monet and Renoir. In 1870, under their influence, he had first started to paint in oils in the
open air, and this development in his work was confirmed during the rest of the decade.
But although his friendship for the younger artists was undoubtedly real – he especially
admired Monet and lent him money on occasions to settle his debts – his views on art and
politics placed him a considerable distance apart from his colleagues.

Manet's first major work of the post-war period, *The Railroad*, painted in 1872-73, offers
an interesting contrast with Monet. The picture shows a woman and a child outside a
railway station, the Gare St. Lazare, in front of a railing and clouds of smoke. Manet used
his favourite model of the 1860s, Victorine Meurent, to pose for the woman. As so often in
Manet's work, the relationship between the figures is left indefinite. The woman certainly
fails to fulfil either of the roles traditionally reserved for women in painting – offering sexual
allurement or representing the virtues of motherhood. When Monet came to paint the Gare
St. Lazare in 1877, his work posed no enigmas and ignored the human interest of the
station. Instead, Monet concentrated on the locomotive and the spectacular visual effects of
its steam.

There is also a marked difference between the paintings of life in Paris produced by
Monet and Renoir at this period and Manet's *Masked Ball at the Opera* (page 160) of
1873-74. Monet and Renoir painted views of the boulevards as attractive spectacles. Manet
chose to depict society with a far less innocent eye, recording a famous costume ball, held
every year, which was one of the most notorious events of the season. In the words of one
contemporary: 'You come to take part in a scene which recalls the bacchanals of old and
which goes on from midnight to five in the morning.'

In the summer of 1874, the three artists entered into their closest working relationship.
Monet and Renoir were living in Argenteuil, north of Paris, and Manet stayed at his
family's property across the Seine at Gennevilliers. During the summer Manet painted *The
Monet Family in the Garden*, while alongside him Renoir, who could not resist working on
the same composition, painted Camille and her son. Monet himself painted a portrait of
Manet at work on the idyllic scene in the garden. On another occasion, Manet painted

Monet and his wife on the boat that the artist used as a floating studio.

But although Manet had evidently been convinced of the value of oil-painting in the open air, and had also followed the example of the younger artists in lightening his palette, his work at Argenteuil still showed a commitment to producing large-scale figure paintings for the Salon. His major painting of 1874, entitled *Argenteuil* (page 48), depicts a modern-life couple – presumably a boatman and his companion – against a background of water, houses and factory chimneys. The realism of the background contrasts with much of Monet's landscape painting at Argenteuil, which often gives little clue that the town was already well on its way to becoming an industrial suburb.

The question of the attitude to adopt to the Salon had by this time already marked a clear distance between Manet and his fellow artists of the Batignolles group. In 1873, Manet for once scored a notable critical and popular success at the Salon with *Le Bon Bock*, a portrait of the engraver Bellot painted under the influence of Frans Hals, the 17th-century Dutch painter whose work Manet had studied in Holland the previous year. It was his first success for over a decade, but it earned him no plaudits from the habitués of the Café Guerbois, who regarded the painting as weak and retrograde.

When Manet's fellow artists of the Batignolles group took the decision to hold a group exhibition in opposition to the Salon, they were unable to attract his support for the project. He took no part in what was later to be known as the First Impressionist Exhibition, opened on 15 April 1874, claiming that 'the Salon is the real field of battle. It's there one must take one's measure.' In his view, for better or for worse, the Salon was the arena in which the public would make its judgement.

But this refusal to join the exhibition did not stop critics seeing Manet as the leader of the Impressionists: reviewing the Salon of 1875, the chronicler Clarétie announced: 'The Impressionists start from Baudelaire . . . M. Edouard Manet sets the tone, marks the cadence. He is the drill sergeant. The painter of *Le Bon Bock* this year showed a canvas he calls *Argenteuil*, and the *plein-air* school loudly proclaims it a masterpiece.' Relations between Manet and his colleagues would never be as close again, however. It is perhaps symbolic of the loosening of ties that in the mid-1870s the artists deserted the Café Guerbois for new haunts.

Interestingly, for all the scandal caused by the Impressionist exhibition, it was Manet who in 1874 had a work banned by the government. This was a lithograph of Polichinelle (page 49), the Commedia del'Arte figure traditionally used for political caricature. In this case, the person mocked was none other than General MacMahon, who had been responsible for putting down the Commune and was now President of the Third Republic. The government felt too weak to tolerate such ridicule and banned the lithograph at the printers. Thus it was Manet, the painter who sought success within the system, who nonetheless posed the greater threat to established authority.

Manet: AUTUMN, 1881.
The subject of this picture, Méry Laurent, was once described as 'an indifferent actress but a courtesan of genius . . .'. She had many rich protectors in her time but was also Mallarmé's great passion, a close friend of Manet's and a source of inspiration to Proust.
73 × 51 cm. Musée des Beaux-Arts, Nancy.

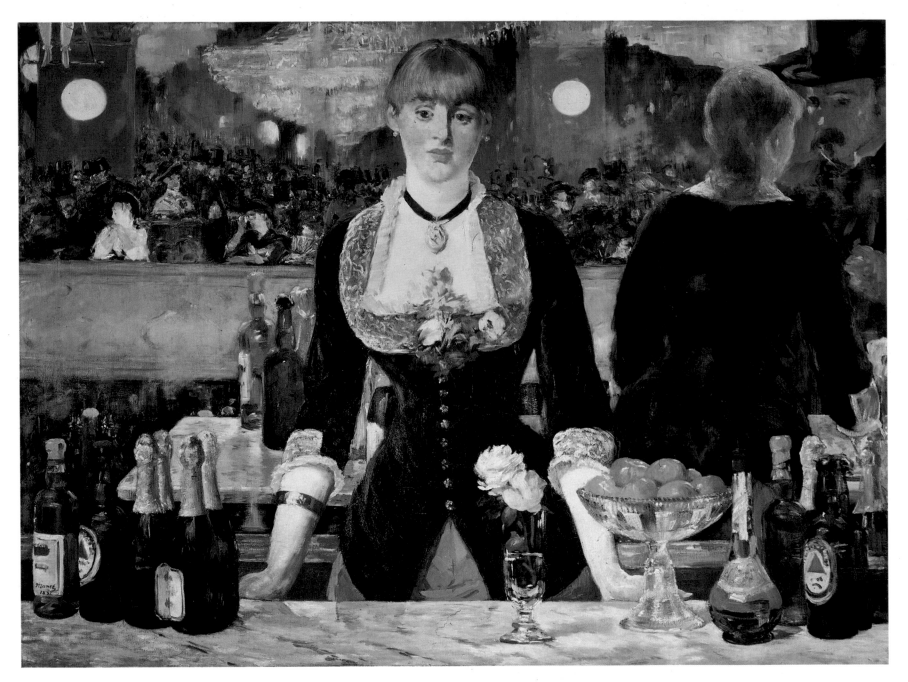

Manet: A BAR AT THE FOLIES-
BERGÈRE, 1881–82.
Another of Manet's mystifying
masterpieces and his last large one. By
moving the barmaid's reflection he made
a double portrait and himself perhaps
into a customer too sensitive to spoil her
reverie. The still life can only be a tribute
to her.
96 × 130 cm. Courtauld Institute
Galleries. Home House Trustees.

Manet never ceased to be disconcerted by his set-backs at the hands of the Salon jury, despite his long history of difficulties in being accepted. In 1876 both his entries for the Salon were rejected, but even so he refused to be associated with the independent Impressionist exhibitions, instead exhibiting the two paintings in his studio. One of those who came to see the two works was a new friend, the poet Stéphane Mallarmé, who was to become an increasingly important influence and support. Mallarmé described his writing of poetry as aiming: 'To paint not the thing but the effect it produces. The verse must therefore not be composed of words but of intentions, and all the words must give way before sensations.' Manet's later work moved in a similar direction, aiming at overall effect rather than particular detail. His portrait of Mallarmé (page 165) shows the poet reclining on a sofa, lost in reverie and smoking one of his habitual cigars. Manet also did some powerful illustrations for Mallarmé's translation of Edgar Allan Poe's poem *The Raven*.

In 1875, Manet had travelled to Venice in the company of his wife and the fashionable painter James Tissot, painting views of the Grand Canal. But his chief subject remained, as ever, the life of Paris. One of his entries for the Salon of 1877 was his famous depiction of *Nana* (page 50), the heroine of Zola's novel of the same name. As in *Olympia* 12 years previously, the subject is a prostitute, but the intensity and ambiguity of the earlier work is gone. Nana is clearly a courtesan moving amongst high society, as we can see from her patron on the extreme right, cut in half by the edge of the picture. In *Olympia* the spectator stood in the place of her visitor, but we are now reduced to observers of a light and pleasant scene, an ironic depiction of modern life which makes no moral comment. Perhaps not surprisingly, the painting was refused by the Salon jury and had instead to be exhibited in a dealer's window, where it drew large crowds evenly split between liking and hating it.

In keeping with his interest in the social life of the city, Manet proposed to the Prefect of Paris in 1879 that he be allowed to do the decorations for the new Hôtel de Ville in which he wanted, in his own words: 'To paint a series of compositions representing, if I may make use of a current expression which well represents my thought, "the nether-regions of Paris", with all the different corporations moving in their midst, the public and commercial life of our time.' Markets, railways and even sewers were to be displayed in his panorama which might have made a suitable monument to his work. But sadly officialdom was unimpressed, and Manet did not even receive a reply to his letter.

Unable to pursue his ambitions on the grand scale, Manet produced a series of studies of café life. He was often to be found at the fashionable Café de la Nouvelle Athènes or the Café Reichshoffen where the various social groups of Paris rubbed shoulders. His work is a record of that intermingling, which produced changes even in his technique. In *The Plum* (page 55) of 1877, he depicts a young woman sitting in front of a plum soaked in spirits and gazing abstractedly in front of her. As she is alone in a café, Manet's audience would have assumed that she was a prostitute but the painting is conspicuous for its

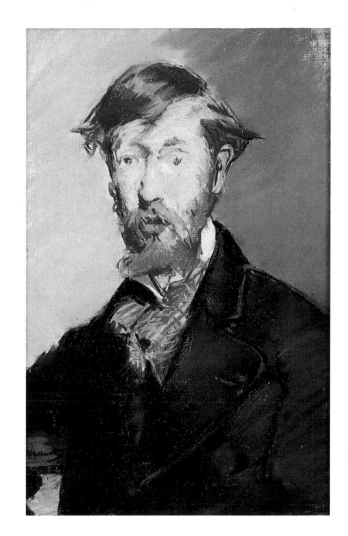

Manet: GEORGE MOORE, 1879.
(Pastel on canvas)
A masterly portrait of the Irish critic who was a friend of Manet, Degas and many others. He was a figure of fun because of his atrocious French accent, but he was a staunch supporter of the Impressionists.
55 × 35 cm. Metropolitan Museum of Art, New York. H.O. Havermeyer Collection.

Manet: Notes and Sheets of 1880 with
watercolour drawings.
Two of these sketches were sent to his
friend and model Isabelle Lemonnier. In
one of them he imagines her diving and
in the other sends her a peach; he quite
often made watercolour sketches of fruit
for his friends at this time. The charming
sketch of legs is of Madame Guillemet.
The sketches of two summer hats and
three women were once in the collection
of Dr. Albert Robin, a friend of
Manet's. They eloquently demonstrate
the artist's sociable gallantry and good
nature.
Diver 20 × 12.3 cm
Peach 20 × 12.5 cm
Legs 18.5 × 11.9 cm
Hats 19 × 12 cm
Heads 19 × 11 cm
Musée du Louvre, Cabinet des Dessins.
Musée des Beaux-Arts, Dijon.

absence of moral condemnation. In his work *At the Café*, Manet moves still further away from traditional concepts of composition. Here none of the figures are seen in their entirety and there is no way in which they can be related to one another. In spite of all the glitter, there is a curious air of boredom, perhaps the refined aloofness of the *flâneur* that Manet had been as a young man.

Manet was clearly aware of the radical nature of his style in these works and was prepared to modify it in paintings for the Salon. In his *Reading* of 1879, a young woman sits reading one of the fashionable papers of the day in front of an open window which is handled in a remarkably free manner. His Salon entry for that year, however, *In the Conservatory*, was far more traditional in its finish. This work returns to the territory of the earlier *The Balcony* and *The Railroad*, with its tense and unexplained relationship between figures contained within a formal space.

Manet also returned to areas of past interest in two works from the turn of the decade which reflect his abiding support for radical Republicanism. The first is a portrait of Georges Clemenceau (1879) which shows the famous radical leader in determined and distinguished pose. Manet made his acquaintance through his brother, Gustave, who succeeded Clemenceau as leader of the Municipal Council of Paris. Clemenceau was a notoriously difficult sitter who was forthright in his views on the results. When asked about this effort he replied: 'My portrait by Manet? Very bad: I haven't got it and that doesn't worry me. It's in the Louvre and I ask myself why it was put there.'

Another dissatisfied sitter at this time was George Moore, the Irish poet who had been introduced to Manet at the Café de la Nouvelle Athènes. In reply to his complaints, Manet said: 'Is it my fault if he has the air of a broken egg-yolk and his face isn't harmonious? This is the thing with all our faces because the cry of our times is the search for symmetry. There is no symmetry in nature.' Manet's eye was too faithful to nature for his sitters, used to flattering society portraits, but that is why his portraits are so convincing. The natural feel was, however, obtained by hard work, as George Moore records: 'He painted it and repainted it: each time it was more luminous and more clear and the painting never seemed to lose any of its quality.'

Another reluctant subject was the base of his last venture into the political arena. Henri Rochefort had been a radical journalist under Napoleon III and was sentenced to deportation in 1873 for his part in the Commune. In 1880, he returned to France after the amnesty for all political prisoners and was a hero of the radicals. Manet painted his portrait and also depicted his sensational escape from prison in 1874 in *The Escape of Rochefort* (1880). Rochefort and some accomplices had managed to make a raft and get to a waiting Australian ship. Manet, however, shows Rochefort out on the open sea in a boat, which not only lends more dignity to the escape but reinforces the idea of Rochefort's loneliness. But here more than ever, Manet was fulfilling Mallarmé's dictum that the effect should arise

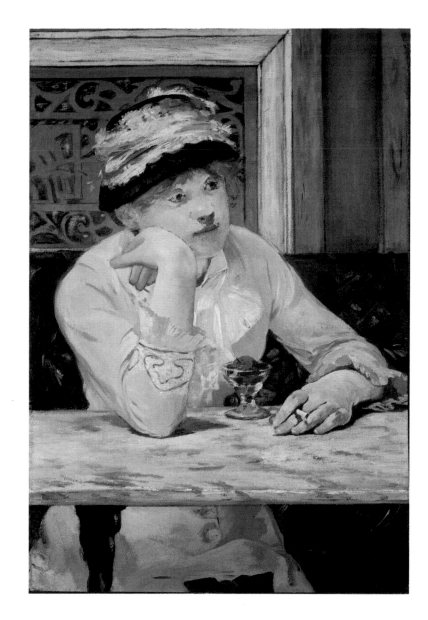

Manet: THE PLUM, 1877.
A wan and uncertain young model painted with great sympathy, economy and skill. The subtle chord of almost dissonant colours seems unique. The background is thought to be the Café de la Nouvelle-Athènes.
74 × 49 cm. National Gallery of Art, Washington D.C. Collection of Mr. and Mrs. Paul Mellon.

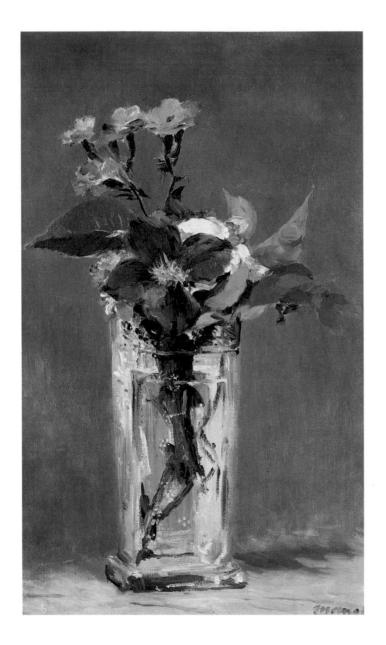

Manet: PINKS AND CLEMATIS IN A CRYSTAL VASE, 1882. Manet painted several small flower pieces in the last year of his life before he was finally bedridden. This one though is considered to have been painted in the summer before when the pinks and clematis were in bloom. All the pictures in the series have a singular and, if only by association, melancholy sweetness. 56 × 35 cm. Musée d'Orsay, Paris.

from the whole composition and not just from central details. Indeed, the main subject of the picture seems to be the sea. Manet had hoped to submit the work to the Salon of 1881, but either he was not completely happy with it or it was not ready in time. The portrait of Rochefort was sent instead.

From 1879 onwards, Manet was increasingly plagued with ill-health, which compelled him, much against his will, to spend more time in the country and impeded his ability to work. However, consolation came in the form of the Legion of Honour, secured for him by his friend, Antonin Proust, now Minister for the Arts in Gambetta's government. Despite his illness, Manet's entry for the Salon of 1882 was one of his greatest works, *A Bar at the Folies-Bergère* (page 52). In it he fused many of the finest elements of his work. On the bar the collection of bottles – including a bottle of Bass Pale Ale – is a perfect example of his mastery of still life. The barmaid, with her expression typically giving nothing away, shows Manet's abiding interest in the ordinary people of Paris around him. For Manet, as for Baudelaire, the Parisians themselves were the very stuff of modernity. Behind her, a mirror reflects a marvellously depicted café scene, in which the crowd are utterly indifferent to the trapeze artist in the top left-hand corner.

It has always been the deliberately false perspective in the mirror, which enables us to see the barmaid and her customer at once, that has attracted most attention in this painting. The direction of the barmaid's gaze suggests that the viewer of the painting is the customer, but the reflection denies this possibility, setting up a tension that contributes greatly to the curiously disturbing effect of this work. It was Manet's final and perhaps most successful experiment with the relationship between spectator and image.

Tragically, the course of Manet's illness could not be checked. His left leg, infected with gangrene, was amputated in a desperate attempt to save his life, but in vain. He died on 30 April 1883 at the age of 51.

Ironically for an artist who had struggled all his life for full recognition of his talents, Manet only achieved the respect that was his due after his death. In the 20th century, his genius has been unquestioned. Yet he was a man who drew his inspiration from the events and, above all, the people of his own time and place. It is his ability to see and record the special and unique in what is normally regarded as ordinary and commonplace that has marked him out. For some the last of the Classics, for others the first Impressionist, Manet is surely best understood as quintessentially of his own time and his own temper.

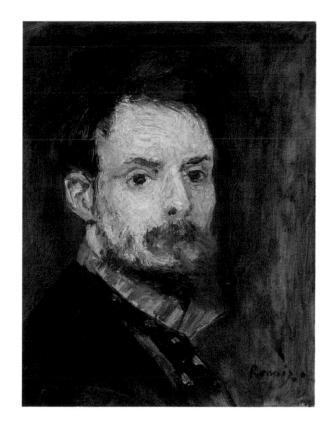

RENOIR'S PLEASURE PRINCIPLE

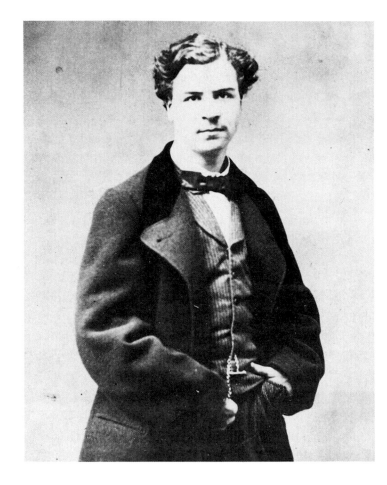

The young Renoir looking relaxed and confident, perhaps still a well-paid painter of porcelain when this photograph was taken.
Bibliothèque Nationale, Paris.

Pierre-Auguste Renoir was born on 21 February 1841 in Limoges, the sixth of his parents' seven children, two of whom died in infancy. His father, Léonard, was a tailor and his mother, Marguerite, a dressmaker. When Auguste, as he was always called, was three years old, the family moved to Paris. There Léonard hoped that the family's fortunes would improve, and that he would find it easier to provide for them.

Strange as it may sound, they found an apartment in the courtyard of the Louvre, which at that time contained not only the famous museum and government offices, but also cheap accommodation. The part of the building in which the Renoirs lived retained some of its former glory, with grand columns, cornices and coats of arms, but was otherwise neglected and shabby. Washing hung from the windows and a variety of cooking smells met the royal nose of Queen Amélie, wife of King Louis-Philippe, who occasionally threw sweets to Auguste and other children from a window in the adjoining Tuileries Palace, the royal residence.

The apartment was small and overcrowded – 'a pocket handkerchief', Renoir recalled – and he much preferred wandering about the streets to remaining there. 'In the streets of Paris I felt at home. There were no motor-cars then, and you could stroll around just as you pleased...' When Renoir was seven, he was sent to a nearby school in a former monastery, and, two years later, joined the choir at the church of Saint-Eustache in Les Halles, where he was given singing lessons by the choirmaster – the composer Charles Gounod.

Renoir greatly enjoyed this break from the monotony and severity of the school routine. He loved the candlelit interior of the huge church, where the porters, butchers and dairywomen from the nearby market came to Mass, and he would later lament the day when 'the priests replaced that living light by the dead light of electricity'. Gounod was convinced that his young pupil would become a fine singer, and offered to give him a complete musical education, but Renoir decided that he was 'not made for that sort of thing'.

Another youthful pleasure was hunting. During the season, a neighbour would take Renoir on hunting expeditions to an area on the edge of Paris planted with wheat, where there was an abundance of game. The boy was sometimes given a share of the bag to take home to his family. But the place where they shot their game was soon to be transformed in the redevelopment of Paris – into a railway station, the Gare St. Lazare.

The Renoir family was hardly affected by the dramatic political events of 1848–52, which brought about the fall of the monarchy and, eventually, the establishment of the Second Empire. But Emperor Napoleon III's decision to enlarge the Louvre put the family home under threat, and in 1854 they were forced to move. Their new home in the run-down, crowded Marais district was undisturbed by the further redevelopment of Paris organised by Baron Haussmann, but Renoir himself was well aware of these changes. As an old man, he mourned the passing of the Paris he had known as a boy: 'What have

they done to my poor Paris! And worse, too, the houses they put up for their own use are so ugly!'

When Renoir was 13, the time came to decide what trade he should follow. He had already shown some aptitude for drawing, as his brother Edmond recalled: 'From the fact that he would use up ends of charcoal on the walls, one concluded that he had a taste for an artistic profession. Our parents therefore placed him with a painter of china.' The firm Lévy Frères produced copies of Limoges and Sèvres porcelain, on which the young apprentice was first set the task of painting borders. When he had demonstrated his proficiency, he was promoted to painting historical portraits in the centre of the plates. He was paid by the piece: two sous for a plate, or three sous for a plate decorated with Queen Marie-Antoinette in profile. Renoir learned to do this so rapidly that he soon came to earn more than was thought appropriate for a young boy. 'It didn't set the world on fire, but it was good honest work,' Renoir later told his son, the film-maker Jean Renoir, 'and there's a certain something about hand-decorated objects. Even the stupidest worker puts a little of himself into what he is doing. A clumsy brushstroke can reveal his inner artistic dreams. I prefer a dull-witted artisan any day to a machine . . .'

To increase his skill at drawing, Renoir attended evening classes at a free school close to where he worked, run by the sculptor Callouette. His progress was rapid, and his improving talent was recognised at the pottery: within a few months he was entrusted with the decoration of pieces normally reserved for more experienced workers. One of those older colleagues was a keen amateur painter, who offered to share his supply of oils and canvases with Renoir. After some time, he commissioned him to paint a picture. One day, the older man arrived to see Renoir's finished work. With due solemnity, a chair was placed in front of the easel for him to look at the painting, which represented Eve with a serpent. The old man studied the painting intently for 15 minutes without making a sound, and then announced to Renoir's parents that he could confidently predict a brilliant artistic future for their son.

Renoir stayed at the porcelain works for five years, learning to throw pots and to fire the kilns. During his lunchtimes, he would often go to the Louvre to study his particular favourites, the French masters of the 18th century – Watteau, Boucher and Fragonard. As he said years later: 'I was earning a good living decorating porcelain. I had been able to help my parents buy a house out at Louveciennes, to which they could retire some day. I could even live independently of them – and at 15, that isn't doing badly.' But when a mechanical process of stamping designs on faience and porcelain was produced, making hand decoration uneconomic, the works were closed, and the 17-year-old porcelain painter found his career at an end.

In order to support himself, Renoir set to work painting fans and colouring heraldic designs for his brother Henri, who was a medallist. He also decorated blinds for a

Renoir: THE ARTIST'S FATHER
1869.
Renoir always remained close to his family and his father's stern demeanour no doubt belies their mutual affection.
61 × 46 cm. The St. Louis Art Museum, St. Louis, Missouri.

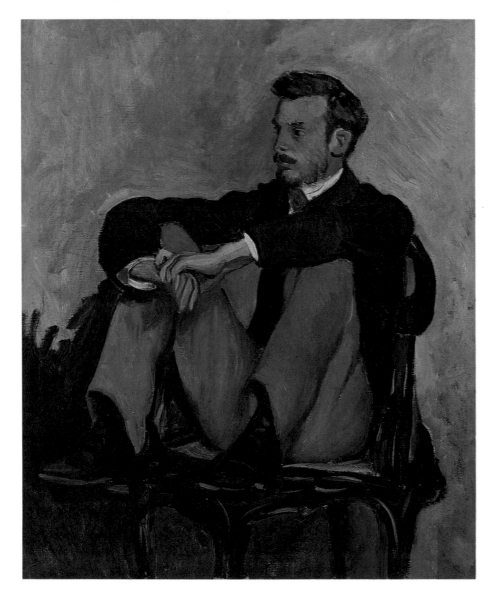

Bazille: PORTRAIT OF RENOIR, 1867.
Seemingly an impromptu study, rapidly executed. The singular pose lends it a challenging vitality. Renoir in his turn painted a portrait of Bazille at work which underlines their youthful comradeship.
62 × 51 cm. Musée d'Orsay, Paris.

manufacturer, and learned the trick of painting clouds to cover large sections of the blinds. It was at this time – when he was desperately short of money – that he realised the importance of painting rapidly. While engaged in a day-to-day struggle to survive, he continued to visit the Louvre museum regularly, becoming registered as a copyist to join the hundreds of other painters who learned by copying the work of the masters. He was drawn to Rubens, but the French school continued to attract him, and the rococo painter Boucher was a particular favourite.

In 1861, at the age of 20, he entered the studio of the Swiss-born painter Charles Gleyre, mainly because he was dissatisfied with his knowledge of figure drawing. He said that at this time: 'My drawing was accurate but a little harsh!' Some of the other students (many of whom came from prosperous families) mocked him as he sat at his drawing-board in his artisan's smock, but Renoir was undisturbed by their comments, and persisted with his studies. He soon made friends with Frédéric Bazille, a comfortably off young man from Montpellier, and with Claude Monet and Alfred Sisley. Although studying at Gleyre's private studio, Renoir was also enrolled at the Ecole des Beaux-Arts. He completed the obligatory courses there and regularly passed examinations, even if he rarely distinguished himself by his performance – his best effort was a fifth place in perspective drawing in 1862.

Gleyre's method of teaching was largely one of leaving his students to their own devices, though he urged them to draw and to restrain themselves in their use of colour. Renoir called him 'a second-rate schoolmaster but a good man'. Nevertheless, Renoir made the most of his time there: 'While the others shouted, broke the window panes, tormented the model, disturbed the tutor, I was always quiet in my corner, very attentive, very docile, studying the model, listening to the teacher . . . and it was I whom they called the revolutionary.' The obedient student came into conflict with his master because of a love of colour and an enthusiasm for his studies, so different from the disciplined control and lifeless rigour expected of academic painters.

Renoir soon saw the limitations of working only in the studio, and with his new-found friends Monet, Sisley and Bazille, took up painting out of doors – en plein air. Like the Barbizon painters before them, they explored the forests of Fontainebleau, setting out with their knapsacks on their backs and spending their nights at inns in Chailly, Barbizon or Marlotte. It was while he was working in a clearing of the forest, attempting to render the effect of light filtering through the trees, that Renoir met two of the idols of the young painters of the day – Courbet and Diaz. It was Diaz who told Renoir that 'no self-respecting painter should ever touch a brush unless he had his model before his eyes'. And it became Renoir's maxim that he should paint from life – if flesh-and-blood models were too expensive, he could instead study the forest which was available free.

Courbet's influence was visible in most of Renoir's large-scale figure painting in the 1860s. He at times adopted Courbet's palette-knife technique, applying layers of colour

with this implement rather than a brush. But the young Renoir was always ready to experiment with a variety of painting styles, instead of following a single line of development. Over a short period, he would produce some works in the manner of Courbet, and yet others quite different in feeling and technique, showing the influence of other artists.

When Gleyre's studio closed in 1864, Renoir continued to paint in the open air, spending much of his time in the Fontainebleau area. He often went on painting expeditions with Jules Le Coeur, the son of a wealthy family with homes in Paris, Berck-sur-Mer and Marlotte. Le Coeur regularly provided hospitality for Renoir in Marlotte, and Renoir's *Jules Le Coeur in Fontainebleau Forest* records their association. It was through Le Coeur that Renoir met Lise Tréhot – she was the younger sister of Le Coeur's mistress Clémence. Eighteen years old in 1866, Lise was soon Renoir's model and his mistress: he had painted some 20 pictures of her in various guises by 1870.

The small, spontaneous, informal paintings Renoir executed wholly or largely out of doors – which were often given away to friends – showed a marked difference from the works he prepared for submission to the annual Salon, which were large, carefully executed, and frequently included classical allusions. In 1863, Renoir's *Nymph with a Faun* was one of the many paintings rejected by the Salon jury, but instead of choosing to exhibit it at the Salon des Refusés, Renoir destroyed the work. He was more successful in 1864 when *Esmeralda* – depicting a scene from Victor Hugo's novel *Notre Dame de Paris* where Esmeralda dances round a fire with her goat – was accepted for exhibition, but the artist was still dissatisfied with his painting and he also destroyed this work immediately after the Salon.

In 1865, his *Portrait of William Sisley* (page 91), the artist's father, and an unidentified painting called *Summer Evening* were accepted, but in the following year his hopes were dashed when a landscape with two figures was rejected by the jury. This painting is probably the one shown on the wall above the piano in Bazille's *The Artist's Studio, Rue de la Condamine*. The landscapist Charles Daubigny, who had intervened with the jury on Renoir's behalf, said: 'We asked for that painting to be reconsidered ten times, without being able to get it accepted.' Renoir had no more success in 1867, year of the Universal Exhibition. He entered *Diana*, a large canvas showing Lise as the goddess of the hunt. It was painted at Bazille's studio in Paris which Renoir, desperately short of money, was pleased to be able to share. Bazille wrote to his mother of *Diana*: 'My friend Renoir has done an excellent painting that has startled everybody. I hope it will be successful at the Exhibition, he needs it very badly.' The jury of 1867 did not share Bazille's opinion, and once more Renoir found himself rejected.

While producing these studio pictures, Renoir also continued to work out of doors, often in close association with Monet. He completed small-scale scenes of contemporary

Renoir: LISE SEWING, 1866.
The first of the artist's many pictures of his model and mistress Lise Tréhot. A tender portrait with strong accents of colour and somewhat in debt to Courbet.
56 × 46 cm. Dallas Museum of Art. Wendy and Emily Reves Collection.

Renoir: WOMAN STANDING BY A TREE, 1866.
This oil sketch is one of a pair that seem to show the artist anticipating himself. It might have been done several years later as it is so carefree and confident in execution.
25 × 16 cm. National Gallery of Art, Washington D.C. Ailsa Mellon Bruce Collection.

Paris, such as *The Pont des Arts, Paris*, and his growing experience of outdoor painting had a beneficial effect on his large-scale studio work. With the backing of Daubigny, his portrait of *Lise* was accepted for exhibition at the Salon of 1868. The effects of colour and light observed in natural surroundings gave this painting a freshness lacking in Renoir's earlier Salon entries. Critical response was mixed. Jules Castagnary was pleased to announce: 'Youth is arriving on the scene.' Wilhelm Thoré Bürger praised the picture's natural effect: 'So true that one might very well find it false, because one is accustomed to nature represented in conventional colours . . .' But there was also hostility, one critic referring to 'a fat woman splashed with white, whose author . . . evidently drew his inspiration no longer from the great examples of Courbet but from the curious models of Manet'.

The acceptance of Renoir's painting for the Salon had no effect on his financial circumstances. During 1869, living with Monet at Bougival, northwest of Paris, he experienced some periods of dire poverty. That autumn he wrote to Bazille: 'We don't eat every day. Yet I am happy in spite of it, because, as far as painting is concerned, Monet is good company.' It was typical of Renoir that his good humour was able to survive in such circumstances – whereas Monet raged against the financial difficulties with which he was beset.

It was during 1869 that Renoir and Monet carried out their project to paint at La Grenouillère, on the Seine just west of Paris. The popular bathing place and restaurant, where Parisians enjoyed a day in the country before returning to the city by train, offered a subject full of effects of light on water. The young artists dreamed of turning their studies of this river spot into larger paintings to be executed in the studio, but this dream remained unfulfilled. Only the studies were ever completed. Full of life and movement, vivid in colour and boldly painted, they have come to be seen as the quintessence of outdoor painting. Of the two artists, Monet had the greater experience of open-air painting, and this shows in his direct and confident handling of his subject, especially in his treatment of the water surface (page 132). Renoir's work, with its characteristically softer touch, is still tentative by comparison. He concentrates on the fashionably dressed figures rather than the landscape. The La Grenouillère studies look forward to the Impressionist painting of the 1870s, but Renoir never lost his enduring interest in the great tradition of French painting. His Salon entries accepted for exhibition in 1870 show this side of his art. *Bather with a Griffon* (page 174) displays echoes both of classical Venuses and of Courbet's contemporary figures, while *Woman of Algiers* shows Renoir's fascination with the theme of the odalisque seen in the Orientalist works of Ingres and Delacroix. The critic Arsène Houssaye recognised Renoir's emerging individuality and his connection with his artistic forebears when he wrote: 'One can study the proud painterly temperament which appears with such brilliance in *Woman of Algiers*, which Delacroix would have signed.'

Two months after the Salon opened, war with Prussia was declared. As the Prussian invasion of France began, Renoir joined a cavalry regiment. He was posted to the southwest of France, far from the scene of the fighting, and the only threat to his life came from a severe bout of dysentery. Released from service after the French defeat, he returned to Paris in the spring of 1871, only to find himself caught up in the Commune revolt. He was again liable for conscription, this time under the compulsory enrolment decreed by the Communards.

Renoir abhorred the Commune and desired only to start painting once more. He decided to flee the capital and rejoin his mother at Louveciennes, but this was by no means easy, since the city was once again under siege, this time by the forces of the French Versailles government. He was able to obtain an exit visa from Paris with the assistance of the Chief of Police, but he was warned that his life would be in extreme danger if he was apprehended by government troops outside the city. As it happened, he did encounter some difficulty with the Versailles forces, but was rescued by Prince Bibesco – a patron whose residence he had helped decorate before the war.

No trace of these dramatic events is to be found in Renoir's art. The tranquil *A Road in Louveciennes* (page 176) probably dates from the period immediately after the painter's flight from Paris. A number of other lyrical landscapes were to follow, including *The Gust of Wind* (page 177), an extraordinary experiment in technique to capture a most elusive natural effect. Renoir's landscape painting after 1871 has shed all the slightly hesitant or derivative elements of his work in the 1860s. He emerges for the first time as a fully assured, mature artist painting in what we recognise as a highly developed Impressionist style.

In April 1872 Lise Tréhot, so often the subject of Renoir's painting in the 1860s, married an architect friend of Jules Le Coeur, thus marking another break with the artist's past. But relations with Monet and Sisley, interrupted by the war, were quickly renewed. Monet had settled in Argenteuil, a rapidly growing suburb which was also an immensely popular boating spot, regarded by Parisians as 'the countryside'. Here, in the summer of 1873, Renoir and Monet once more worked together as they had done at La Grenouillère in 1869.

Unlike Monet, Renoir was still attempting to exhibit at the official Salon. In 1873 his two entries were rejected by the jury, but were exhibited at a Salon des Refusés held that year to show the works that had been turned down for the Salon itself. Although the dealer Durand-Ruel had bought some of Renoir's paintings, giving him enough money to rent his own studio in the Rue St. Georges, the artist was still desperate to have his work shown and noticed. So it was with great enthusiasm that he joined in the organisation of the independent group show of 1874, to be known as the First Impressionist Exhibition.

Renoir took on almost single-handed the task of hanging the works at the exhibition, which opened on 15 April at the photographer Nadar's former studio on the Boulevard

Renoir: PARISIAN WOMEN IN ALGERIAN DRESS, 1872. Renoir sometimes indulged in Orientalism and shamelessly based this picture on Delacroix' *Women of Algiers*. The Parisiennes don't quite match the conviction of the latter's models but they are deftly painted.
156 × 129 cm. National Museum of Western Art, Tokyo.

Renoir: THE DANCER, 1874. Shown at the First Impressionist Exhibition, this picture won only lukewarm praise and was generally criticised for a lack of substance. 142.5 × 94.5 cm. National Gallery of Art, Washington D.C. Widener Collection.

des Capucines. Unlike normal Salon submissions, the paintings were generally small in size, and their grouping in interesting and arresting ways proved to be a difficult problem. When he could not find a suitable place for one of the canvases sent by Giuseppe de Nittis, Renoir simply omitted it, contrary to the rules of the co-operative organisation of the exhibition. He was later forced to find a place for it.

His own submissions included *La Loge*, showing a couple in a box at the theatre, posed by Renoir's brother Edmond and a professional model, *The Dancer* (page 64) and *The Parisienne*. In his facetious review in *Charivari*, Louis Leroy discussed his visit to the exhibition in the company of an academic painter, Joseph Vincent, and *The Dancer* came in for this comment: 'Upon entering the first room, Joseph Vincent received an initial shock in front of the *Dancer* by M. Renoir. "What a pity," he said to me, "that the painter, who has a certain understanding of colour, doesn't draw better; his dancer's legs are as cottony as the gauze of her skirts."' Renoir's work was generally, however, either favourably received or ignored. He told his son Jean Renoir years later: 'They [the critics] ignored me. And it is rather disconcerting to be ignored.' He managed to persuade the dealer Père Martin to buy *La Loge* for 425 francs so that he could pay his rent. Then, assisted by Béliard and Latouche, his fellow members of the 'Control Committee', he prepared a statement of the co-operative's financial position, after which it was unanimously decided to liquidate it.

After the exhibition, Renoir spent part of the summer of 1874, as he had the previous years, at Argenteuil with Monet. Sometimes the two friends produced very similar paintings, often of the river Seine. Renoir's representations of the river employ a short, broken brushstroke, and a vivid palette, emphasising contrasts of blue and yellow. He also painted Monet, his wife Camille and their young son Jean. On one occasion, Edouard Manet had set up his easel in the Monets' garden in order to paint Madame Monet and her son, when Renoir arrived and set up his own easel alongside him. Manet watched Renoir from the corner of his eye, pausing to look at his canvas from time to time. Finally he whispered to Monet: 'That boy has no talent. You're his friend, tell him to give up painting!' The story indicates a close and joking relationship between the painters, rather than bitter rivalry. The resulting paintings both show Camille Monet seated on the grass with her son sprawled beside her, although Manet's version also includes Monet gardening.

The warmth and pleasure depicted in the paintings belied Renoir's perilous financial position. The art market, exceptionally buoyant in the years immediately after the Franco-Prussian War, had slumped. As Cézanne commented: 'It is a very bad time for selling; all the bourgeois are unwilling to spend their *sous* . . .' To try to generate some interest, Renoir decided to organise an auction of paintings at the Hôtel Drouot, the Paris auction house. He persuaded Monet, Sisley and Morisot to join him in this venture. The critic Philippe

Burty wrote in the catalogue for the sale that the paintings were 'like little fragments of the mirror of universal life, and the swift and colourful, subtle and charming things reflected in them well deserve our attention and our admiration'. The public did not agree, and the viewing day before the auction, which was held on 24 March 1875, was marked by such hostility that the police had to be called to prevent fist-fights. The artists saw their work fetch extremely low prices: the highest price bid for one of Renoir's 20 works was only 300 francs. But the auction had a positive side: two important new collectors of Renoir's work emerged, the customs administrator Victor Chocquet and the publisher Georges Charpentier. Chocquet wrote to Renoir on the day of the auction. Renoir recalled: 'He paid me all sorts of compliments on my painting and asked me if I would consent to do a portrait of Madame Chocquet.' Renoir accepted, and when he visited Chocquet's apartment in the Rue de Rivoli, discovered that his new patron had a collection of Delacroix's work, and wanted one of his Delacroix paintings to appear in Renoir's portrait of his wife. He explained: 'I want to have you together, you and Delacroix.'

Charpentier was a young publisher, and he and his wife commissioned Renoir first to paint their children, then to decorate two large panels which hung in the stairwell of their imposing Paris home, and then to do a portrait of Madame Charpentier herself. Charpentier published the work of the Naturalist school, and the authors Emile Zola, Edmond de Goncourt, Alphonse Daudet, Gustave Flaubert and Guy de Maupassant were also his close friends. Madame Charpentier was rapidly becoming renowned as one of Paris's outstanding hostesses. Her salons were known for mixing politicians like Gambetta with authors, musicians and painters, and Renoir soon found himself a part of the Charpentiers' regular circle, adopted by Madame Charpentier as 'her' painter, a role he was happy to play. He decorated menus and place cards for her dinners, and sometimes caused amusement by his social gaffes: on one occasion he forgot to put on his dinner jacket, appearing in his shirtsleeves. To make him feel at ease, his host took off his own dinner jacket and the other guests, including Gambetta, did the same.

Renoir exhibited at the Second Impressionist Exhibition in 1876 and at the third show in the following year, when he exhibited *Dancing at the Moulin de la Galette* (page 54). Showing a crowd at the popular open-air dance hall in Montmartre, this is a work which in its size and complexity suggests a Salon painting, but in its mood of carefreeness and in its concern with rendering the dappling of light through the trees is characteristically Impressionist. The models were Renoir's friends, and the sketches and preliminary painted study for the painting indicate that Renoir had moved away from the Impressionist emphasis on working on the spot, and was employing a more traditional approach to the process of making a large painting. *The Swing*, also shown at the Third Impressionist Exhibition, reveals the same interest in light effects, while its theme, the evocation of pleasure, links it to Renoir's favourite painters, the French masters of the 18th century like

Renoir: PORTRAIT OF VICTOR CHOCQUET, c.1875.
An inspired collector and a friend in need, Chocquet immediately discerned Renoir's and Cézanne's affinities with the old masters, particularly Delacroix. 46 × 36 cm. Fogg Art Museum, Cambridge, Massachusetts.

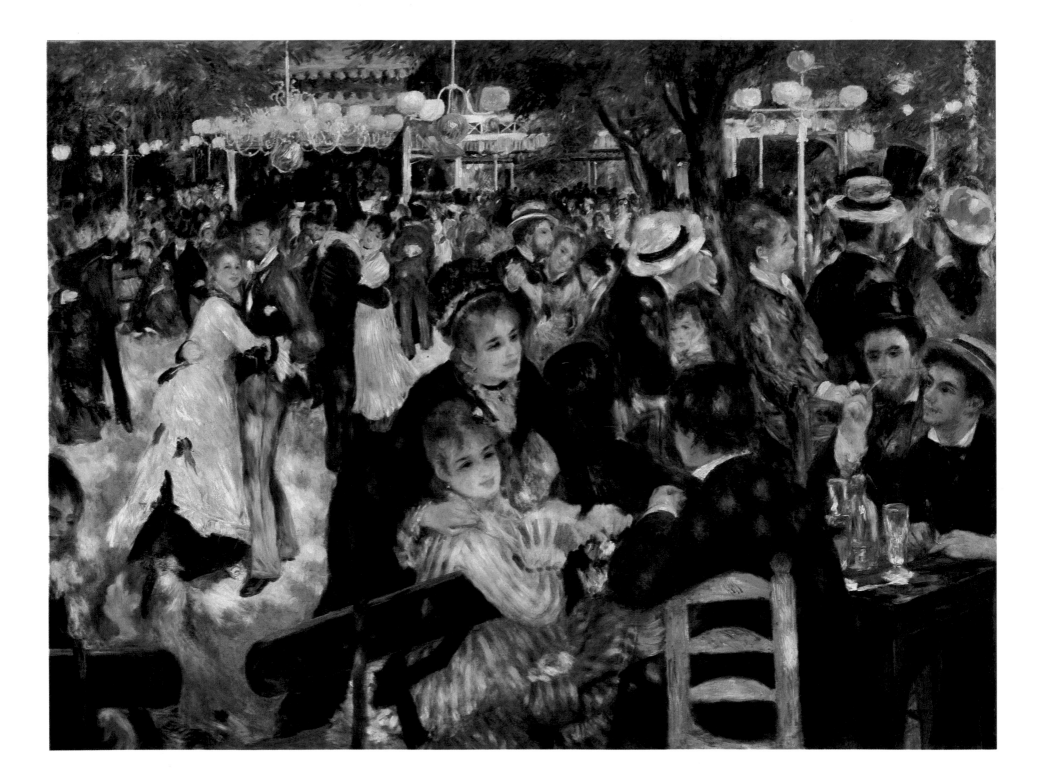

Boucher and Watteau.

Renoir was becoming increasingly disillusioned with the chances of attaining success by remaining outside the forum of the Salon, since the general critical response to the independent exhibitions was as unsympathetic as ever. He decided to return to submitting to the annual Salon, and in 1878 showed *Le Café*. But it was through Madame Charpentier that he was given a chance to make his mark in the stronghold of official art: in 1878 she commissioned him to paint a portrait of herself and her two children, Georgette and Paul, and she made sure that the finished picture (page 67) was accepted and prominently hung at the 1879 Salon. She lobbied friends on the Salon jury relentlessly and invited critics and influential figures like Charles Ephrussi, later owner of the periodical the *Gazette des Beaux-Arts*, to see the painting at her home. The result was that Renoir was widely praised, hailed by some critics almost as a returning prodigal – Baignières wrote in the *Gazette des Beaux-Arts*: 'he has returned to the bosom of the Church and we should bid him welcome.' Renoir's Salon success marked a definitive break with the idea of independent group exhibitions, although he remained on terms of friendship with his former colleagues. Pissarro wrote: 'Renoir has a big success at the Salon. I believe he is launched. So much the better! Poverty is so hard.'

Pissarro's comment was in fact premature. Renoir was to find in succeeding years that it was Madame Charpentier's intervention that had been responsible for his success, rather than a change of heart on the part of the critics or the public. He insisted that the orthodox channel of the Salon was the best way to recognition, and it is ironic that he is often regarded as the paradigm Impressionist, when his allegiance to the movement lasted only four years. Explaining his position, he wrote to the dealer Paul Durand-Ruel: 'There are in Paris perhaps 15 amateurs capable of appreciating a painting without the Salon. There are 80,000 more who will not buy anything if it has not been in the Salon . . .' To his friend Paul Bérard, a diplomat whom he had met through the Charpentiers, he wrote jokingly: 'I'm going to get back on the right path and I'm going to enlist in Bonnat's studio [Léon Bonnat was an academic portrait painter]. In a year or two I'll be able to make 30,000 billion francs a year!'

Through Madame Charpentier, Renoir's circle widened greatly and he found himself in some demand as a portraitist. Following Madame Charpentier's example, several society figures commissioned Renoir to paint their wives or children, among them the banker Louis Cahen d'Anvers. Renoir first painted Irène, the eldest daughter, and then a double portrait of Elisabeth and Alice, the younger daughters. He often found these portrait commissions tiresome, complaining once to Bérard: 'I must still work on this damned painting because of a high-class *cocotte* who was imprudent enough to come to Chatou and want to pose and it has cost me two weeks of delay . . . I don't know where I am, except more and more irritated.' But the commissions, and the fact that Durand-Ruel

Renoir: DANCING AT THE MOULIN DE LA GALETTE, MONTMARTRE, 1876.
Painted on the spot with friends as models, this is the first of Renoir's large and complex figure compositions of ordinary people enjoying themselves.
131 × 175 cm. Musée d'Orsay, Paris.

Renoir: PORTRAIT OF MADAME CHARPENTIER AND HER CHILDREN, 1878.
Madame Charpentier firmly believed in Renoir's talent and her influence ensured that this picture was well hung at the Salon of 1879. It was quite well received by the critics although the artist was accused of weak draughtsmanship. But Marcel Proust later compared it to 'Titian at his best'.
154 × 190 cm. Metropolitan Museum of Art, New York.

Renoir: PORTRAIT OF
RICHARD WAGNER, 1882.
Wagner sat for Renoir in Palermo the
day after the composer had completed
Parsifal. The artist was given 35 minutes
and the picture went, perhaps not
surprisingly, unappreciated.
52 × 45 cm. Musée d'Orsay, Paris.

had begun to buy his work regularly, ensured that his financial difficulties were over. He was now able to begin travelling.

His first destination was Algiers. He made two visits, the first in March 1881 and another the following year. He went partly in homage to Delacroix, who had made a famous journey to Algeria 50 years earlier, and partly because by this date Algiers was part of the accepted artistic Grand Tour, something without which any artist's experience was considered incomplete. He duly admired the exotic scenery and the intense light, later referring to 'this marvellous country [where] the magic of the sun transforms the palm-trees to gold . . . and the men look like Magi'.

In October 1881 he set off for Italy, arriving in Venice on 1 November. The views he painted there are obviously touristic: the Grand Canal and the Doge's Palace. He then moved on to Rome, where the Raphael frescoes at the Villa Farnesina made a profound impression on him. He told Durand-Ruel: 'They are very beautiful and I should have seen them earlier. They are full of knowledge and wisdom.' Increasingly dissatisfied with his own painting, and looking for a more unified and generalised approach, he found the frescoes in Pompeii equally impressive, and two years later urged a friend: 'Go and see the museum in Naples. Not the oil paintings, but the frescoes. Spend your life there.' He himself spent two months in Naples, although he was homesick and, as he said, 'a little bored far from Montmartre'.

In January 1882 he visited Palermo in order to paint the portrait of Richard Wagner (page 68). Renoir had been an admirer of Wagner's music since the 1860s, and he was very nervous about the meeting. He was granted 35 minutes for a sitting, and Wagner's comment on the result was that he looked 'like a Protestant minister'. Finally, in January, Renoir left Naples and went first to Marseilles, and then on to L'Estaque to see Cézanne. While at L'Estaque he developed pneumonia, and was seriously ill for some weeks.

It was during his illness that arrangements were being finalised for the Seventh Impressionist Exhibition. Renoir had not shown with the Impressionists since 1877, but this time Durand-Ruel was organising the show, and as Pissarro said: 'For Durand-Ruel as well as for us the exhibition is a necessity.' Renoir conceded that he could not prevent the dealer exhibiting the paintings he already owned: 'This morning I sent you a telegram as follows: "The paintings of mine that you have are your property, I can't prevent you from disposing of them, but I won't be the one who will exhibit. . ." I am only defending our mutual interests, since I think that exhibiting there would make canvases drop by 50 per cent.' Durand-Ruel showed 25 of Renoir's paintings from his stock.

Renoir also showed at the Salon, but his disillusionment about both his reputation as a painter and the direction his painting was taking appeared to be justified by the lack of critical or public interest aroused. Renoir felt that he had reached an impasse. Years later, he told the dealer Ambroise Vollard: 'I had wrung Impressionism dry, and I finally

came to the conclusion that I knew neither how to paint nor how to draw. In a word, Impressionism was a blind alley, as far as I was concerned.' After years of concentration on colour, he began to reconsider the importance of line. His study of Raphael and the Pompeiian frescoes was accompanied by a renewal of interest in Ingres, and a return to the museums, to study the work of the masters. He destroyed several of his canvases, and began to work out the compositions of paintings in a series of preparatory drawings. He also made independent drawings of drapery and of foliage, and outlined forms in black ink on his canvases before he began to paint. This was in marked contrast to the techniques of Impressionism, and was accompanied by a new classicism in the choice of subject-matter. In 1886 he told Berthe Morisot that 'the nude seemed to him to be one of the most essential forms of art'. Even his paintings of domestic scenes, such as the *Children's Afternoon at Wargemont*, began to show a preference for frieze-like generalisation in the treatment of facial features.

Renoir's three years of technical experimentation culminated in the *Bathers* of 1887 (page 186), a major painting for which he had made at least 19 preparatory studies, and one which drew on a variety of sources, among them Jean Goujon's *Fountain of the Innocents* at Les Halles; Girardon's *Bathing Nymphs* at Versailles; Ingres' *The Turkish Bath*; Raphael's *Galatea*, which he had admired in Rome; and Boucher's *Diana Bathing*, which he had always loved. He wrote to Durand-Ruel: 'I think I have advanced a step in public approval, a small step . . .', but Durand-Ruel did not agree, and felt that Renoir's new harsh manner, his *manière aigre* or *Ingriste* approach, would harm his sales.

Not only Renoir's painting, but also his personal life changed during the 1880s. At the beginning of the decade he had met a seamstress from Essoyes in southern Champagne, Aline Charigot. She posed for him often, and accompanied him on at least part of his Italian trip. On 21 March 1885, she gave birth to their first son, Pierre. The painter and collector Gustave Caillebotte was the boy's godfather, but even close friends like Berthe Morisot were not introduced to Aline or told of the child until years later. A series of paintings on the subject of maternity, inspired by the birth, showed again Renoir's new preference for classical themes, far removed from the precise observation and specificity of the Impressionist years.

The classicism of the 1887 *Bathers* was not to set the tone for Renoir's work through the rest of his life. Richness of colour and fluidity of brushstroke would soon return to his painting. But the break with the Impressionist style of his work in the 1870s and early 1880s was final.

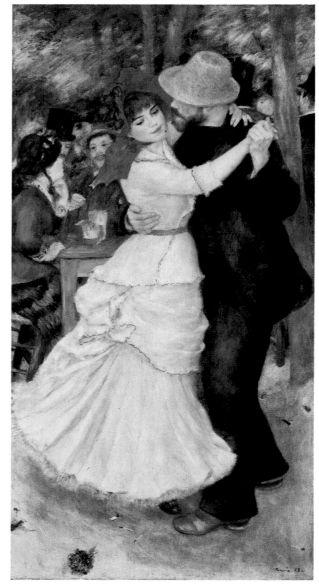

Renoir: DANCE AT BOUGIVAL, 1882–83.
This is one of three large pictures of dancing couples that Renoir completed in less than a year and it is the one most charged with personal feeling. The model for the girl was the young Marie-Clémentine Valadon, later famous as the painter Suzanne Valadon.
182 × 98 cm. Museum of Fine Arts, Boston.

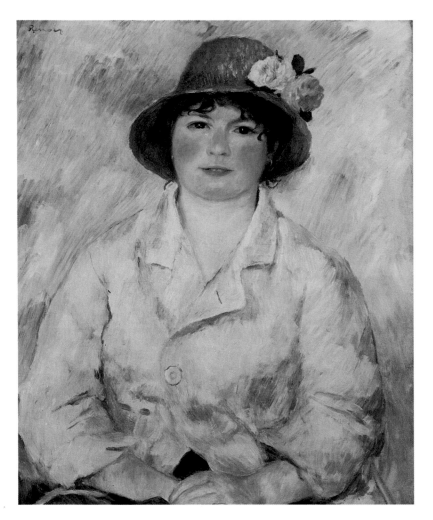

Renoir: PORTRAIT OF ALINE
CHARIGOT (MADAME
RENOIR), c.1885.
Aline Charigot first appeared in
Luncheon of the Boating Party (on the
extreme left). She figured in many
pictures but this one is the 'straightest'
portrait of her as the robust country girl
she was. Although it belongs to the
linear period, her contours are as much
suggested as defined. She married Renoir
in 1890, five years after the birth of her
first son Pierre.
65 × 54 cm. Philadelphia Museum of
Art. Purchased: W.P. Wilstach
Collection.

Like Pissarro's excursion into Pointillism, Renoir's 'Ingres' period only lasted about four years and he soon transformed his 'dryness' into a sumptuous sensuousness, producing some of the most beautiful nudes he ever painted. He also portrayed his three sons, imparting his pleasure in his family in many spontaneous studies. In 1898 he first moved to Cagnes-sur-Mer on the Mediterranean. There his work became more of a generalised idyllic celebration of women, landscape and still life that clearly show his affinity with Boucher and other 18th-century masters. Looking back at them now, not of course for the first time, moved him forward to his own kind of Post-Impressionism which would strongly influence some of the 'Fauve' painters. In spite of his hands being crippled with arthritis he continued working indefatigably, also modelling some remarkable sculpture with a little necessary physical assistance. He died in 1919. Since his death, his popularity remains undiminished. His talent to delight hardly ever faltered and his work conveys the pleasures of looking and living in perhaps a purer, more entirely joyful form than has been provided by any other artist in history.

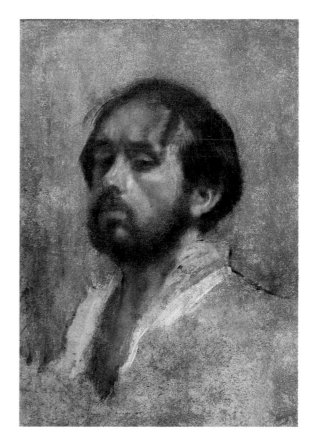

DEGAS MOVES INTO THE PRESENT

Ingres: BATHER, 'THE
VALPINÇON BATHER', 1808.
A picture that was almost a sacred icon
to Degas. His understanding of the
female figure seen from all angles was
one of the principal aspects of his art.
144 × 97 cm. Musée du Louvre, Paris.

'OGiotto, don't prevent me from seeing Paris, and you, Paris, don't prevent me from seeing Giotto!' In this outburst, which Degas confided to the pages of his notebook, the young artist vividly expressed one of the persistent conflicts of his early career. Giotto, the great 14th-century painter, whose frescoes had so enthralled Degas on his visits to Italy, represented the historic tradition of European art. Paris, on the other hand, signified all that was modern, a bustling and glamorous metropolis at the forefront of world trade and a leader in taste and fashion.

The dilemma that troubled Degas perhaps more than any other painter connected with the Impressionist circle, was the need to reconcile his deep respect for the artists of the past with an urgent sense of the modernity of his own culture. Modern cities and modern sensibilities had opened the way for a new attitude to painting, and the story of Degas' early years can be seen as a slow and sometimes painful attempt by a born traditionalist to come to terms with the challenge of contemporary culture.

Edgar Degas was born in 1834 to a wealthy Parisian banking family with aristocratic connections. He was brought up in Paris, where he was to spend most of his life. The relationship between Degas and his father Auguste, a man of cultivated taste devoted to music and theatre, was an important one. It is not every young artist who grows up with a parent sufficiently well informed about the arts to offer his son critical and technical advice at a formative stage in his career, or one who is able to introduce him to friends with important collections of contemporary paintings.

Generally the family ties were strong, perhaps made stronger when Auguste was left to bring up the family of five children after the death of his wife in 1847. The loss of his mother when he was 13 years of age must have affected Degas deeply, and some attempt has been made to connect this event with his failure in later life to establish stable relationships with women. Degas was always reticent on the subject – as he was on any aspect of his intimate life – but there is a certain fascination in the notion of an artist so apparently devoted to the celebration, in his art, of women in every conceivable role from high-society beauty to common prostitute, who had yet decided to remain celibate.

It was through Auguste de Gas (an earlier spelling of the family name) that the young painter first saw the Ingres *Bather* owned by a friend of the family, Edouard Valpinçon, and consequently now known as the *Valpinçon Bather* (page 72). The painting made a lasting impression on him – his famous pastels of women at their toilette produced 30 or more years later seem like modern restatements of the same theme, even to his preference for the turned back and the half-drawn curtain – and was indirectly the source of one of the most colourful and oft-repeated stories from Degas' early years. It is said that the young Degas was instrumental in persuading Valpinçon to lend his *Bather* for an important exhibition of Ingres' work at the Universal Exhibition of 1855, and it was subsequently arranged that Degas should meet the grand old man of French 19th-century art in person.

Degas' trepidation must have been considerable, but it soon turned to confusion when Ingres unaccountably slipped and fell unconscious at his feet. Degas was despatched to fetch Madame Ingres, and the briefest of interviews was brought to an end.

For Degas and many of his generation, Ingres was the living representative of the great classical tradition in European art, a tradition which venerated drawing and associated it with the classical values of discipline and moral rectitude. It is perhaps significant that a second version of the meeting between Ingres and Degas exists, in which the old man supposedly advised the aspiring artist to 'draw lines, young man, draw lines'. The idea that art is fundamentally based on line – and therefore on drawing – was an article of faith for Ingres and his neo-classical followers that clearly made a profound impression on the young Degas, who was to be one of the greatest draughtsmen ever. But Degas' artistic personality was too rich and complex to allow his adulation of Ingres to engulf him completely, and he also came under the apparently contradictory influence of Delacroix, the leading exponent of French Romanticism, whose name was synonymous with a fresh and imaginative use of colour. These twin influences on the young artist helped him become both a master of line and a bold experimenter in the field of colour.

After an education at the Lycée Louis-le-Grand, Degas enrolled briefly at law school, but left to study painting at the studio of Louis Lamothe – a disciple of Ingres – in 1845, and at the Ecole des Beaux-Arts in 1855. Degas already had a room at home converted into a studio, and his first works were self-portraits and family portraits, which provide many important insights into his development both as an artist and as a human being. His uncles, aunts and cousins served as reasonably willing models for the artist's early experiments while he learned his trade.

One of the earliest milestones in Degas' career was the haunting, delicate *Self-Portrait* of 1857. In this etching he suggests the slightly pampered, somewhat aloof young artist, half concealed by shadow – as if reluctant to advance into the public eye. It contrasts tellingly with the more mature *Self-Portrait* painted about five years later. Here the artist appears almost arrogant, as he tilts his head backwards and looks down his nose at us, his chin now bearded and his shirt-front daringly thrown open. There is clearly some youthful posturing behind these pictures, just as there was behind the provocative depictions by Courbet of his own face, or even the youthful self-portraits of Rembrandt, both artists whom Degas had studied and admired. But there is also a developing self-awareness and an increasing technical resourcefulness, which was to serve Degas well as his art became more public and more controversial.

At this stage in his life, Degas had a private income, and did not need to court either popularity or customers. He was also able to travel widely to study classical works of art, and by 1860 he had visited Italy a number of times on extended study tours – a kind of self-imposed artistic apprenticeship. As he travelled, Degas filled his notebooks with drawings

Degas: ANGEL WITH A
TRUMPET, 1857.
Many similar drawings were produced at this time but none with quite such grace and subtle precision.
42 × 28.5 cm. Kunsthalle, Bremen.

Degas: PORTRAIT OF GIULIA
BELLELLI, 1859–60.
A study for the large Bellelli family
portrait (an idiosyncratic but highly
formal work), this sketch startlingly
foreshadows Degas' later vision.
36 × 25 cm. Dumbarton Oaks
Collection, Washington D.C.

were painted are not often known, but there are few indications that they were ordered or commissioned by the sitter. If Degas seems to have accepted no commissions, it may have been in order to leave himself the freedom to paint subjects as he wished. The portrait became a visual feast that was no longer dependent upon strictly representing the likeness of the person. This is most evident in one of his last female portraits from the decade, *Madame Camus* (page 81), exhibited at the Salon in 1870. In compositional terms, the sitter appears off-centre – a position unusual in conventional portraiture. The effect is to bring a natural feel to the subject, who is represented in her own environment, less posed than in a traditional portrait, and balanced by a group of half-concealed objects at the other side of the canvas.

At the same time, there is a freshness of observation, a sense of vitality, which makes the painting feel modern, as if Degas were reflecting part of the life of contemporary Paris. But in this example, dominating everything else in the picture, there is the extraordinary colour. A warm, glowing russet envelops and threatens to overwhelm the woman and everything around her, to the point where a contemporary critic suggested that the picture might be better used as an illustration in a book on colour theory. Colour, lighting, composition and brushwork all combine to make this one of the most experimental of Degas' – or perhaps any previous artist's – adventures in portraiture.

The experimental side of Degas' approach to art was encouraged by his friendship with Edouard Manet. Degas met Manet around 1862 at the Louvre, and the two artists seem to have shared similar aesthetic tastes and bourgeois attitudes. Undoubtedly, Manet's influence encouraged Degas to move away from his traditional beginnings in art and towards the direction followed by the future Impressionist group. Born two years before Degas in 1832, Manet had achieved an early artistic maturity and had confidently challenged many of the orthodox artistic notions of his day. The two artists had similar privileged backgrounds and both seem to have had a dislike of all things Bohemian. For a while they became good friends, and both could be seen in the cafés favoured by the younger and more progressive artists of the day.

In the late 1860s, Degas could be found at the Café Guerbois in the company of such artists as Renoir, Cézanne, Sisley, Monet, Bazille and Pissarro, as well as Manet. There would also be present critics and writers who supported the young artists, such as Zola, Astruc and Duranty. Degas was far from seeing eye to eye with all of this group. His respect for the classicism of Ingres and his strong views on the 'unsuitability of making art available to the lower classes' must have clashed with the attitudes of the politically radical Pissarro and the artistically single-minded Monet, for example. Degas was noted for his acid wit and the sharpness of his intelligence, qualities that could be used to wound. Even his relations with Manet were interrupted by quarrels and periods of marked coldness.

But Degas must have been influenced by the vigorous café discussions, especially when

they touched on the importance of modern city life as a theme for the artist. In fact, Degas had begun, at least to a limited degree, to explore modern and unconventional subjects in the early years of his career. The theatre and the dance first appeared in his work from around 1866, but his first experiments with contemporary subject matter, exemplified in colourful pictures of the social world of horse-racing, dated back to 1860–62. It is perhaps characteristic of Degas at this stage in his life that he should choose to paint an activity which was genuinely modern and popular, but one which also had strong aristocratic and artistic connections. Horses had appeared in his sketch-books from an early date, though these were often based on sculptures or paintings rather than living models, and it is a curious fact that three of Degas' four major history pictures contain prominent images of horses. His earliest sketches of horses and riders seem to follow a standard artistic 'formula' for such subjects, and only as the decade progresses does first-hand observation begin to take over from well-learned stereotypes.

One of Degas' earliest oil-paintings of the races is *Gentlemen's Race: Before the Start* (page 191), which bears the date 1862. The painting is a good example of Degas' later habit of repainting parts of his pictures, sometimes years after they were first completed. In this case, the central group of jockeys is almost entirely over-painted in a bold and vigorous manner which suggests his style of the late 1870s. In the background, however, it is possible to make out some tiny, doll-like figures and horses left from the original picture, which show vividly how the artist's style had changed in those crucial years. Whatever its subsequent repaintings, the *Gentlemen's Race* must always have been a boldly conceived and freshly executed picture, full of the sense of anticipation just before a race begins.

Some of the most original and delightful horse-racing pictures by Degas are not of horses at all, but of the spectators and riders who made the race-track such a glamorous place to be seen. He drew jockeys in their striped and patterned racing colours, fashionably dressed women picnicking by the race-track and top-hatted gentlemen with binoculars and shooting-sticks. Sometimes Degas' sketches have a rapid, half-finished quality that conjures up the excitement of the race-track and the vitality of this increasingly popular modern spectacle. He even managed to carry over some of the sense of exuberance into his more finished oil-paintings of the races, surprising the viewer with an unusual viewpoint or an off-balance composition. One such picture, *Steeplechase: the Fallen Jockey*, made history for the artist when it was accepted by the Salon in 1866, becoming the first 'modern-life' picture to be publicly exhibited by Degas. The subject could hardly have contrasted more strongly with his *War Scene from the Middle Ages*, exhibited only one year before.

The vividness and immediacy of Degas' horse-racing pictures often conceal their origins in detailed and extensive preparatory drawings, combining observations made on the spot with meticulous studies posed in the studio. Despite changes in his subject-matter, the activity of drawing was as important as ever and, amongst other things, built up for the

Degas: PRINCESSE DE METTERNICH, c.1870.
This picture was made from part of a photograph which included the lady's husband. Degas was the first great artist to use photographs without shame – indeed with enthusiasm. His hero Ingres had been more circumspect about referring to daguerreotypes.
41 × 29 cm. National Gallery, London.

Degas: WOMEN ON A
RACECOURSE, 1869–72.
A striking sheet of studies in oil on
paper for future possible use. As most of
the figures seem to be the same woman it
is very likely to have been made in the
studio.
45 × 31 cm. Musée du Louvre, Cabinet
des Dessins.

artist a private reference collection which he was to turn to again and again in his later career. An image like *Lady with Binoculars* (page **79**) crops up in at least eight drawings or paintings and studies of figures and horses reappear in pictures as much as a decade apart.

Degas' new interest in modern subject-matter was partly influenced by the example of contemporary literature and, in at least one case, possibly led to a painting directly based on a published novel. The painting, called *Interior* (page **196**), or sometimes *The Rape*, may show the moment from Emile Zola's *Thérèse Raquin* where two young lovers, having previously murdered the woman's husband, find that their earlier passion for each other has been destroyed. Degas' dramatic use of artificial light and stark, bold shadows emphasises the violence of the story, just as his keen eye for detail is both descriptive and suggestive. The picture is unusual in Degas' work in the precise and rather theatrical quality of its narrative, though it combines his usual accuracy of observation with a sharp sense of modern attitudes and experiences.

Direct and penetrating observation of the visible world became one of the mainsprings of Degas' work, though many of his pictures show how observation was combined with careful preparation, elaborate studio practice and the sophisticated artifice of a painter steeped in tradition. He himself said: 'No art was ever less spontaneous than mine. What I do is the result of reflection and study of the great masters. Of inspiration, spontaneity, temperament I know nothing.'

As Degas approached the historic and difficult years of the early 1870s, his pictures showed a new maturity – as well as a profound originality. His reverence for the Old Masters still haunted his paintings, but contemporary life had taken hold of his imagery. *The Orchestra of the Opera* (page **195**) of 1868–69, with its abrupt, truncated squad of very real-looking musicians, brings us face to face with Paris in the Second Empire, while, floating above the musicians' heads, as if to offer a glimpse of things to come, we see one of the first appearances of the subject with which Degas has become particularly identified: the pink and green haze of the ballet-dancer's tutu.

The year 1870 was one of the great turning-points in Degas' career. Before that date he had worked in relative obscurity, finding his way artistically and only gradually establishing himself in the Parisian art world. In 1870, the Franco-Prussian War broke out and most artistic activity came to a halt. Degas himself joined the National Guard to help defend Paris against the Prussians, but the war lasted less than a year and soon he was back at his easel. Within three years, however, several other remarkable events had occurred which helped to shape his career: he had travelled to America to visit his relatives in New Orleans and painted several pictures while he was there; he had first complained about trouble with his eyesight; he had begun to concentrate on one of the most popular themes of his art, the ballet; and he had emerged as one of the principal organisers and exhibitors in the notorious First Impressionist Exhibition of 1874. In many senses, the decade or so after

1870 represents the full maturity of Degas' art, the period when he became a minor public figure and the starting point for many of his most well-known subjects: the dancers, the café scenes, the laundresses, the milliners and the portraits of women.

Degas was the essential Parisian and most of his work from this period represents or reflects upon his native city. Despite his conservative background, he enjoyed the life of the cafés and cabarets and he would often walk for miles or take the omnibus just to observe the life of the city. When he was in New Orleans in 1872 he clearly missed the streets of Paris. In a letter home he wrote of the brilliant light and bright colours of Louisiana and then added: 'But one Paris laundress with bare arms is worth it all for such a Parisian as I.' His choice of the laundry girl for a number of drawings and paintings at this time is in itself remarkable. Enormous numbers of women and girls were employed in the city to wash and iron the clothes of the dress-conscious citizens but, because wages were low, laundresses were often associated with prostitution and were hardly considered a proper subject for conventional art. Degas' pictures of them are strangely ambiguous. He draws attention to their laborious tasks and unglamorous attire but at the same time manages to create monumental, beautifully drawn compositions that are bathed in the sort of dappled light we normally associate with an Impressionist landscape.

Degas always refused to be called an Impressionist, but his relationship with the Impressionists was an important one historically, even if their approaches to art seem to present more differences than similarities. Degas was friendly with several of the prominent figures of Impressionism, such as Renoir and Pissarro, and he actively promoted their exhibitions as an alternative to the official Salons – he participated in all the Impressionist group shows except the seventh in 1882. However, like his friend Manet, he was not in sympathy with a number of their practices. While the Impressionists preferred the landscape, Degas painted the city and its populace; when Monet and Pissarro worked in the open air, Degas preferred the studio and the carefully posed model; and, in place of the rapidly observed light of the countryside, Degas chose the harsh, unchanging glare of gas-lamps and stage-lights. His was a city art based on careful observation and a knowledge of the subject, closer to the novels of Zola and Flaubert and the Realist school than the mainstream of Impressionist painting. Degas even immortalised one of the Realist writers, Edmond Duranty, who was also an admirer of the new Realism in painting, in an audacious portrait of 1879. As in a number of portraits from this period, Degas meticulously itemised the accessories and surroundings of the sitter as if to intensify the documentary authority of this image of contemporary life. In seeing his books and papers and the disorder of his desk we experience the man's activities and private behaviour, as well as the outward appearance of his body.

The pictures that Degas chose to show at the Impressionist exhibitions included a large number of ballet subjects and he soon became known as the painter of the dance. He even

Degas: LADY WITH BINOCULARS, c.1865. (Oil on paper)
A study for a painting, *At the Races*, this is one of several studies of a compelling subject in which Degas himself seems to be under scrutiny. It seems quite possible that on occasion he used the same means of observation himself.
28 × 23 cm. British Museum Department of Prints and Drawings.

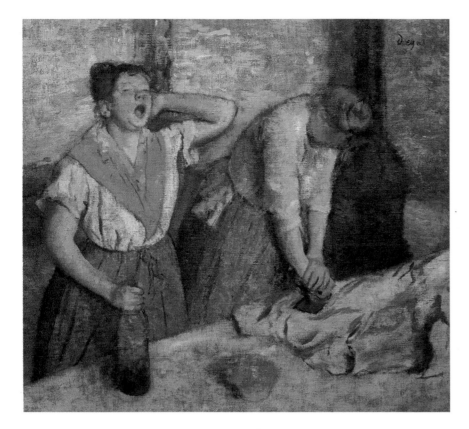

Degas: TWO WOMEN IRONING,
c.1884.
An unstifled yawn has engaged Degas'
attention and perhaps his sense of
humour. He often depicted people at
such unguarded moments. Ordinary
working women as well as dancers,
singers and prostitutes interested him.
76 × 82 cm. Musée d'Orsay, Paris.

complained: 'They call me the painter of dancers; they don't realise that for me the dancer has been a pretext for painting fabrics and representing movement.' His early ballet pictures, such as the *Ballet Rehearsal with Spiral Staircase* (page 198) and *The Rehearsal* (page 199) are full of detail, showing a large area of the stage or the rehearsal room with many of the properties associated with the dance. A violin or piano provides the music, a dance-master or male observer acts as a foil to the ballerinas, and a top-hat or artfully placed chair adds an element of improvisation to the composition. The dancers themselves seem to delight in the variety of their positions, some resting or just adjusting their costumes, others practising at the bar and often only a minority involved in actual dancing.

Informality is usually the key-note of Degas ballet scenes and it is surprising how few of his pictures represent performances rather than practice sessions. We know that Degas had access to the rehearsal rooms of the Paris Opéra (the building where the ballets were performed) and he spent many hours back-stage or in the wings watching the dancers in their less public roles. There is an almost perverse delight in the awkwardness and impropriety of some of the figures, as they scratch their backs, yawn or massage their tired ankles. As in Degas' pictures of laundresses, he appears to have been fascinated by the paradox of the physical exertion and the hours of boredom on the one hand and the glamorous fiction that could be made out of such unpromising material on the other.

Many of Degas' ballet pictures contain remarkable technical innovations which remind us what an experimental artist he could be. He characteristically chose to represent the scene from an unusual angle, either from a high or low vantage-point, or sometimes from very close range. A number of his drawings show a curious preference for back-views of dancers, for cropping the head or arm of his subject or for placing them eccentrically on the paper or canvas. He experimented with black-and-white, with brilliant and surprising combinations of colours, and with unusual mixtures of painting materials. There are ballet pictures painted on silk with metallic pigments, many examples of pastel and water-based paints combined on the same sheet of paper, and even dancers dancing their way across the semi-circle of a ladies' fan. Familiar and delightful though they may seem to us today, we know that Degas' pictures of the dance seemed strange and even shocking to his contemporaries.

The ordinary dancers of the Paris Opéra, unlike the principal ballerinas, were hard-worked and poorly paid and, like the laundresses, had a reputation for easy-going morality. Degas often hired dancers to pose in his studio for his ballet pictures, though he was known for his scrupulous propriety in his relationships with them. As with the rest of his studio-based art, Degas' dance paintings were based on a methodical process of observation, drawing and compositional study which was quite unlike the spontaneous picture-making of his Impressionist colleagues. He would draw and re-draw a particular figure, demanding that his model should pose unflinchingly for hours on end, and then store away

the drawings in his reference collection for future use. As his repertoire increased, Degas tried more daring and original positions for his dancers. Movement becomes more pronounced and individual figures balance on tip-toe or pirouette in an empty space. The depiction of detail becomes less important and colour, energy and visual excitement almost threaten to obliterate the subject altogether. In some of the fan designs and later pastels, a blaze of colour or a dazzling haze of pigment captures the dynamism of the dance without the laborious depiction of stage and scenery.

In contrast to the rarified atmosphere of the Opéra, Degas took a delight in the more popular and sometimes thoroughly bawdy world of the café-concerts. On one occasion, the artist's brother René came over from New Orleans to visit Paris and Degas introduced him to this Parisian equivalent of the English music-hall. René was shocked at the vulgar performers and the socially diverse audience, the very features that so attracted his brother and became the subject of hundreds of his drawings, paintings and prints. Degas' delight in the subject communicates itself in an unprecedented brilliance of colour and vividness of light and shade, and in some of his most inspired and original compositions. Like his admirer and disciple Walter Sickert, who recorded the great age of music-hall entertainment on the other side of the Channel, Degas' socially elevated background enabled him to distance himself from the spectacle while enjoying the uninhibited display of extrovert appetites.

To the Parisians of the 1870s, the café-concerts were still something of a controversial novelty. Baron Haussmann's mid-century rebuilding of Paris had opened up the wide boulevards in the city centre that we know today and created spacious pavements and open vistas with unprecedented opportunities for public display and entertainment. The café-concerts combined the functions of the bar and the variety theatre, and anyone who could afford the price of a drink was entitled to enjoy the entertainment. The result was an unusual social mix, from the top-hatted dandy to the gaudily over-dressed whore, enjoying the latest songs and humour in the glare of gas-lights.

Degas' pastels of the café-concerts (page 82) have all the daring and vivacity of the performances themselves: a jumble of hats, faces and musical instruments in the foreground suggests the chaos of an audience, the stark division of the picture by diagonals and verticals evokes the tension of the occasion, and the raking stage-light accentuates the vividness of the entertainment. Lighting is used to plunge entire areas of the composition into shadow and emphasise a gesture or a face; footlights illuminate the underside of a singer's face, distorting the features or exaggerating the brilliance of her costume. Chandeliers, gas-globes and even fireworks blaze above or behind the stage, at times threatening to distract attention from the performance itself. The more mundane cafés of the Paris streets, frequented by workers, prostitutes and bohemian artists and writers, also became the subject of Degas' art. His *Absinthe* (page 83) contrasts starkly with the

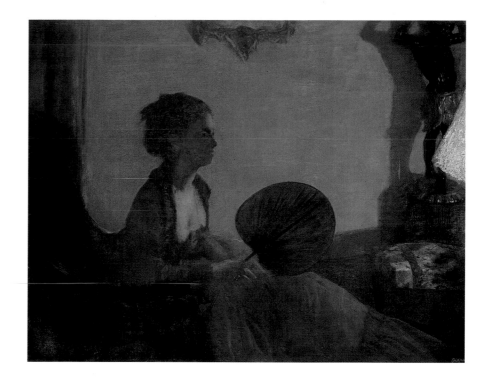

Degas: MADAME CAMUS, 1869–70.
This painting, with an originality of colour and lighting that was surely a deliberate challenge, can still startle us today and shows clearly why Degas preferred to paint his friends rather than commissioned portraits. It was shown at the Second Impressionist Exhibition as *Portrait, Evening*.
73 × 92 cm. National Gallery of Art, Washington D.C. Chester Dale Collection 1963.

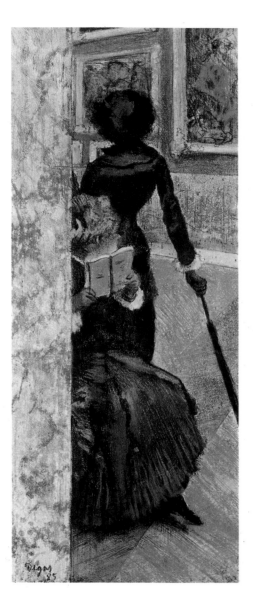

Degas: MARY CASSATT AT
THE LOUVRE, 1885.
Mary Cassatt was an American artist
who became a close friend of Degas and
the other Impressionists. She figures in
several prints and paintings by Degas.
30 × 13 cm. The Art Institute of
Chicago.

certainly appears in Degas' work. He uses close-ups, unusual framing devices and abrupt divisions of the picture-space; his interest in high vantage-points is echoed in the work of a number of Parisian photographers; and his manipulation of focus, from sharp detail to deliberate areas of haze, seems to reflect an awareness of photography and its language. When it is remembered that photography itself was still in its infancy and that most artists had a confused or hostile reaction to it, Degas' response to the camera and its productions seems extraordinarily imaginative and perceptive.

Also towards the end of the 1870s, Degas turned more and more to the use of pastel. The dense colours of pastel pigments and their suitability for pictorial effects like smudging, softened focus and surface texture complemented his new range of subject-matter and eventually eclipsed oil-paint as his principal medium. Degas gradually attracted a small admiring group of collectors who bought his work. Patrons from Germany, England and America began to seek out Degas and his pictures, supplying a steady and much-needed source of income for the artist. Degas' youthful financial independence was now a thing of the past, as his family fortunes collapsed and he took on the debts resulting from his brother's commercial mismanagement. The artist's hard work and prodigious production were partly the result of his commitment to his art, but also a reflection of his need to sell pictures to earn a living. As his reputation increased, he was able to raise his prices and eventually achieve a comfortable standard of living, but the long hours spent in the studio, with few other interests to distract him, continued almost to the year of his death.

One of the great consolations of Degas' life was his friends and he became a man who elevated friendship to a high level of seriousness. Some artist friends, such as Paul-Albert Bartholomé and Jean-Lous Forain, remained close to him until the end, and one or two families, like the Rouarts and Halévys, provided a welcoming domestic retreat which his own home life could not supply. Degas wrote to his friends and visited them in their illnesses and would travel great distances to attend a funeral or comfort the bereaved. Despite his stern public face and the caustic wit that he could direct at the pretensions of others, Degas was capable of great personal loyalty and private sentiment. In turn, his friends rallied to him in his own adversity and could often be relied upon to support and encourage his artistic activities. Degas painted the portraits of a number of his intimates.

One of Degas' closest friends and most loyal patrons was Henri Rouart. They had been at school together and served in the same artillery battery during the Prussian siege of Paris; in later life Degas painted several members of the Rouart family and he was a constant visitor to their house. Henri Rouart, himself a gifted amateur painter, bought a number of fine paintings by Degas, among them the *Beach Scene* which had been exhibited at the Third Impressionist Exhibition in 1877. The *Beach Scene* is unusual in Degas' work in that it shows an outdoor subject many miles away from his beloved Paris, but before assuming that it represents an untypical outdoor painting session for Degas, it must be

remembered that he was always an artist committed to the artifice of the studio. When an admirer asked him how he had so brilliantly captured the light and colour of the golden sand in this picture, Degas replied that he had just laid his overcoat on the studio floor and painted that!

A picture as well-drawn and boldly conceived as the *Beach Scene* was almost bound to attract admirers and it comes as no surprise to discover that the art critics of the day were less dismissive of Degas than they were of most of his Impressionist contemporaries. Degas' great admiration for the Old Masters shines through in the composition and the technical mastery of even his most provocative modern-life picture and his superb draughtsmanship was acknowledged by all but the most stubborn critics. He continued to visit the Louvre to pay his respects to his favourite paintings, urging colleagues and admirers to study the art of the past and learn from the Masters the discipline of drawing and colour. Even in his old age, Degas was still experimenting with techniques and materials that he believed would bring him closer to the artists he admired, such as Mantegna, Veronese and Van Dyck.

Degas' obsession with drawing and with the methodical processes of the Old Masters were two of the features of his career that most distinguished him from many of the artists of the Impressionist circle and both gave rise to some of his more memorable aphorisms. He once said: 'I have always tried to urge my colleagues to seek for new combinations along the path of draughtsmanship, which I consider a more fruitful field than that of colour. But they wouldn't listen to me and have gone the other way.' And, on another occasion, he quipped: 'You know what I think of painters who work outdoors. If I were the government I would keep a company of policemen watching out for anyone who painted landscapes from nature!' Degas was notorious for such pointed witticisms, though at times his love of irony seems to have distorted his real opinions. In spite of this he remained on good terms with artists like Pissarro and even encouraged younger painters, such as Paul Gauguin, with whom he can have had little in common.

The 1870s and 1880s were eventful years in Degas' artistic career and the pictures that he produced then have defined his artistic identity for all time. The painter of ballet-dancers and laundresses had become the definitive painter of the modern city of Paris, a city which supplied an endless series of subjects for his restless and imaginative creativity. Paris fulfilled all his needs and his art and his friends filled his days. His domestic life was largely uneventful and tended to become more reclusive as time went by, until he was likened to a hermit and barred his apartment to unwelcome visitors. He developed a loathing of journalists and newspaper critics and was even known to break off long-standing acquaintanceships when inaccurate or indiscreet opinions about him were published in the press. By 1886, as he approached the middle of his career, after more than a decade of artistic celebrity and even some notoriety, Degas increasingly retreated into the disordered but colourful world of his studio to devote himself to the true obsession of his life: his art.

Degas: PHOTOGRAPH OF A NUDE, c.1890–95.
The artist's photographic talent and painter's vision are perfectly joined here. Surely one of the greatest nudes in all photography.
J. Paul Getty Museum, Malibu.

Degas: AFTER THE BATH,
WOMAN DRYING HERSELF,
1888–92.
This pastel, which marks the beginning
of Degas' last period, seems to be both a
great painting and a drawing. Nobody
had used this soft medium with such
power before. It has curious distortions
and abstract qualities and Degas seems
to speculate in our presence about
possible variations without seeing the
need to come to any final decisions. It
shows clearly what a modernist he
became in his old age.
104 × 99 cm. National Gallery,
London.

Degas was now a celebrated artist who, before blindness and old age finally overwhelmed him, produced works mainly in pastel and crayon that are as admired today as anything he ever did. His failing eyesight also attracted him to sculpture, not only to model his perennial subject-matter of dancers and women performing the ritual of their toilet, but also to revert to his former passion for race-horses, where he reaped more of the fruit of his supreme powers of observation. Also his enthusiastic preoccupation with photography became even more marked, particularly in capturing movements of dancers described in sequence. Perhaps partly owing to his encroaching loss of vision his pastels were executed with stronger, purer colour and his ever-present interest in the ambiguous possibilities and the abstract qualities of the draughtsman's line seems more emphatic — his admiration for Gauguin and his purchase of a van Gogh eloquently demonstrate the broadening of his appreciation of the work of the succeeding generation.

Since Degas' death in 1917 (when Monet, the last survivor of the seven great Impressionists, had still to paint his last great works at Giverny) his reputation has grown even further into a general acknowledgement that he is one of the great masters of all time — as it has also created a more lively and sympathetic interest in his enigmatic personal character.

SISLEY'S GENTLE STRENGTH

Sisley: MONTMARTRE FROM
THE CITÉ DES FLEURS, 1869.
One of Sisley's precisely structured
spatial compositions which emphasises
how much his later generally diffuse style
was a matter of deliberate choice.
70 × 117 cm. Musée des Beaux-Arts,
Grenoble.

toned colours of the painting suggest that Sisley (perhaps under the influence of Monet and Renoir, who also painted in Louveciennes at this period) was beginning to lighten his palette. The ground, trees and buildings are all rendered in tones of green, brown, black and ochre, offset by the white of the snow and seasoned by patches of local colour, such as red or blue. What Sisley lacks in terms of compositional precision in comparison with Pissarro, he makes up for with his keen eye for the distribution of colour.

This is not to say that Sisley lacked the ability to create exciting or dramatic compositions. The artist could, for example, realise the full potential of motifs like the bridge across the Seine at Villeneuve-la-Garenne (page 211), painted in 1872, or the bridge across the Thames at Hampton Court, painted in 1874. Yet it is true that such severely disciplined compositions are relatively rare in Sisley's work, and it is apparent that it was not his purpose to bludgeon the viewer into a state of submission. Rather, it was his intention to beguile the spectator, to captivate the eye, and so to liberate the spirit by revealing what one early writer referred to as 'the smiling mood of nature'. Another contemporary writer summed up Sisley's painting thus: 'It is an art that is free, honest and poetical, where the spirit dreams, the eye derives pleasure and the hand is intelligent.'

But from 1870 onwards, Sisley's life was far from reflecting the 'smiling mood' of his art. Up to that time, he had enjoyed reasonable financial security through the support of his prosperous father. But the Franco-Prussian War ruined his father's business and Sisley was henceforth required to support himself, his wife and children through his painting. He was never again free of the threat of poverty.

During the first half of the 1870s, Sisley worked almost exclusively by the Seine, living at Louveciennes, Marly-le-Roi and Sèvres, villages all heavily steeped in French history. The countryside of this area known as the Ile de France was made especially his own by Sisley. As a contemporary English critic wrote: 'He is the painter of great blue rivers curving towards the horizon; of blossoming orchards; of bright hills with red-roofed hamlets scattered about; he is, beyond all, the painter of French skies which he presents with admirable vivacity and facility.'

The places where Sisley lived and worked, to the west of Paris, were within easy reach of the capital. Very close to Louveciennes was Bougival, a popular weekend resort to which Parisians spilled out by train, eager to enjoy such pursuits as rowing, sailing or picnics. It is typical of Sisley that, unlike Monet and Renoir, he rarely chose those themes as subjects for his pictures, preferring to depict the landscape of the riverbank at moments of calm – almost as if he had waited for the crowds to disappear. For instance, the famous restaurant of La Grenouillère near Bougival, which is so densely populated in Monet's and Renoir's pictures, is shown by Sisley deserted and boarded-up. Some of the artist's finest pictures are of Bougival and of another weekend resort, Argenteuil. Painted at the beginning of the 1870s, they showed a fully developed style. The composition of many of these paintings

Renoir: WILLIAM SISLEY, THE ARTIST'S FATHER, 1864.
Another token of Renoir's friendship with the English exile.
81 × 65 cm. Musée d'Orsay, Paris.

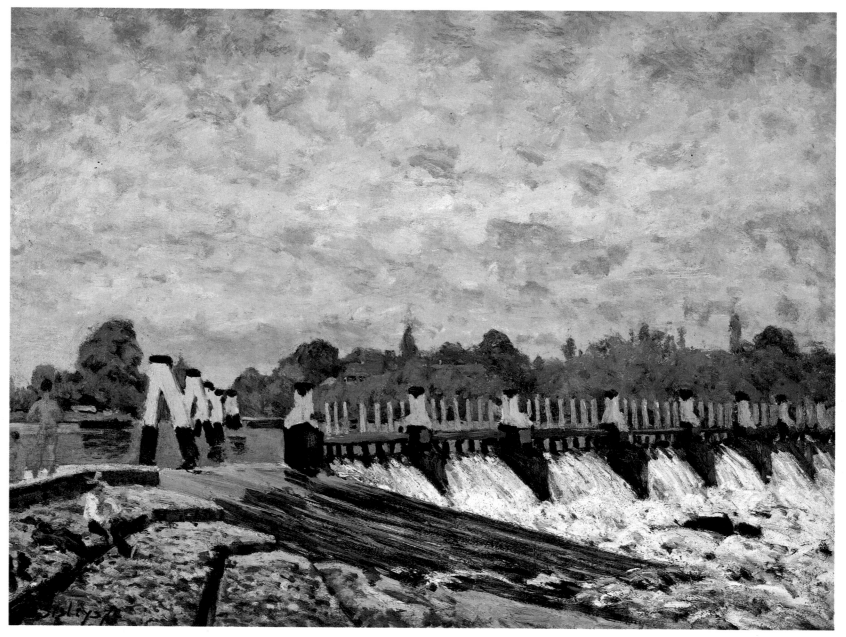

Sisley: THE WEIR AT MOLESEY,
1874.

One of the less well-known of Sisley's pictures painted on his visit to England in 1874, it is interesting both in its composition and varied brushwork. The stark contrast of the white water passing through the weir and that bypassing it is bold and exhilarating, as is the plunge into the background created by the receding posts. The sky, though contributing to the whole, seems also to be offered as a separate, rather abstract interest.

50 × 74 cm. National Galleries of Scotland, Edinburgh.

relies upon a system of diagonals. The internal rhythms are taut but elegant, like the incisions left in the ice by a skater. The paintings are also notable for the delicate tonal nuances of green, pink, violet, powder blue and cream. The landscape seems almost becalmed by its own beauty; only the sky and the water move.

The expressive quality of Sisley's work clearly owes much to his love of the countryside, equalled only by his love of music, inherited from his mother. As he himself once told a friend: 'A gay, singing phrase from a Beethoven scherzo captivated me. It called forth a response in me from the very beginning, and I sing it continually, humming to myself as I work.' His ability to record a landscape in meticulous detail encouraged Sisley to explore his surroundings in greater depth. Louveciennes itself presented a number of motifs – the main street, the wooded heights, the houses – that the artist began to treat frequently, sometimes shifting his viewpoint only slightly. As a result, Sisley's paintings from these years provide a fairly complete record of the village. The choice of such subject-matter was, of course, closely related to the desire to depict a motif at different times of day under varying conditions.

The logical conclusion of Sisley's approach was to paint in series, and this he did during the 1880s and 1890s, but it is notable that already by the mid-1870s groups of pictures are often devoted to a particular motif: a pathway in Louveciennes, the flooded banks of the Seine, or the building at Marly that housed the pumps installed at the time of the *ancien régime* to force the water up to the required level for the fountains at Versailles.

In 1874 Sisley left the Ile de France briefly for a short visit to England. He spent the summer there at the invitation of the baritone Jean-Baptiste Faure. Apart from the help given by the dealer Durand-Ruel and the critic Duret, it was thanks to patrons like Faure (who bought five of Sisley's English pictures) that the artist was able to afford the bare necessities such as canvas and oils. Sisley's stay in England was very productive. In his English pictures the artist introduced what was for him an unusual sense of movement – painting boat races and regattas on the Thames. The banks of the Thames at Hampton Court and Molesey evidently attracted him in the same way as the Seine, as evidenced by the group of paintings resulting from this special visit (page 92).

In that same year, Sisley exhibited five landscapes at the First Impressionist Exhibition. Like his colleagues, he had lost all faith in the possibility of achieving recognition through the Salon. But despite this identification with the Impressionist group, Sisley's art continued to develop in its own individual manner. Gradually, during the course of the 1870s, his style became bolder and looser. The brush was applied with greater vigour, and colour was no longer merely being dabbed on to the canvas but streaked across its surface with a more forceful wrist action. The surface of the paintings is more heavily worked, and areas such as the sky are rendered with a growing abandon. Sisley at this stage adopts a less reticent style; the colour contrasts are stronger and the overall effect more luminous.

Sisley: WILDFLOWERS, c.1875. Flower pieces by Sisley are as rare as still lifes. This one makes his reluctance to paint more of them difficult to understand.
65.5 × 50.5 cm. Virginia Museum of Fine Arts, Richmond. Gift of Mr. and Mrs. Paul Mellon.

Sisley in later life. Just before Sisley's
death Pissarro wrote: 'He is a great and
beautiful artist, in my opinion he is a
master equal to the greatest'.

The second half of the 1870s was a time when the Impressionists were testing their theories to the full. Some, like Renoir, felt that both the style and the movement had already reached the limits of their potential. Others, like Degas, argued that greater emphasis should be placed upon figure painting. Sisley, however, does not appear to have entered into these debates, and contented himself with continuing to explore landscape. In 1879 he decided to try once more to exhibit at the Salon, rather than at the Fourth Impressionist Exhibition. Motivated entirely by the need to make some money to relieve his dire financial circumstances, Sisley's submission to the Salon was a complete failure: his entry was rejected by the Salon jury.

In the following year Sisley moved away from the Ile de France, back to the Fontainebleau forest which he had frequented in the 1860s. He settled in the area near Moret-sur-Loing, and this region was to provide him with most of his motifs for the rest of his life. His work continued its evolution towards greater complexity of technique and intensity of colour. High tones of blue, green, red and yellow were applied with a fluid, varied brushstroke. But his dedication to capturing the ever-changing effects of light and colour in the open air remained absolute.

Like Monet and Renoir, Sisley last participated in an Impressionist group show in 1882, when he exhibited 27 paintings. He remained in favour of group exhibitions, but submitted to the growing trend for one-man shows. It might be said that Sisley never deserted Impressionism; the movement deserted him. One of the most famous critics of Impressionism, Lionello Venturi, wrote of Sisley: 'Monet, Renoir, Pissarro each made a personal contribution to the development of Impressionism, but Sisley was happy to accept it just as it was. He almost seems to have adopted Impressionism because his friends were Impressionists. But after absorbing the style, he penetrated the essence of things far more deeply than they did.'

Success continued to elude Sisley up to his death. He led a retiring life at Moret-sur-Loing, although some of his old colleagues, especially Monet, remained close friends. Sisley was not unaffected by new trends in painting in the 1880s and 1890s; traces of the influence of Neo-Impressionist theories and of Monet's innovative experiments can be found in his work. But chiefly he pursued his own unwavering commitment to landscape in the purest Impressionist tradition. From 1895, his ability to work was limited by an illness which was later diagnosed as cancer of the throat. It was of this that he died on 29 January 1899. Both Monet and Renoir were present at his funeral.

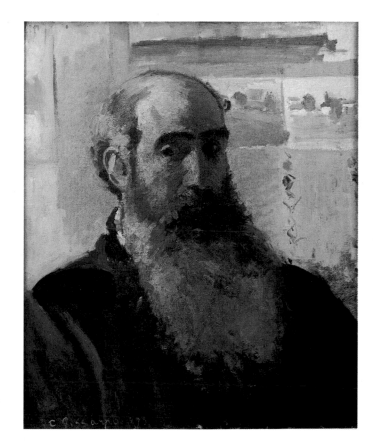

PISSARRO'S HONEST VISION

Pissarro: THE ARTIST'S
STUDIO, CARACAS, 1854.
An enjoyably unpretentious drawing of
the artist and his friend Fritz Melbye
working in their studio.
38 × 55 cm. Banco Central de
Venezuela, Caracas.

Camille Pissarro was born on 10 July 1830 at Charlotte Amalie, capital of the island of St. Thomas, in the Virgin Isles. St. Thomas was then a Danish colony at the heart of the sugar industry, and a major commercial and shipping centre. Pissarro's father Frédéric had come to the islands from Bordeaux in 1824, setting up in business with a shop in the main street of the town. Although his wife, Rachel, had been born on the islands, the Pissarros retained strong links with Europe, and regarded France as their spiritual home. When Camille was 11, he followed his brother Alfred in being sent to France to complete his education at a boarding school in Passy, a suburb of Paris. He was already showing an interest in drawing, and Auguste Savary, the school's founder and drawing master, ignored Camille's father's desire to see this trait eradicated.

Instead, he encouraged Pissarro, and gave him instruction in drawing. The pupil covered the pages of his books with sketches of West Indian scenes, trying to stem his homesickness by recording the banana plantations and coconut trees of his native island. Savary gave him examples of his own landscape paintings, regularly accepted at the Salons, to copy, and urged Pissarro to remember the importance of observation and direct perception of nature.

In 1847, after his son had spent five years in Passy, Frédéric Pissarro decided that the time had come for him to return home and enter the family business. Pissarro soon showed that Savary's parting advice – 'Mind you don't forget to draw coconut trees' – would not go unheeded. He became a familiar sight, sketching at the harbour, dreaming of escaping from what his brother called 'this damned hole, good at best to amass a fortune'. One day at the harbour he met a Danish artist, four years older than himself, Frederik Siegfried George Melbye, known as Fritz. Melbye had been exhibiting his work regularly in Copenhagen for some years, and was travelling in the West Indies, fascinated by the luxuriant vegetation and exoticism of the tropics. The journeyman painter immediately perceived talent in Pissarro's sketches, and encouraged him in his dream of becoming an artist.

Despite his family's opposition, Pissarro set sail for Venezuela with Melbye in 1852. They arrived in the port of La Guaira in November, and moved to Caracas the following month. Many years later, Pissarro recalled his momentous decision: 'I was in St. Thomas in '52 in a well-paid job, but I couldn't stick it. Without more ado I cut the whole thing, and bolted to Caracas to escape the bondage of bourgeois life. What I've been through you can't imagine, and what I'm suffering still is terrible ... nevertheless, it seems to me, if I had to begin over again, I should do precisely the same thing ...'

Melbye was already known in the small but flourishing artistic community of Caracas, whose members welcomed him and his young protégé. The two painters rented a spacious house near the main square, and Pissarro found many subjects for his notebook: the thronged market-place, the tavernas, the street-musicians and the ornate architecture of the town. Sometimes he would escape to the countryside, packing his materials and a few

provisions in a rucksack, and spending his days sketching the peasants and the vegetation.

In 1854, Pissarro decided to return to St. Thomas, spending about a year there dedicating himself to his drawing, and serving in the shop to help his father. He finally persuaded his parents that no amount of argument would sway him from his chosen course of becoming a painter. His departure for France was delayed while the family waited for his brother Alfred to return from Paris to assist with the business, but in mid-September 1855 Camille left St. Thomas for the last time, bound for Europe.

He returned to Paris in time to see the Universal Exhibition, a huge display intended to impress all visitors with France's achievements in the realms of industry, commerce and culture. Almost 5000 works of art were displayed in the Palace of Fine Arts on the Avenue Montaigne, and the arch-rivals Ingres and Delacroix were both well represented in retrospective exhibitions. Pissarro was bewildered by the array of work, but was especially struck by the paintings of Camille Corot.

His first teacher in France was Anton Melbye, brother of Fritz, and a reasonably successful painter of popular nautical scenes. However, it was not long before Pissarro began to frequent other studios, and through Melbye he met Corot, who received him warmly. Corot looked approvingly at Pissarro's work, but pointed out: 'We do not see in the same way', he said, 'you see green and I see grey and blonde.'

To instruct his followers, Corot would sometimes give them one of his drawings to copy. These were often drawings he had executed many years earlier. Pissarro was given an 1836 drawing, *Le Martinet near Montpellier*, which Corot considered to display those qualities of a firm grasp of form combined with close and careful observation of nature that he most esteemed. He urged the young man to begin painting in the country around Paris, but Pissarro found it difficult to adjust to his new home and wandered the streets, notebook in hand, absorbing the atmosphere of the city and observing the changes being made by the Emperor Napoleon and Baron Haussmann. He began to turn from drawing to work more frequently in oils, but his early paintings were memories of the tropics, such as *Coconut Palms by the Sea; St. Thomas, Antilles* (page 98). It was a while before he felt able to record his impressions of Paris.

At his father's insistence, Pissarro enrolled for a short time at the studios of three masters from the Ecole des Beaux-Arts – François Picot, Isadore Dagnan and Henri Lehmann – but he disliked their rigid and inflexible approach, and was happier working in the company of young fellow artists whom he met at the cafés, sometimes at the table presided over by Gustave Courbet at the Café Andler. Here noisy debates raged about Realism and the importance of painting out of doors. Pissarro was soon testing some of these theories, painting in the forests around the village of Montmorency, north of Paris, in 1858. He was sufficiently pleased with the results of his studies to submit a painting to the Salon of 1859. *Landscape at Montmorency* was accepted, but attracted little critical notice.

Corot working outside. Perhaps the best photograph of Pissarro's benign though exacting mentor, whose influence on the *plein air* painters of France was enormous.
Collection Sirot/Angel, Paris.

During these years, Pissarro's personal circumstances changed. Around 1857, his parents moved their home to France, and it was with them that he stayed at Montmorency. He was still lodging with his family (who also continued to pay him a monthly allowance) two years later when Julie Vellay, a vine-grower's daughter from Burgundy, entered the service of Madame Pissarro. She and Camille began a romantic liaison which was to result in two children born out of wedlock.

Pissarro regularly attended the Académie Suisse, a free drawing school, where he could paint or draw from the live model in an atmosphere very different from the constraint of the academic studios. He met Claude Monet there in 1859. As Monet later recalled: 'At this juncture I met Pissarro, who was not then thinking of posing as a revolutionary, but was quietly working in the style of Corot. This was an excellent model to have chosen and I followed his example . . .' Later, Pissarro met Paul Cézanne, and was the first to discern talent in the clumsy drawings of this touchy, sullen genius.

Pissarro's own paintings suffered mixed fortunes. In 1865 his three submissions to the Salon shared the fate of thousands of other works when they were rejected by the jury. They were exhibited at the extraordinary Salon des Refusés, where the critic Jules Castagnary noted that they showed the influence of Corot, and warned: 'The manner of Corot seems to please him – a good master, sir, but beware of imitating him too closely.'

The following year, the Salon jury was more liberal, and Pissarro's two entries were accepted. They were landscapes, one of La Roche-Guyon, a small town on the right bank of the Seine, halfway between Paris and Rouen, and the other of Varenne-Saint-Hilaire, on the river Marne southeast of Paris. Both these paintings were once thought to have been lost, but one of them may be *The Towpath* (page 221). During the summer, Pissarro was glad to accept the offer of his friend Ludovic Piette to come to his farm at Montfoucault in Brittany. Piette came from a long line of wealthy landowners, but painting was his passion, and he was always a loyal supporter and friend of Pissarro. Over the years his farm came to be a retreat for the artist, a place where he could reconsider his ideas about painting in tranquil surroundings, and find new subject-matter in scenes of rural life.

As Pissarro became more confident of his own abilities, his approach to landscape painting grew bolder, and Corot was not pleased to see a disciple slipping away from him. Abruptly, Pissarro stopped describing himself in Salon catalogues as a 'pupil of Corot'. His new, more vigorous approach – revealed in *The Banks of the Marne in Winter* – was praised at the Salon of 1866 by a new critic, Emile Zola, who wrote: 'An austere and serious kind of painting, an extreme concern for truth and accuracy, a rugged and strong will. You are a great blunderer, sir. You are an artist that I like.'

Pissarro found the subject-matter for his painting in the countryside around Paris. In 1866, he moved to Pontoise, 30 km from the capital, and easily accessible by train. He was delighted with the gentle landscape, finding many potential motifs along the banks of the

Pissarro: COCONUT PALMS BY THE SEA, ST. THOMAS, ANTILLES, 1856.
Painted in Paris, this picture is curiously subdued in colour and mood. It is signed Pizarro (Spanish spelling), a practice the artist continued for a short time after his return to France. 26.7 × 34.9 cm. Collection of Mr. and Mrs. Paul Mellon, Upperville, Virginia.

Pissarro: SEATED FIGURE, SEWING, 1852.
An early example of Pissarro's interest in peasant subjects. This figure was observed on the island of St. Thomas. 11 × 12 cm. Ashmolean Museum, Oxford.

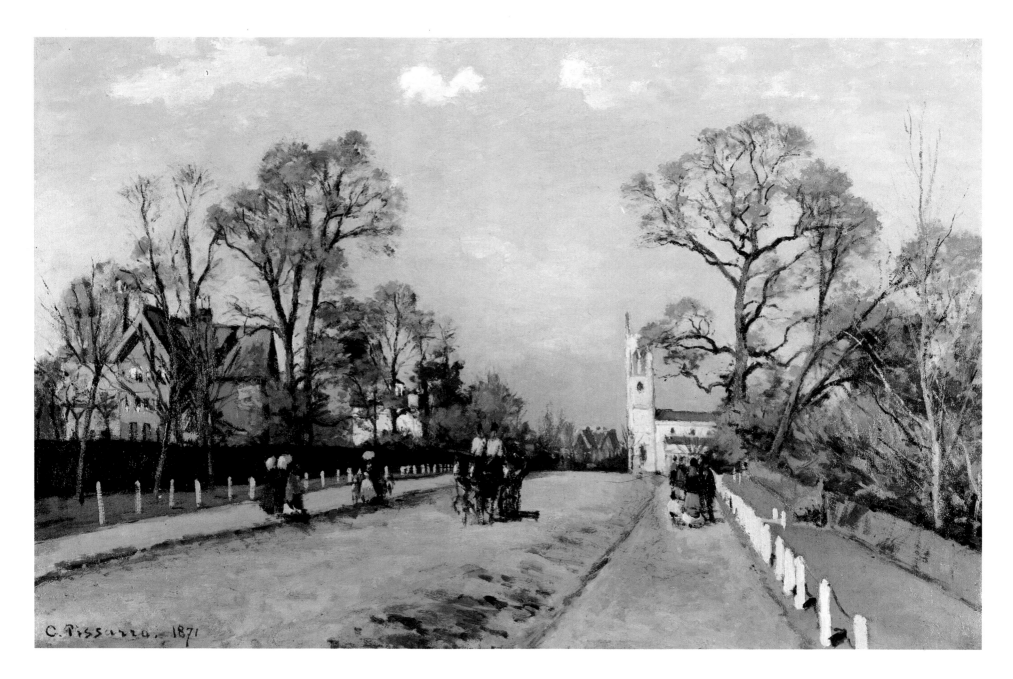

Pissarro: THE AVENUE,
SYDENHAM, 1871.
Pissarro enjoyed the English spring of
1871, while at Louveciennes near Paris
the Prussians ransacked his house,
destroying many paintings.
48 × 73 cm. National Gallery, London.

others to join him in the Pontoise region. Edouard Béliard, the Cuban painter Aguiar, and Armand Guillaumin were the first to accept his invitation. In September 1872 Cézanne joined them. Pissarro told Guillemet: 'Our friend Cézanne raises our expectations and I have seen, and have at home, a painting of remarkable vigour and power. If, as I hope, he stays some time at Auvers, where he is going to live, he will astonish a lot of artists who were in too great haste to condemn him.'

For almost 18 months, Pissarro and Cézanne worked together regularly and endlessly discussed theories about painting. The experience was important for both men. From Pissarro, Cézanne learned a new patience, and he emulated Pissarro's practice of working outdoors. Often he would simply watch Pissarro at work, and once a peasant passing by commented to Pissarro: 'Your workman does not overtax himself!'

Cézanne's palette changed during his stay at Pontoise, and he began to paint more slowly and carefully. Later he was to say it was only under Pissarro's influence that he developed a taste for work. Pissarro's patience and ability to recognise talent, however undeveloped, made him an excellent teacher: Mary Cassatt said once that he was such a teacher he could have taught stones to draw correctly. For his part, Pissarro recognised that Cézanne was less concerned with variations in light and colour than himself, and his own work responded to the stronger sense of structure in Cézanne's paintings.

Pissarro's confidence increased when, in January 1873, an auction sale at the Hôtel Drouot, part of the collection of Ernest Hoschedé, saw his work fetch high prices. He wrote to Duret: 'The effects of the Drouot sale have made themselves felt as far away as Pontoise. People are greatly surprised that a picture of mine should run up to 950 francs. They even say such a figure is amazing for a mere landscape.' But as the year went on, his optimism faded, and by October he wrote to Duret: 'I haven't a halfpenny to bless myself with.' He began to believe more strongly than ever that the only hope lay in the organisation of co-operative, juryless exhibitions. By the end of the year, his modifications of the constitution of a local bakers' co-operative had been accepted by his fellow artists, and an 'anonymous co-operative society, of variable size and capital, . . . formed by painters, sculptors, engravers and lithographers' came into being. Their first exhibition, which opened on 15 April 1874, came to be known as the First Impressionist Exhibition. Pissarro earned only 130 francs as a result of the exhibition, and wrote to Duret with bitter irony: 'Our exhibition goes well. It is a success. The critics destroy us and accuse us of not having studied; I am returning to my work, it is better than reading the reviews. One learns nothing from them.'

Pissarro was distressed by the failure of the exhibition not only because of his own financial predicament, but because of his deep-rooted belief in the need for a co-operative venture, regulated by mutual agreement and not subject to the decision of a jury. Following the dissolution of the co-operative society which had organised the first exhibition, he

Pissarro: THE LITTLE COUNTRY MAID, 1882. Degas may well have influenced the composition of this picture with its cut-off pictures, chairs, table and door, but it looks forward in colour and brushwork to the artist's Neo-Impressionist style. The child is very probably Pissarro's fourth son, Ludovic-Rodo. 63.5 × 53 cm. Tate Gallery, London.

became involved with another such venture, a society called *L'Union*. Cézanne, Béliard and Guillaumin were also members, but by the time an exhibition was arranged, in 1877, Pissarro had withdrawn from the group.

In 1876 the core of members who had arranged the first Impressionist show – Pissarro, Monet, Renoir, Degas, Morisot and Sisley – decided that a second exhibition was essential for them all. The exhibition was held at Durand-Ruel's gallery in the Rue Le Peletier, and Pissarro showed 12 paintings. Critical opinion was divided, with some of the critics, notably Albert Wolff, writing in *Le Figaro*, being violently opposed to the work on view, while others, such as Philippe Burty, were interested in the intentions of the new art and showed their understanding of it in their comments. One of the critics, G. d'Olby, writing in *Le Pays*, placed Pissarro with Monet as the only two exhibitors 'who could truly justify the title of Intransigents and renovators of art'. The term 'Intransigent' was as widely used at this time as 'Impressionist', and with its connotations of opposition to the establishment, is one with which Pissarro would have been very much in sympathy.

Much of Pissarro's time was spent in Paris in a desperate attempt to find buyers. The pastrycook Eugène Murer could sometimes be counted on to purchase a canvas, although he paid rock-bottom prices. A letter addressed to him in July 1876 indicates Pissarro's plight: 'I sent Petit [a dealer] a little panel for which I count on getting 50 francs. But they've asked me to call again, Monsieur Petit being out for the day. What am I to do? I long for this drop of water like a traveller in the desert. Could you not advance me this amount? They are anxiously waiting for it at Pontoise.' In November, Murer arranged a lottery with a painting by Pissarro as the prize, but the winner, a neighbourhood servant, asked Murer if she could have a cream bun in preference to the painting, an arrangement with which both parties were well satisfied. The painter and collector Gustave Caillebotte came to Pissarro's rescue when he bought three paintings. Caillebotte also took the initiative in organising a Third Impressionist Exhibition in 1877, and paid for the rental of the premises himself.

The paintings that Pissarro produced in the mid-1870s belie the crises that he was experiencing in the day-to-day battle to survive. *The Quarry, Pontoise* is one of several paintings executed with a palette knife, a return to the Courbet-like technique of the 1860s, prompted by Pissarro's wish to give a stronger sense of structure to his work. Cézanne also adopted the palette-knife technique at this time, in paintings like *The Etang des Soeurs at Osny* (page 249), showing that the collaboration between the two artists was still an active one. Pissarro sometimes combined brush and palette knife in such paintings as *The Harvest at Montfoucault*, a work revealing clarity of expression and confidence of handling, exhibited at the Third Impressionist Exhibition in 1877.

By the autumn of that year, Pissarro had begun to use smaller brushstrokes, and to elaborate the surface of the painting, as may be seen in *The Côte des Boeufs, Pontoise*, and *The*

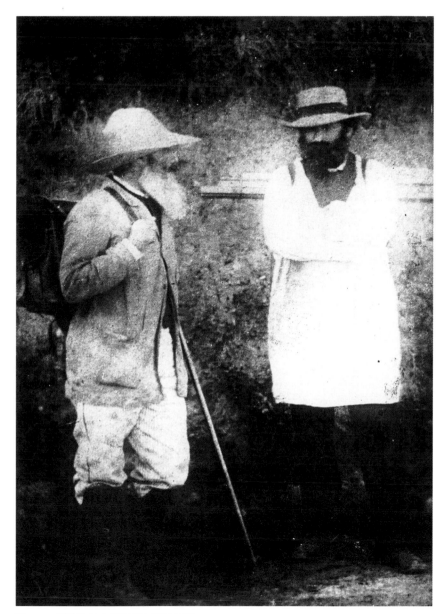

Pissarro: THE GARDEN OF LES MATHURINS, 1876.
This bright picture was probably inspired by one of Monet's paintings of his house at Argenteuil, though it also seems to contain the germ of Neo-Impressionism in its use of complementary colours.
113 × 165 cm. The Nelson Gallery and Atkins Museum, Kansas City.

Pissarro and Cézanne. Two painters who influenced one another decisively during the late 1870s. When he died Cézanne described Pissarro as 'humble and colossal'.
Roger-Viollet, Paris.

Pissarro: THE MARKET STALL,
1882. (Tempera and watercolour over
black chalk)
Although technically a drawing this
work is comparable to paintings of the
period. Tempera was cheaper to use
than oil and so such items were more
modestly priced to promote sales.
61 × 48 cm. Glasgow Museums and Art
Galleries.

Red Roofs. The dense, almost tapestry-like effect of these paintings is the result of careful working and reworking, often in the studio. Although Pissarro still valued *plein-air* painting, he had realised that it was not possible to produce larger, more elaborate paintings entirely in the open. Part of the reason for this decision to modify his technique was the need to sell: the artist hoped that dealers and collectors would find it easier to accept more highly worked paintings.

The 1877 exhibition was lauded by Georges Rivière in the journal *L'Impressionniste*, published to coincide with the show: 'What enchantment, what remarkable works, masterpieces even, are accumulated in the salons at the Rue Le Peletier.' Of Pissarro's landscapes, he wrote: 'Where can we find more grandeur, more truth and more poetry than in these beautiful landscapes . . .' Not all the critics agreed. 'Baron Grimm' wrote in *Le Figaro*: 'Seen in its entirety the exhibition of the Impressionists resembles a number of freshly painted canvases upon which has been spilled a stream of pistachio, vanilla or red-currant ice-cream.' In the months after the exhibition, all the Impressionists found themselves struggling. As Cézanne told Zola: 'It appears that profound desolation reigns in the Impressionist camp. Gold is not exactly flowing into their pockets and the pictures are rotting on the spot. We are living in very troubled times.' Durand-Ruel was not selling Impressionist paintings, concentrating instead on the work of the Barbizon school, and without his support, the Impressionists had to find buyers for themselves.

Pissarro's output dwindled as he spent fruitless days in Paris trying to sell paintings. The work he was producing did not please him. He confided to Murer: 'It is no longer bearable. Everything I do ends in failure . . . When will I get out of this mess and be able to give myself with tranquillity to my work?' But he still totally rejected the path chosen by Renoir in 1878 — return to the Salon. Pissarro's commitment to the independent exhibitions was unswerving, despite the personality differences which were beginning to surface within the Impressionist group, and which made the arrangement of the fourth exhibition in 1879 so difficult.

At this exhibition, held at 28 Avenue de l'Opéra, Pissarro showed a large body of work: 22 oils, four pastels and 12 fans. The fans and pastels were included for the first time in the hope of attracting buyers, but seemingly nothing could please some of the critics. The ever-hostile Albert Wolff made reference to the size of Pissarro's contribution: 'The fecundity of these painters tells you that they are easily contented . . . Before lunch Pissarro knocks off his dozen paintings; he shows 40.'

At the following year's exhibition, Pissarro showed fewer works, only ten paintings, a fan and several etchings. Etching was a new enthusiasm, and the examples on view were intended to form part of a publication, *Le Jour et La Nuit*, in which Pissarro was collaborating with Degas and Cassatt. This fifth exhibition revealed the rifts among the ranks of the original group: Monet, Renoir, and Sisley had all chosen to submit work to

the Salon. The organisation of the sixth and seventh exhibitions, held in 1881 and 1882, proved to be even more difficult, but Pissarro held firm to his belief in the value of the shows, despite all the problems they created. In 1882, Durand-Ruel took over the organisation of the exhibition. As Pissarro wrote to Monet: 'For Durand as well as for us the exhibition is a necessity. Personally I should be disconsolate not to satisfy him. We owe him so much that we can't refuse him this satisfaction . . .' The exhibition finally included the work of all the major Impressionists with the exception of Degas.

Pissarro's own contribution of 25 oils, a distemper and ten gouaches indicated a change in subject-matter: only nine of the works were landscapes. The remainder showed peasants at work or at rest. Several were of a large single figure, such as *The Shepherdess* (page 234).

Pissarro was becoming increasingly interested in colour theory and in developing the use of colour in his paintings. He had already begun to oppose areas of complementary colours in his works of the late 1870s. Now, he refined his practice by introducing colours from one area into the complementary area, so that an overall harmony was retained. To permit this, while retaining the effect of contrast that he sought, he made his brushstrokes smaller and finer. In 1888 he said that there were two main principles in Impressionism: not to mix pigments, and to study the complementaries. These had become the abiding principles of his art by the early 1880s. In order to increase the effect of harmony, he began to use white frames instead of the conventional gilt frames whenever possible, and by the time of the 1881 Impressionist Exhibition, it was his practice to frame graphic work, lithographs or etchings in frames complementary to the dominant tone of the work. He also became increasingly concerned about the decorative schemes of the rooms in which his work was hung: at the 1882 exhibition his work hung in a room with lilac walls, bordered with canary yellow.

By 1884 the Pissarro family had moved from the Pontoise area to Eragny-sur-Epte, near Gisors. Gisors was on the main railway link between Rouen and Paris, so Pissarro could still get to Paris in two hours, while for the rest of the family the large house and garden were a delight. A visitor described the garden as a 'kind of Garden of Eden, full of mystery, which invited one to run wild, or throw oneself down in the midst of wild grasses.' After renting the house for eight years, Julie Pissarro requested Monet for a loan so that the property could be purchased, a decision Pissarro greatly regretted. He also referred to the house in English as 'Eragny Castle', and came increasingly to regard it as a millstone round his neck.

In 1885, through Armand Guillaumin, Pissarro met Paul Signac, who was the same age as his eldest son Lucien. Five years earlier, Signac, as a visitor to the Fifth Impressionist Exhibition, had been forcibly ejected by Paul Gauguin when he attempted to sketch one of Degas' works on view. Now he was painting landscapes in pure colours, using an Impressionist brushstroke. In the autumn Signac introduced Pissarro to Georges Seurat,

Pissarro: MADAME PISSARRO SEWING NEAR A WINDOW, 1878–79.
One of several paintings of Madame Pissarro by her husband. She was born a simple country girl and rather unjustly earned a reputation for henpecking Pissarro, but considering the privations her family had to endure her complaints were probably not excessive.
54 × 45 cm. The Ashmolean Museum, Oxford.

Cézanne seems more of a Southerner in this photograph than in any other. Here he is Zola's hot-blooded friend – a poet as well as a painter.

Paul Cézanne was born in 1839 – the same year as Sisley, a year before Monet and two years before Renoir and Bazille. By generation and by affiliation he counts as an Impressionist painter. Much of his work from the early 1870s to the early 1880s shows characteristics associated with the 'orthodox' Impressionism of the time (particularly as practised by Pissarro) – for example, the replacement of gradual modelling and tonal shading by a surface of distinct coloured touches. But it is as a 'Post-Impressionist' that Cézanne has been marked out in modern art criticism and art history. In 1922, when the critic Clive Bell published his collected essays on modern art, he titled the book *After Cézanne*. 'Cézanne,' he wrote, 'is the full stop between Impressionism and the contemporary movement.' And he described that movement as one 'in every turn and twist of which the influence of Cézanne is traceable'. Yet this idiosyncratic artist who contributed so much to modernism was, especially in his earlier years, characterised by a baroque romanticism that seemed to have more relation to the art of the past than was apparent in the paintings of Monet, Sisley or Pissarro.

The first 22 years of Cézanne's life were spent in and around Aix-en-Provence in the south of France. His parents were married five years after his birth. At that time his father, Louis-Auguste Cézanne, owned the hat factory in which Paul's mother was employed, but in 1847 he took over an ailing bank, transforming it with his partner into a new and successful enterprise. This enabled him, 11 years later, to purchase a substantial property outside Aix, the Jas de Bouffan, where many of his son's landscapes were subsequently to be painted. It is easy to read the practical self-sufficiency of the self-made man into Paul's early portraits of his father. Paul stood in awe of him, and was in return always treated as an incompetent – even when the artist was middle-aged, his father used to open his post. By contrast, he was emotionally dependent on his mother, and this seems to have developed into an insecurity with others (he found it notoriously difficult to get on with people), but also a morbid fear of being touched and a distinct unease when confronted with nudity.

The idea of a life dedicated to the arts was clearly not one he acquired from his parents. It seems rather to have grown during his years at school, where he was a good pupil – winning prizes in maths, Latin and Greek – though far from a brilliant one. It was there that he met Emile Zola and Baptiste Baille, and the three formed a close friendship which lasted through their teenage years and beyond. Zola's father had left Paris to build a water supply for the town of Aix, but died soon after, leaving mother and son in some hardship. By living poorly, she managed to pay for her son's education at the Collège Bourbon. None of the three students was happy with their education – Cézanne once wrote of Aix: 'A habitual and regular calm envelops our dull city.' But Zola already had intimations of future greatness when he said that he and Cézanne were 'attracted to each other by secret affinities, the as yet vague torment of a common brutal mob of dreadful dunces who beat us'.

Zola's departure for Paris in 1858 instigated a regular correspondence, and it is through

what survives of the letters between the future novelist and Cézanne that we can best capture the flavour of the young men's interests and ambitions. By the end of 1858, Cézanne was enrolled as a student of law at Aix University, a course he was, as he said, 'forced to choose' – no doubt by his father. Zola represented an alternative world of values: one in which the arts reigned supreme. He also represented the distant possibility of escape into an actual – if still largely imaginary – Bohemian world. The correspondence is full of the normal self-dramatisations of youth regarding love, poetry and drink, but it is also clear that Zola and Cézanne confirmed in one another a conviction of distinctness.

Zola wrote from Paris in February 1860: 'I see myself surrounded by such unimportant and prosaic beings that it makes me happy to know you, who are not of our century, who would invent love if it were not such an old invention . . . I somehow glory in the fact that I understand you and esteem you according to your value.' And, two months later, in response to a letter in which Cézanne, who still thought himself a writer, not a painter, had written of 'Painting, which I love, although I don't succeed', Zola challenged him: 'You! Not succeeding? I believe that you deceive yourself . . . There are two men inside the artist, the poet and the craftsman. One is born a poet, one becomes a craftsman. And you, who have the spark, who possess what cannot be acquired, you complain when, to succeed, you have to train your fingers in order to become a craftsman.'

This notion of a poetic genius distinct from craftsmanship was one which Zola and Cézanne shared. A Romantic idea, it was also a means of asserting a youthful modernism against the rigours of academic training. Since the age of 17, Cézanne had been attending classes in the municipal school of drawing at Aix under Honoré Gibert, who was also curator of the local museum. Here he was rehearsed in strict, traditional techniques of draughtsmanship from plaster casts and the occasional posed male nude. Between the values of this training, however, and the two friends' cherished aim of sincere and original self-expression, there was a wide gulf.

The strength of their friendship no doubt helped each to preserve his idealism more or less intact. In face of the evidence of Cézanne's early struggles with painting – clumsy and derivative as they clearly were – Zola's confidence in his friend's gift is surprising and strangely touching. Re-reading a poem in one of Cézanne's earlier letters, he wrote in August 1860: 'You are more poetically talented than I . . . A poet has many means to express himself – pen, brush, chisel, musical instrument. You have chosen the brush, and you have done right, because everyone must follow his bent . . . But allow me to mourn the writer who dies in you . . . Instead of the great poet who is walking out on me, give me at least a great painter, otherwise I would be angry with you.'

Meanwhile, Cézanne stayed on in Aix, decorating room panels in the Jas de Bouffan with portraits of the *Four Seasons* (page 112), yet frustrated by his lack of progress with painting, clearly inattentive to his studies in law, yet unable to oppose his father outright

Cézanne: LIFE DRAWING, 1862. The artist's early drawings at art school in Aix obeyed the rules. Cézanne is acknowledged as a great draughtsman today, though his drawings were not well known during his lifetime. 61 × 47 cm. Musée Granet, Aix-en-Provence.

Cézanne: THE FOUR SEASONS,
1859–62.
These four panels were painted to
decorate a room at the Jas de Bouffan.
Cézanne signed them all 'Ingres' and
dated Winter '1811' perhaps in self-
mocking irony as well as youthful
defiance.
Each 314 × 97 cm. Petit Palais, Paris.

and pursue what he saw as his vocation in Paris. Zola was emphatic: 'You are being forced to do work which repels you. You want to ask your father to let you go to Paris in order to become an artist. I do not see any contradiction between this demand and your actions. You neglect the law, you go to the museum, painting is the only work which you accept; there is, I think, an admirable unity between your wishes and your actions.'

Louis-Auguste Cézanne finally relented in the spring of 1861. A joyful Zola announced his friend's arrival in Paris in a letter to Baille. The visit was not, however, to live up to expectations. Following Zola's encouragement and advice, Cézanne enrolled at the Académie Suisse, where Pissarro was among those attending at the same time. The academic regime at Aix had been based on the belief that certain ways of drawing were correct, and that these could be taught and learned. Within this regime, Cézanne was a not unsuccessful student. In Paris, however, the thin, tall, darkly handsome 22-year-old was faced with the very different circumstance of attempting to learn where no single method or model was imposed. Dreamed of for so long, the capital had perhaps come to stand for the realisation of his ambitions, as if he had only to reach the city to be a true painter.

In reality, of course, he carried his frustrations with him. After only six weeks, he wrote home to a friend: 'I thought that when I left Aix I should leave behind the ennui that pursues me. I have only changed place, and the ennui has followed me. I have left my parents, my friends, some of my habits, that's all.' He seems to have tried Zola's patience. 'He is made of one single piece,' the latter wrote to Baille, 'obstinate and hard in the hand. Nothing can bend him, nothing can wring a concession from him.' Cézanne visited the museums and the Salon, worked at his drawing and painting, and in moments of discouragement spoke of returning home. In the autumn he did so, and for the next year worked as a clerk in his father's bank, though continuing to attend drawing classes in Aix. In November 1862, however, he was back in Paris, this time for a stay of some 20 months.

It was during this second visit that Cézanne began to find his place among the other artists of his generation. Through attendance at the Académie Suisse from six to eleven every morning, he came to know Guillaumin, Pissarro and Monet, and through them he met Bazille, Renoir and Sisley. The immediate goal of Cézanne's studies was to gain admittance to the Ecole des Beaux-Arts, but he failed the entrance examination – the examiners noted that he painted 'riotously'. He was alone among the future Impressionists in being admitted neither to the Ecole nor to any of the private studios run by Academicians such as Gleyre. Not only was he thus largely cut off from practical instruction, he was also barred from the normal channels of professional advancement. An allowance from his father provided more financial independence than many of his contemporaries enjoyed, but it could not secure him recognition as a painter. His heavy, expressive drawings were largely ridiculed at the Académie Suisse, and his paintings were consistently rejected by the Salon juries during the years from 1863 to 1869 when he made

Cézanne: THE NEGRO SCIPIO, 1866.
Scipio was a model at the Académie Suisse in Paris, and Cézanne seems to have made of him a figure of weariness and suffering. Indeed, it has much in common with another picture, *Suffering* or *The Magdalen* of the same year. 107 × 83 cm. Museu de Arte, São Paulo.

Cézanne: HAMLET AND
HORATIO (after Delacroix),
1870–73.
The artist always revered Delacroix, and
much of his early work bears witness to
this. Delacroix made many lithographic
illustrations to Hamlet and Cézanne has
here produced a dramatically coloured
summary of their spirit.
22 × 19 cm. Sydney Rothberg
Collection, Philadelphia.

submissions. His personality also seems to have provoked hostility or distrust – his uncouth manners, his violent obsession with his work and his dark moods of self-doubt.

Cézanne's work of these years up to 1870 stands apart from the early works of the more typical Impressionists. The surfaces of his paintings are, for the most part, heavily worked, often with a palette knife; his figurative elements tend to the dramatic; and his compositions are marked out with strong tonal contrasts. These are characteristics which evoke the work of Delacroix (whose 1864 exhibition impressed him), Courbet and Daumier, and, more generally, a tradition of subject paintings with emotive themes. Although Cézanne was to become one of the greatest landscape painters in the history of art, he was distinguished from most of the other future Impressionists in the 1860s by his lack of interest in landscape.

Of all forms of painting, landscape was the one in which a degree of individuality and experiment was most easily accepted in the mid-19th century. The imaginative and mythological themes in Cézanne's paintings of the late 1860s – such as the erotic *Orgy* and *Temptation of Saint Anthony*, or the macabre *Autopsy* – were more likely to be viewed with critical attention and to be assessed for their technical skill. Paintings on such themes were expected to be 'well made' in a traditional sense – an expectation that Cézanne's works did not fulfil. An important precedent for a modern kind of subject painting was provided by Manet, whose work was the focus of attention at the Salon des Refusés in 1863, when Cézanne was also among those represented. But Manet was at least well versed in technique, even if he chose to break some traditional rules. The most frequently voiced criticism of his work was that it was unfinished. Cézanne, on the other hand, producing paintings in what he referred to as his *couillard* (butch) manner – direct expressions of a deep inner suffering and turmoil spilled out on to the canvas – was destined to be seen by the great majority as a merely incompetent painter.

What survives of Cézanne's work from the 1860s is likely to be only a small fraction of his actual output, and one which is far from representative of his ambitions at the time. In a letter to a mutual Provençal friend, Zola described Cézanne's work during a stay at Bennecourt, near Nantes, in the summer of 1866: 'He develops more and more in the original direction which his nature prescribes for him. I have great hopes for him . . . at the moment he is engaged in painting works, great works, on canvases four to five metres wide.' Though works of this size were produced by artists hoping to gain attention in the Salon, none of Cézanne's surviving paintings of this period is larger than 150 cm wide, and the great majority are considerably smaller.

Cézanne never wholly abandoned the ambition to produce large-scale subject paintings. Around the end of the 1860s, however, he seems to have been obliged – as was Monet around the same time – to accept that modern painting was to be pursued for the time being in the smaller dimensions associated with still life, landscape and, possibly,

portraiture. By then his Romanticism had been tempered by his exposure to the Realist notions associated with Courbet and to the developments in landscape painting which followed upon the work of Corot and of the Barbizon school. From 1866, his acquaintance with Pissarro grew into close friendship. The older painter was the only one of his circle not to view Cézanne as eccentric and frustrated, and it was in his company that Cézanne was to develop that more detailed, fluid and considered technique which was to bring him into closer alignment with his progressive contemporaries. Yet he was still more often in the company of other aspiring Provençal artists than of those who were to make up the main body of the Impressionists. Monet, Renoir, Sisley and Bazille were accustomed to paint in each other's company in and around Paris; Cézanne remained relatively isolated from them, not only in temperament, but also by virtue of his tendency, during the years between 1864 and 1870, to spend at least as much time in Aix as in Paris.

In 1869, he met and formed a relationship with a young model, 11 years younger than himself. She was his first mistress and she was to remain with him for the rest of his life. Her name was Marie-Hortense Fiquet, and she can be seen in many portraits painted by Cézanne. The relationship was not without its difficulties, however, since Paul was financially dependent on his father and afraid to tell him about the affair – with the result that the couple had to survive on a single man's allowance. During 1870–71, for the duration of the Franco-Prussian War and the Commune, they lived in L'Estaque, near Marseille on the Mediterranean (Paul's father had enabled him to avoid the army by paying for a substitute to take his son's place). There Cézanne painted several landscapes in his distinctive style, conveying the essence of a scene while eliminating much of its detail.

The spring of 1872 found the family (Hortense had just given birth to a son) settled at Pontoise, where Pissarro also lived. The two men often painted in each other's company – Cézanne absorbing some of the lessons of *plein-air* painting. The following year, they left Pontoise for Auvers, a few miles up the river Oise. The move brought Cézanne into contact with Dr. Paul-Ferdinand Gachet, an eccentric collector and amateur painter, and one of the first purchasers of the young artist's work. The studio and etching equipment in Gachet's house enabled Cézanne to try this print technique, as well as painting a large number of still lifes of flowers and scenes around the house. It was with the landscapes he painted at Auvers during this period up to 1875 that Cézanne first showed he had come of age as an artist.

Cézanne learned much from Pissarro, who seems to have respected his work for its actual expressive qualities and not simply for its future potential. It was only at Pissarro's insistence that Cézanne was invited to contribute to the independent exhibition of 1874, now known as the First Impressionist Exhibition. Other members of the group resisted his participation – Degas especially – fearing that the public would be too outraged by his odd canvases. Finally their objections were overcome, and Cézanne submitted three paintings

Cézanne: DR. GACHET, c.1873. (Charcoal)
The doctor who loved the Impressionists and who once owned *Hamlet and Horatio* (opposite). He is perhaps most famous for his vain attempts to help van Gogh in 1890.
32 × 22 cm. Musée du Louvre, Cabinet des Dessins.

Cézanne: PORTRAIT OF
VICTOR CHOCQUET,
c.1879–82.
This portrait of the artist's admirable
patron shows, when compared to
Renoir's (page65), the enormous artistic
gulf between the two friends. It is an
amazingly radical work for its time.
46 × 38 cm. Gallery of Fine Arts,
Columbus, Ohio.

1874: 'Once the impression is captured they declare their role terminated . . . They are Impressionists in the sense that they render not a landscape but the sensation produced by a landscape.' Three years later the notion of painting as the recording of sensation had clearly been accepted into the vocabulary of sympathetic criticism. What was now at stake was the *strength* of this sensation. Rivière claimed a superior integrity for Cézanne in these terms: 'In all his paintings, the artist produces emotion, because he himself experiences before nature a violent emotion which his craftsmanship transmits to the canvas.' Thus the edgy energy of the 'poet' which Zola had noted and supported in his friend was coming to be esteemed by perceptive avant-garde critics as the powerful sensation animating an impression of nature.

Rivière's was still an isolated voice in 1877, however. Cézanne was not even approaching financial independence through his work. Both the nature of his relationship with Hortense Fiquet and the existence of his son were still kept secret from his father. With no increase in his parental allowance, he relied upon the generosity of Zola to support his family. He was heavily in debt. In March 1877 he signed an IOU to the colour-merchant Julien Tanguy, from whom he acquired his painting materials. The sum mentioned was over 2000 francs and seven years later it had still not been paid. (For comparison: between 1878 and 1884 the average monthly wage of a shop-clerk was 100 francs.) Tanguy was often willing to accept paintings in lieu of payment, and already by the mid-1870s his shop had become the principal repository of Cézanne's work. It was with a purchase from Tanguy that Cézanne's most important early patron had made the first of many acquisitions. Victor Chocquet, a customs officer, had formed a collection of works by Delacroix and had become an admirer of Renoir. The latter took him to Tanguy's and introduced him to Cézanne's work. He was to become a loyal and generous supporter. Cézanne included a portrait of Chocquet among his contributions to the 1877 exhibition.

The Third Impressionist Exhibition was the last to which Cézanne contributed. He remained on terms of close friendship with Pissarro and for periods during the early 1880s he painted in company with Renoir, nursing him through a bout of pneumonia when he fell ill at L'Estaque in 1882. Generally speaking he was loyal to the idea of the Impressionist 'cause', but he was also persistent in seeking admission to the Salon. He continued to submit annually, although he was to have no work accepted until 1882, when, by designating himself as 'pupil of Guillemet' (a friend who had secured a place on the jury), he had one painting admitted without official scrutiny.

He sought few other opportunities to exhibit. Although, at 200 francs per month (raised to 300 in 1878), the allowance from his father was by no means large enough comfortably to support a bourgeois household and an artistic practice, it removed from Cézanne the absolute necessity to sell his work – and thus the necessity to have it shown. He seems always to have been more concerned to prove himself as an artist than to achieve

a market for his work. He was an increasingly rare visitor to the café society of the contemporary Parisian art world, and when he did appear seems to have impressed more by his Provençal accent and casual dress than by the substance of his conversation. 'If this can interest you,' Edmond Duranty wrote to Zola in 1878, 'Cézanne has appeared recently at the little cafe on the Place Pigalle [this was the Café de la Nouvelle Athènes, which had largely come to replace the Café Guerbois as a meeting place for Manet, Degas and others]; he was attired in one of his costumes of olden times: blue overall, jacket of white linen completely covered with smudges from his brushes, etc., a battered old hat. He had a certain success. But those are dangerous demonstrations.' Dangerous perhaps in the sense that such behaviour served to confirm a conventional prejudice against the 'intransigents'; also, perhaps, because it might serve to suggest connections between artistic radicalism and political anarchy. This connection is made more explicit in the reminiscences of George Moore, another frequenter of the Café de la Nouvelle Athènes, for whom Cézanne was no more than a legendary figure. 'We used to hear about him – he used to be met on the outskirts of Paris wandering about the hillsides in jack boots. As no one took the least interest in his pictures, he left them in the fields . . . His work may be described as the anarchy of painting, as art in delirium.'

Cézanne's works of the late 1870s and the 1880s fall into three main groups: landscapes, mostly of Provençal subjects, still lifes and compositions of bathers. For the relatively small number of single figure studies he produced during these years, Cézanne rarely looked further than the immediate circle of himself, Hortense and his son Paul. Except in so far as the theme of bathers retains some sense of its classical antecedents, there is now little evidence of Cézanne's earlier preoccupation with mythological subjects. There are even fewer signs of an interest in the imagery of 'modern life'. Indeed, one reason for Cézanne's comparative isolation in Provence during much of this period may have been that it allowed him to concentrate on the technical problems of modern painting without having to conceive these in terms of changing urban or suburban environment. In the summer of 1876 he wrote enthusiastically to Pissarro from L'Estaque: '. . . there are motifs which would need three or four months' work, which would be possible, as the vegetation doesn't change here. The olive and pine trees always keep their leaves.' Certainly he seems to have become increasingly definite about the kinds of motifs he could most fruitfully work with, and these included neither the forms of urban social imagery treated by Manet, Degas and subsequently Lautrec, nor the peasant themes which were now preoccupying Pissarro.

Landscape is the central theme of Cézanne's work during this period. Both what he had learned from Pissarro in the early 1870s and his sense of identification with the other Impressionists encouraged him to rethink his ideas about what a modern painting should or could be like. In Pissarro's company he had learned to build the surface of the painting out of a series of studied touches, each determined by some tonal variation in the motif. This

Cézanne: PAUL CÉZANNE, 1883–85.
One of the artist's several portraits of his son of whom he was particularly fond. Paul posed for the remarkable Harlequin pictures of c.1888 and towards the end of his father's life he acted as his agent and adviser on practical matters.
35 × 35 cm. Musée de l'Orangerie, Paris. Walter Guillaume Bequest.

Cézanne: MADAME CÉZANNE, 1885.
Hortense Cézanne sat for more than 25 portraits by her husband over as many years. They are an essential and oddly moving guide to his development – impersonal and yet redolent of a unique individual presence.
43 × 38 cm. Philadelphia Museum of Art.

illumination and variegated settings of these paintings, but the combinations of figures and figure-groupings point rather to the continuation of his earlier interest in imaginative subjects. In his preoccupation with nudes in an outdoor setting, Cézanne recapitulates and renews one of the central themes of the Humanist tradition. Relatively modest in scale for the most part, these paintings were to lead up to the major achievements of Cézanne's last years, and also to furnish a measure of achievement and ambition for subsequent artists.

The year 1886 marked the end of a period in Cézanne's life. In April of that year he wrote his last letter to Emile Zola. The writer had sent him a copy of his latest novel, *L'Oeuvre*. The central figure, Claude Lantier, is a painter, portrayed as an unfulfilled genius whose frustrations lead to madness and suicide. Zola had drawn heavily on his reminiscences of Cézanne. Publicly successful himself, he seems to have had no other means to represent to himself his friend's apparent failure than attribute it to lack of ability. What he offered was not so much a judgement on Cézanne's career as a betrayal of the shared – if Romantic – commitments of their youth. Cézanne wrote with a tone of regret and finality: 'I thank the author . . . for this kind token of remembrance and ask him to allow me to press his hand in memory of old times.' He signed himself: 'Ever yours under the impulse of years gone by.' There is no evidence of any contact between the two men after this date. Later in the same month Cézanne finally married Hortense Fiquet. His father's blessing on the union came just in time, for the old banker died in the autumn. At the age of 47 Cézanne was at last left in control of his own fortune, the owner and occupier of the Jas de Bouffan, the substantial house and estate near Aix where he had found many of his most successful motifs over the past 20 years, and where he was even now addressing long familiar scenes in paintings of increasing richness and complexity.

After his father's death, Cézanne became more isolated as an artist than ever. But he pushed steadily forward towards the goal of consolidation and simplification that only he could see. Among a very few there was a growing interest in what he was doing. After the dealer Vollard showed a hundred of his paintings in 1895 he became a figure of great importance to the whole young avant-garde and went on to paint masterpieces like his Grandes Baigneuses *and landscapes of and near Mont Sainte-Victoire in which he surely achieved a great part of his ambitions, though the anxiety that had driven him persisted to the end. Cézanne died in 1906, not suprisingly after catching a chill while working outside. Given his painstaking methods and constant hesitations his 800 paintings and 400 watercolours are a monument not only to an extraordinary vision but also to an heroic industry.*

135 MAJOR WORKS

MOUTH OF THE SEINE AT HONFLEUR, 1865

124

THE CAPE OF LA HÈVE AT LOW TIDE, 1865

Monet 125

THE BODMER OAK AT BAS-BRÉAU, FONTAINEBLEAU FOREST, 1865

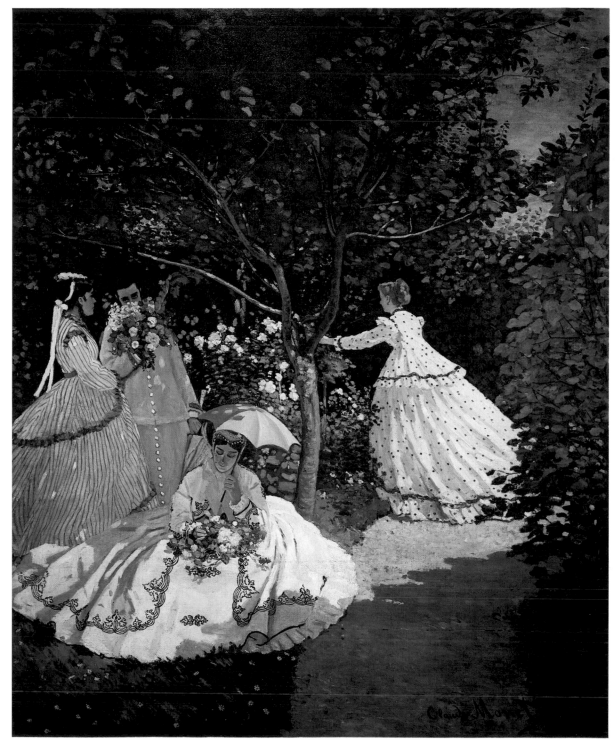

WOMEN IN THE GARDEN, 1866

Monet 127

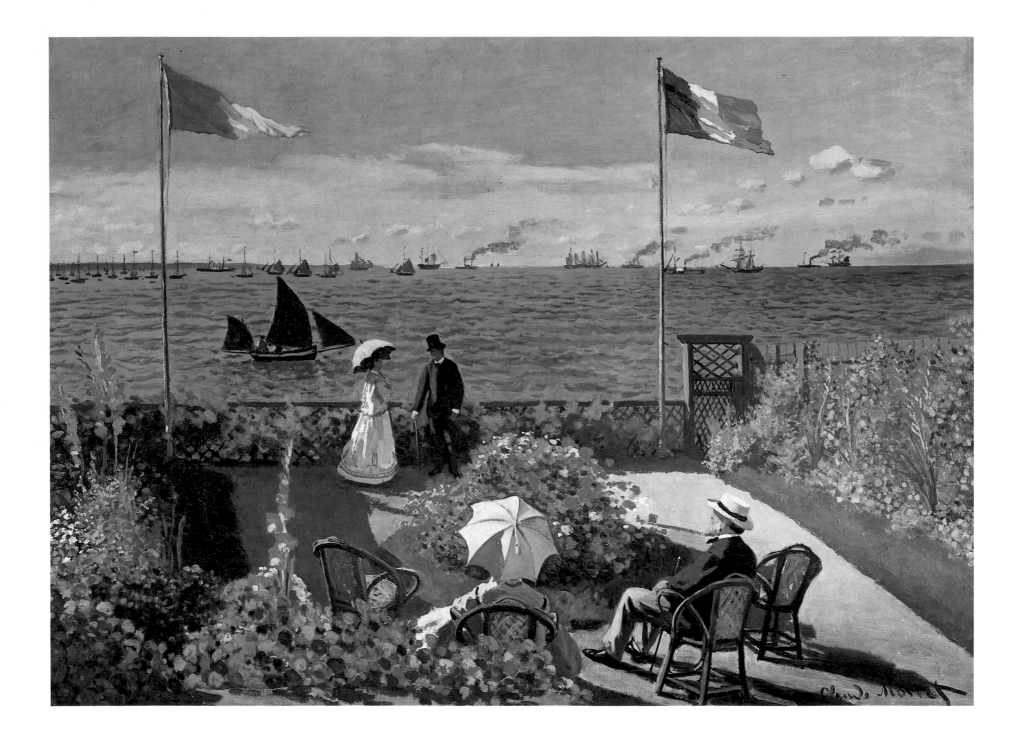

TERRACE AT SAINTE-ADRESSE, 1867

JEANNE-MARGUERITE LECADRE IN THE GARDEN, 1866

Monet 129

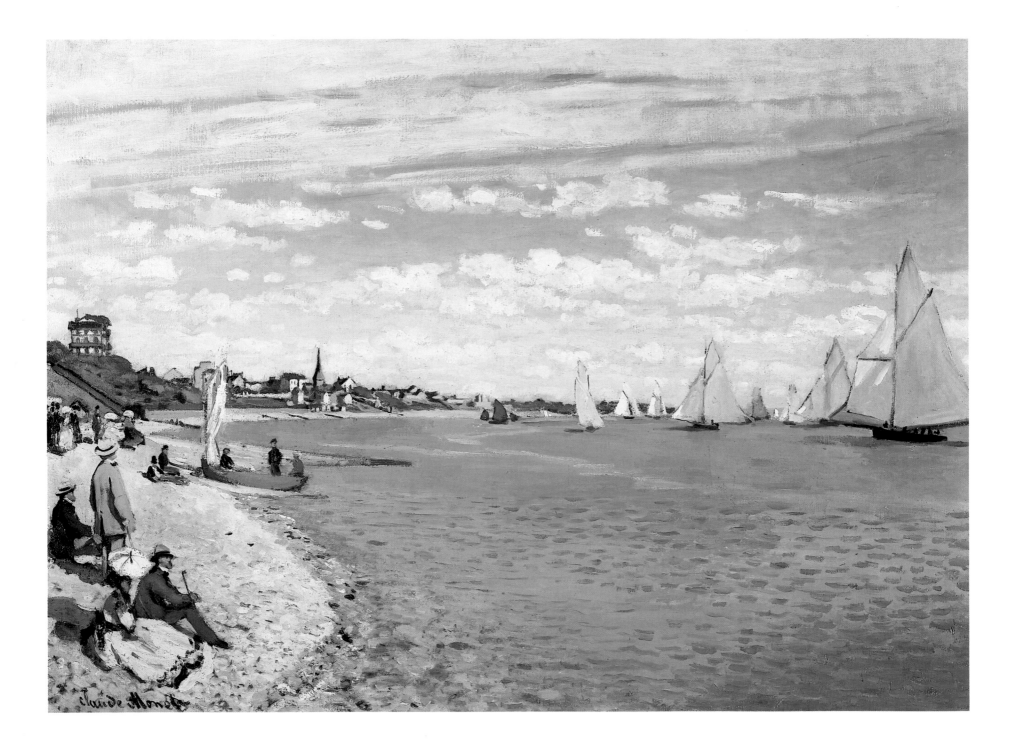

THE BEACH AT SAINTE-ADRESSE, 1867

THE MAGPIE, 1869

Monet 131

BATHERS AT LA GRENOUILLÈRE, 1869

THE BEACH AT TROUVILLE, 1870

Monet 133

MARINE VIEW – SUNSET, 1874

LA PROMENADE (WOMAN WITH A PARASOL – MADAME MONET AND HER SON), 1875

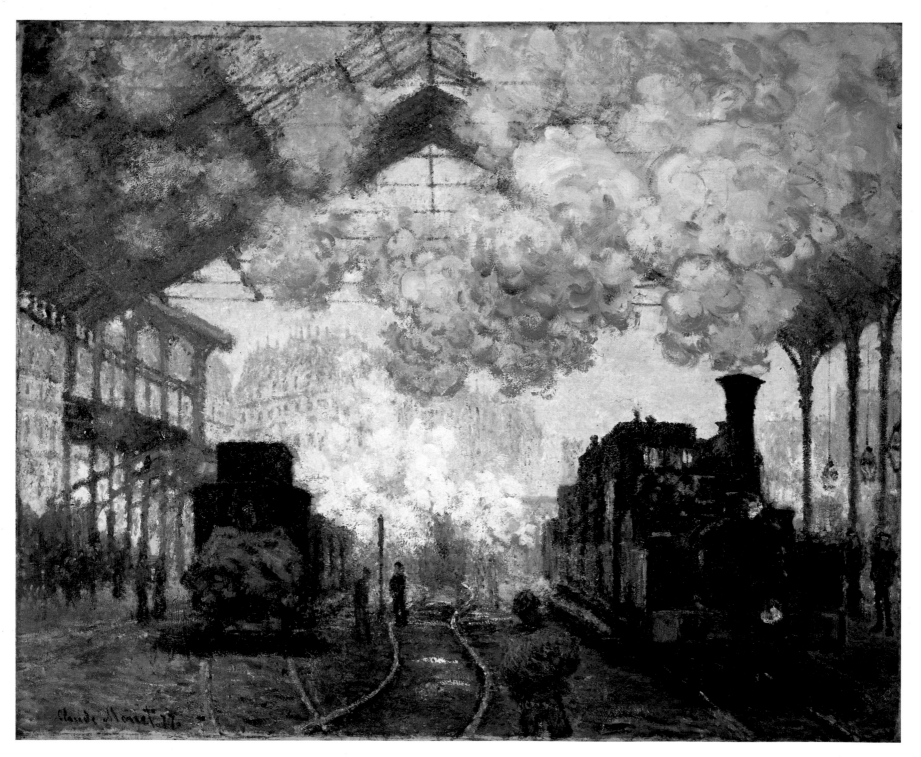

GARE ST. LAZARE, PARIS, 1877

136

PONT DE L'EUROPE (GARE ST. LAZARE), 1877

Monet 137

LANDSCAPE WITH ORCHARD AND FIGURES, 1879

THE ARTIST'S GARDEN AT VÉTHEUIL, 1881

APPLES AND GRAPES, 1879

SUNFLOWERS, 1880

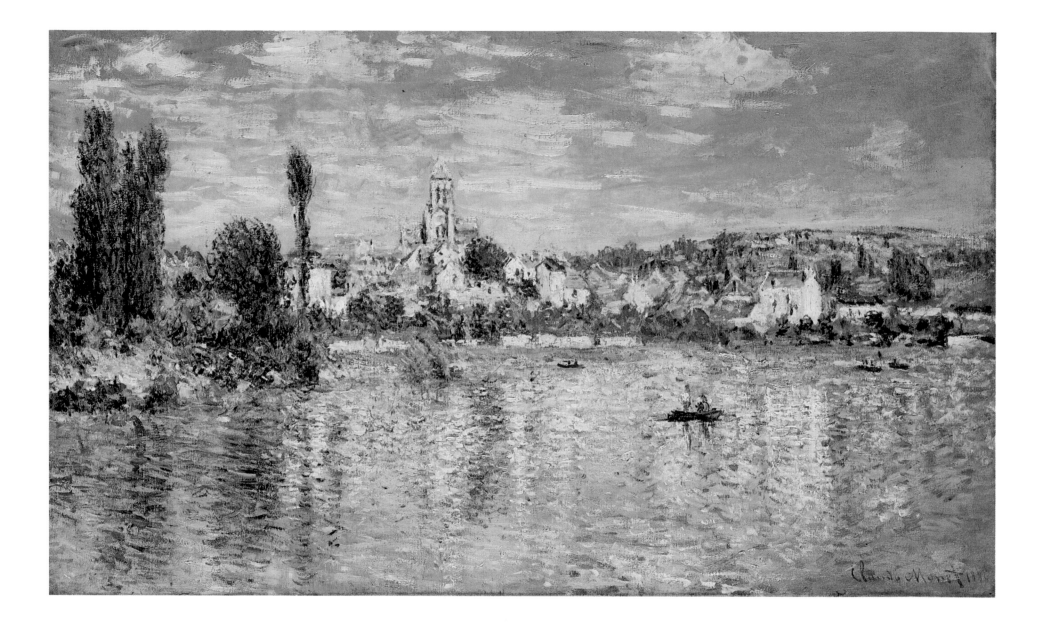

VÉTHEUIL IN SUMMER, 1880

142

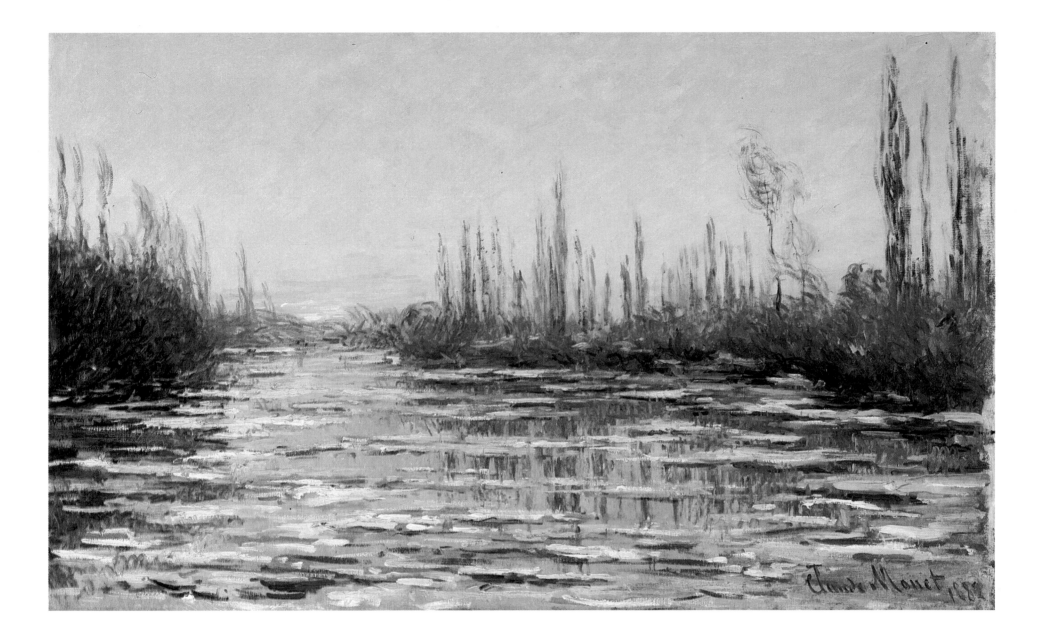

FLOATING ICE ON THE SEINE, 1880

Monet 143

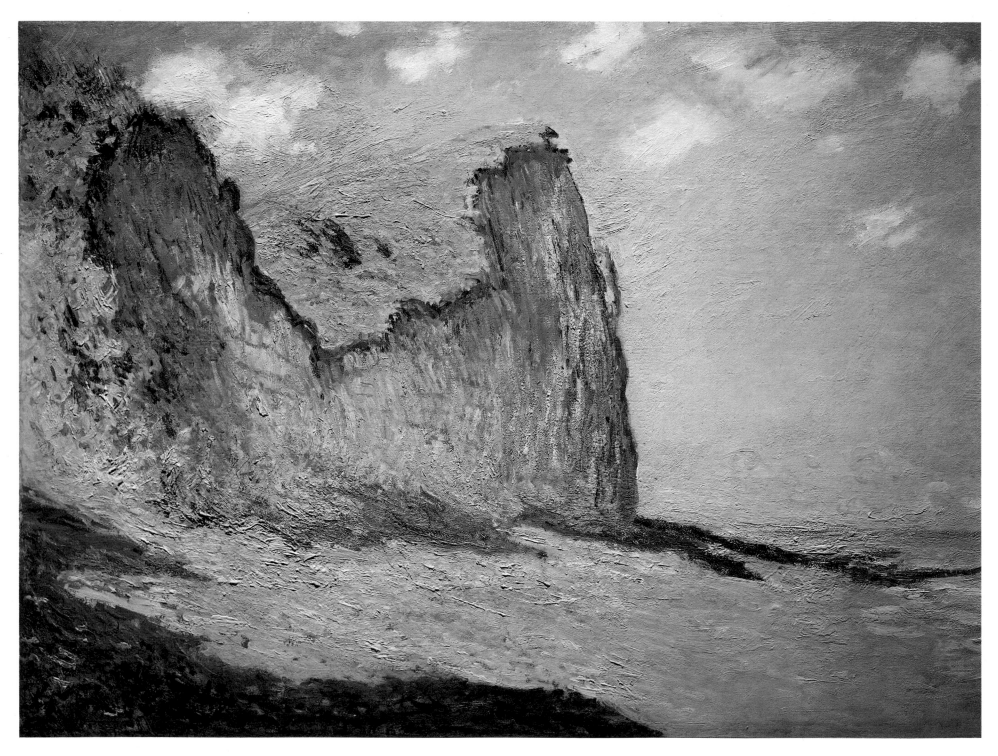

CLIFFS NEAR POURVILLE, 1882

144

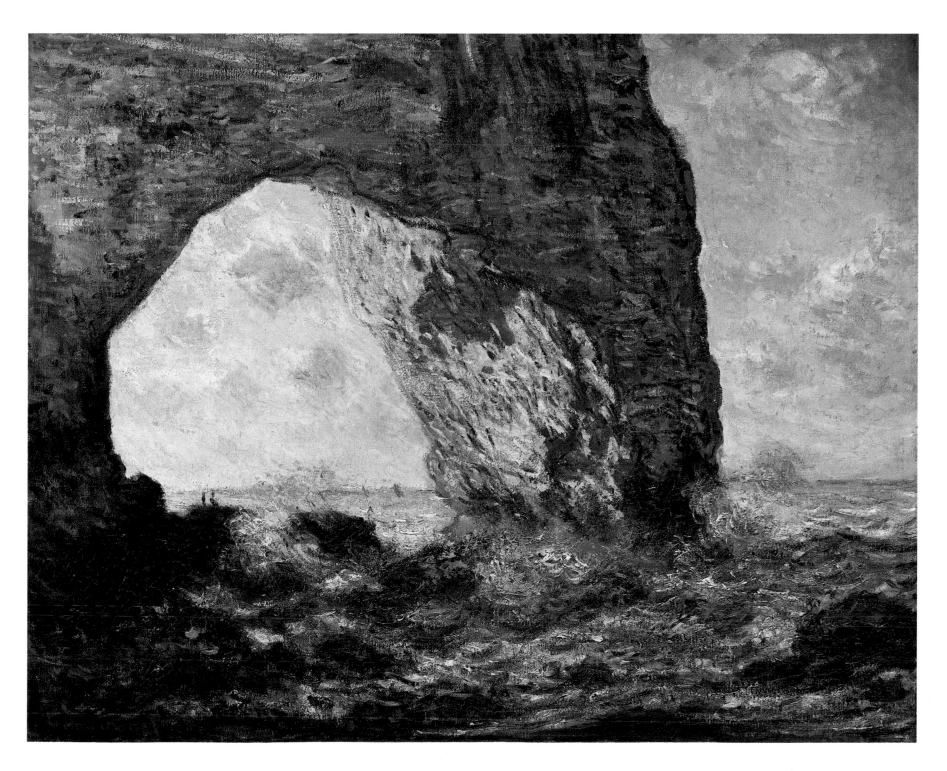

THE MANNEPORTE, ETRETAT, 1883

Monet 145

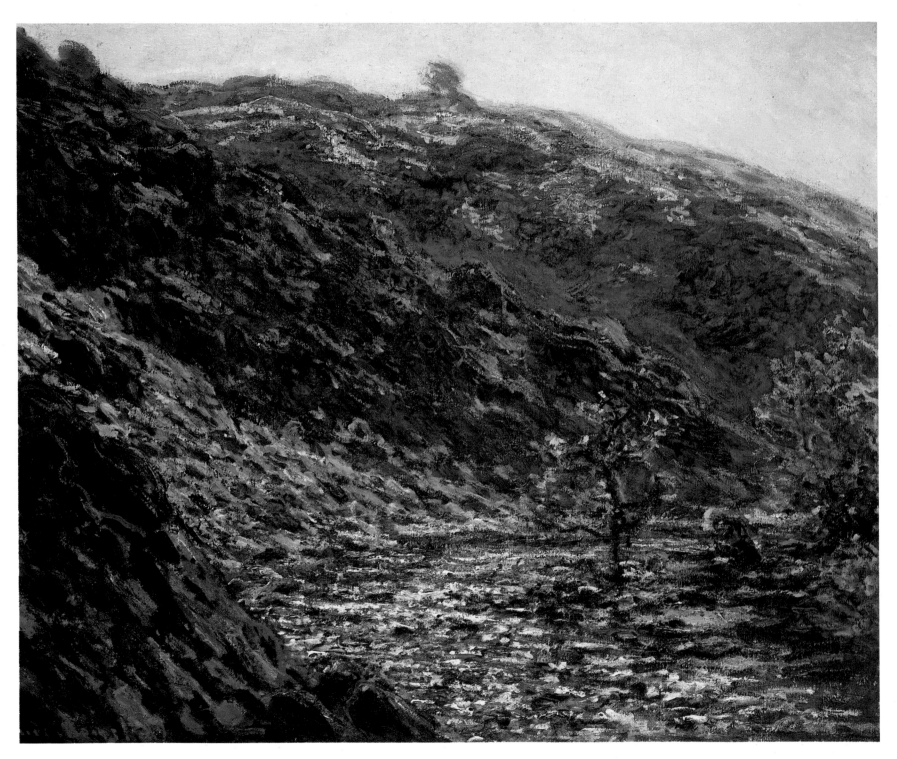

RAVINE OF THE CREUSE, 1889

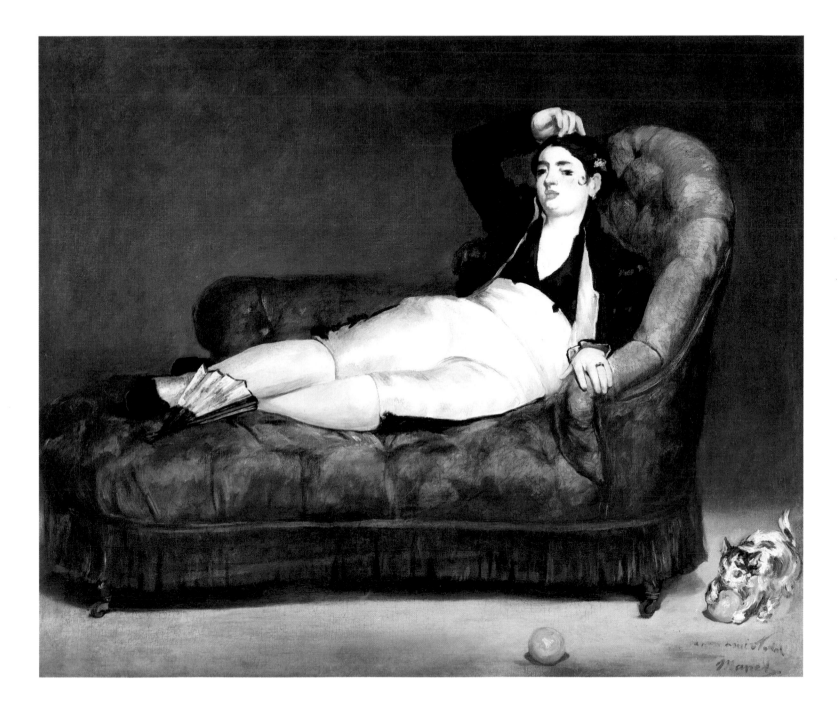

YOUNG WOMAN RECLINING, IN SPANISH COSTUME, 1862

Manet 147

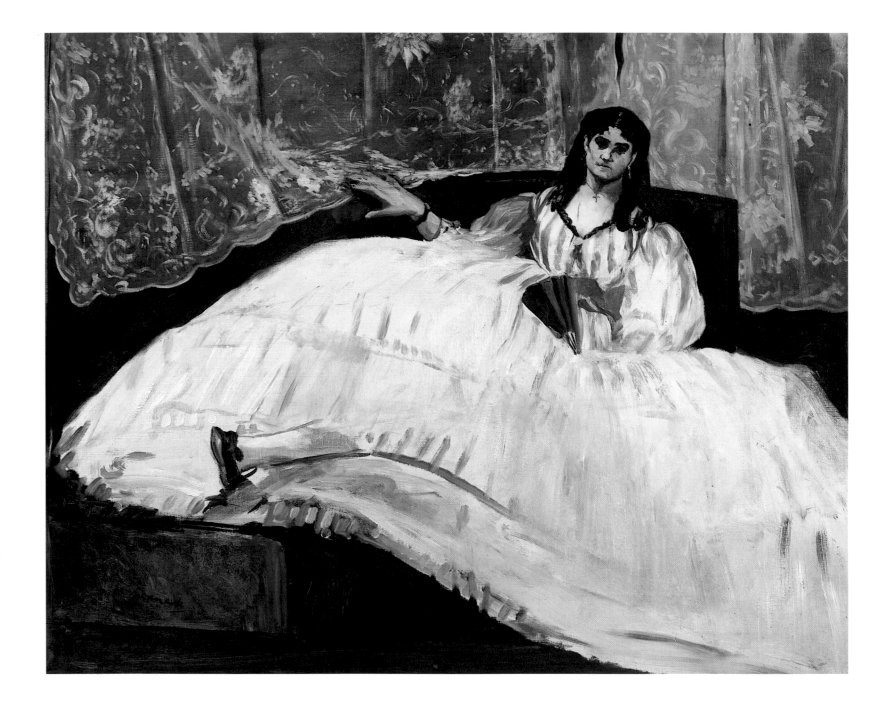

PORTRAIT OF JEANNE DUVAL, 1862

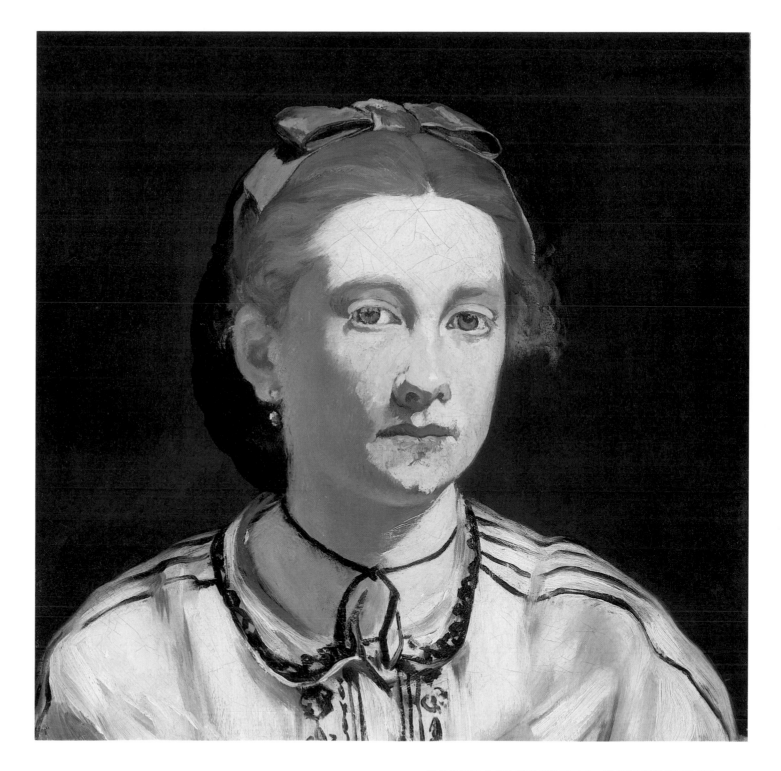

PORTRAIT OF VICTORINE MEURENT, 1862

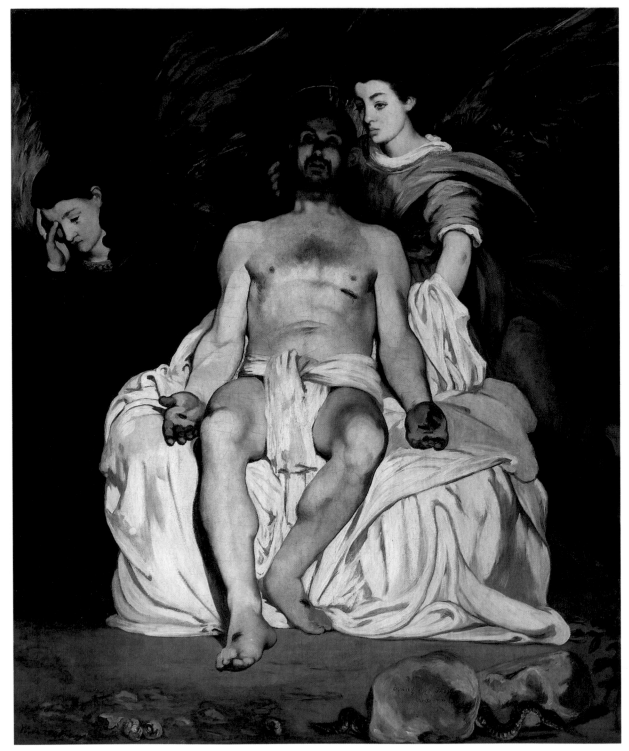

THE DEAD CHRIST WITH ANGELS, 1864

BATTLE OF THE KEARSARGE AND THE ALABAMA, 1864

THE BURIAL, 1867–70 BOULOGNE HARBOUR BY MOONLIGHT, c.1869

Manet 155

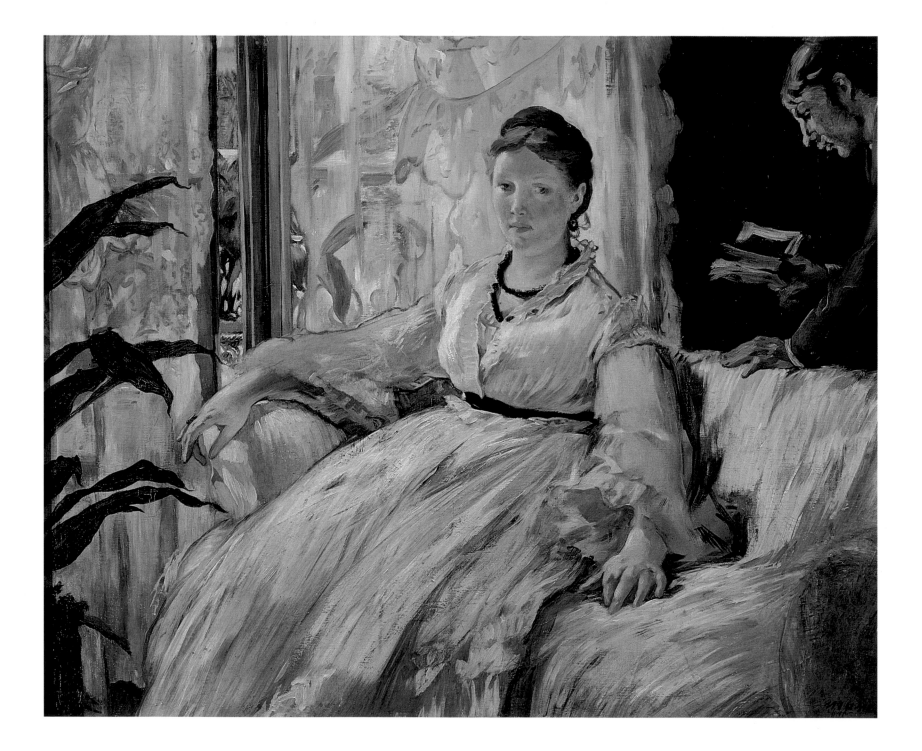

READING, 1865–73

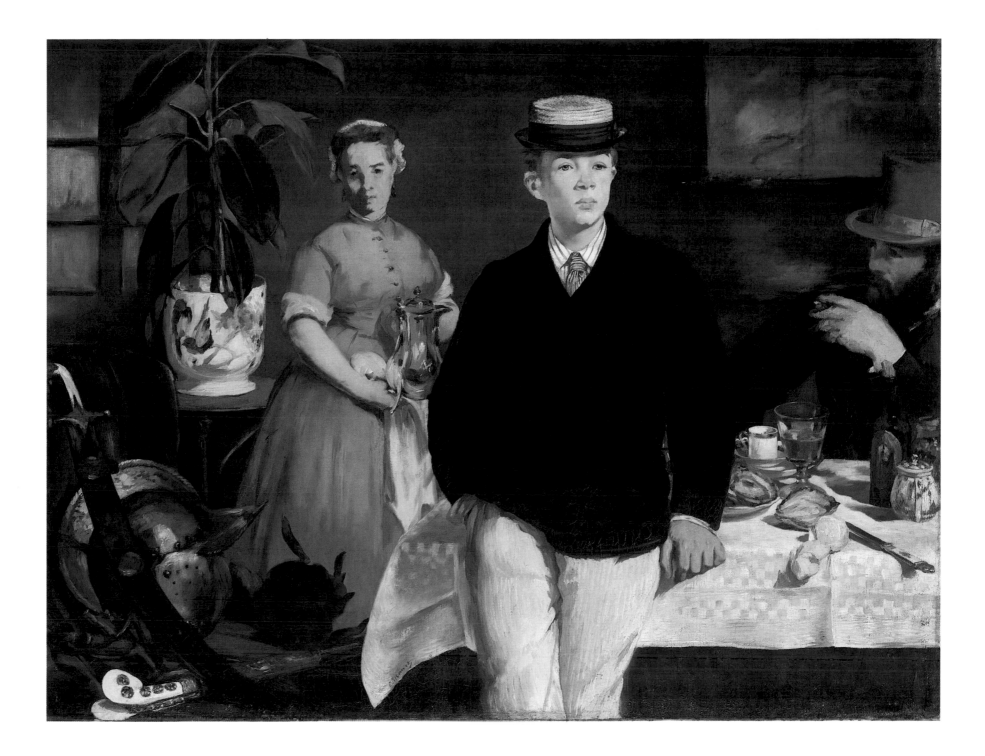

LUNCHEON IN THE STUDIO, 1868

Manet 157

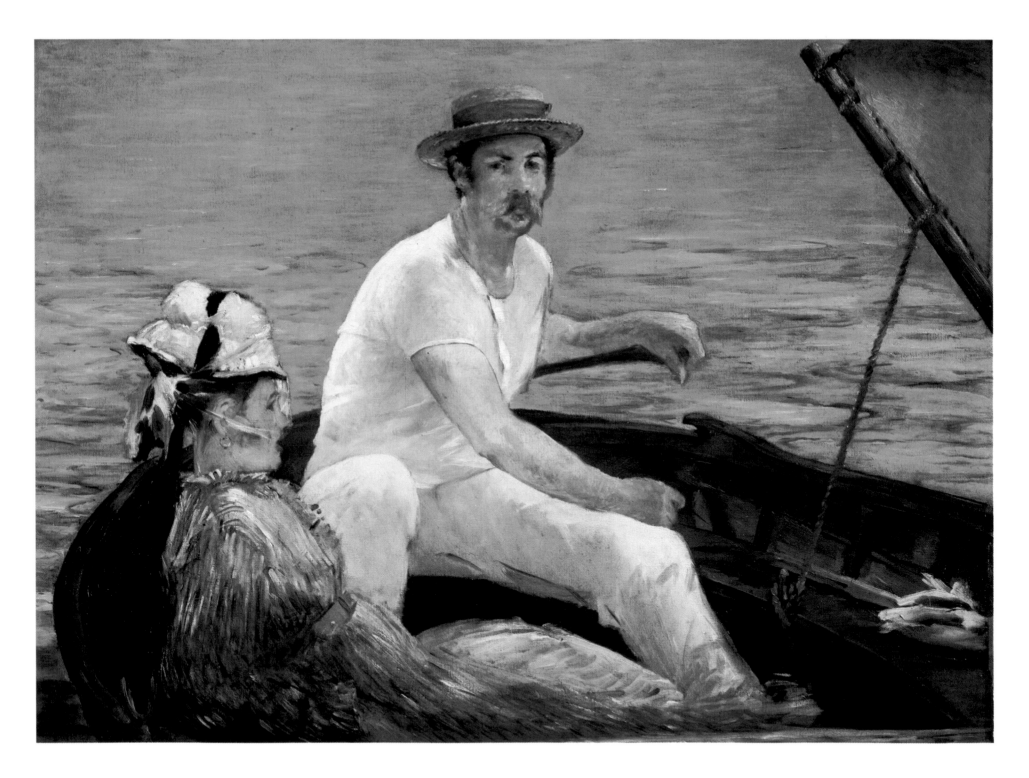

BOATING, 1874

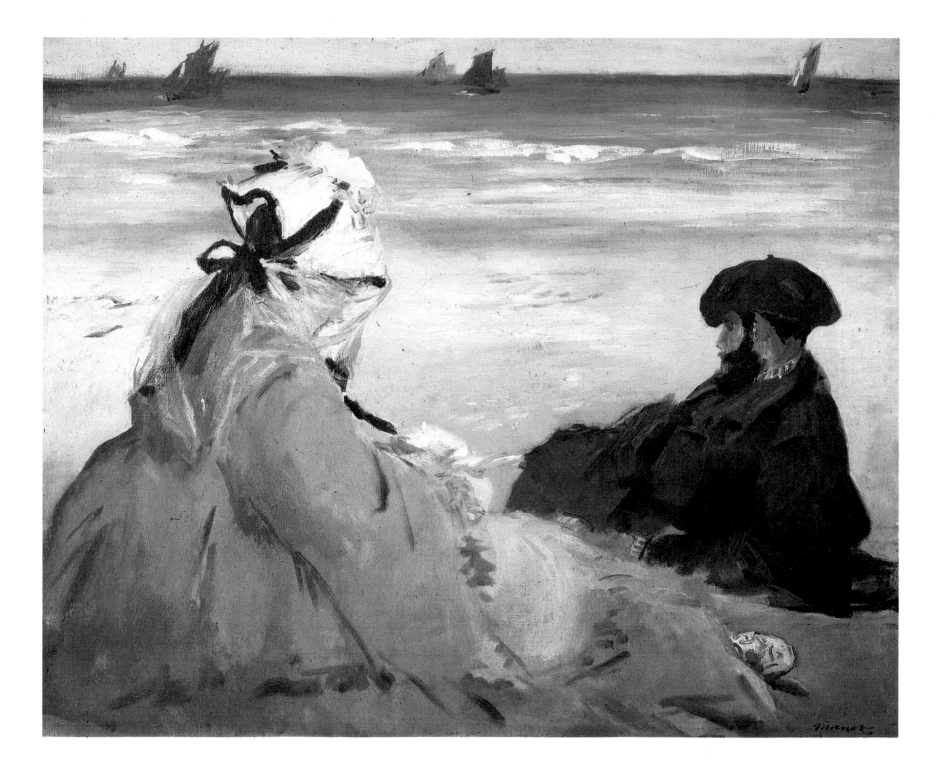

ON THE BEACH, 1873

Manet 159

MASKED BALL AT THE OPERA, 1873

LADY WITH FANS (PORTRAIT OF NINA DE CALLIAS), 1873–74

Manet　161

MADAME MANET ON A BLUE COUCH, 1874

PORTRAIT OF BERTHE MORISOT WITH HAT, IN MOURNING, 1874

YOUNG WOMAN AMONG FLOWERS, c.1876

PORTRAIT OF STÉPHANE MALLARMÉ, 1876

Manet 165

GIRL SERVING BEER, 1879

THE ARTIST, 1875

THE WAITRESS, 1878 or 1879

THE LEMON, 1880–81

PORTRAIT OF MADEMOISELLE ROMAINE LECAUX, 1864

STILL LIFE, 1864

STILL LIFE, ARUM AND FLOWERS, 1864

SPRING BOUQUET, 1866

BATHER WITH A GRIFFON, 1870

STILL LIFE WITH A BOUQUET, 1871

PORTRAIT OF RAPHA, 1871

A ROAD IN LOUVECIENNES, c.1872

THE GUST OF WIND, c.1872

Renoir 177

ON THE SEINE, 1880

178

THE SEINE AT CHATOU, c.1881

Renoir 179

JUGGLERS AT THE CIRQUE FERNANDO (TWO LITTLE CIRCUS GIRLS), 1879

YOUNG WOMAN READING AN ILLUSTRATED JOURNAL, 1880–81

PLACE CLICHY, c.1880

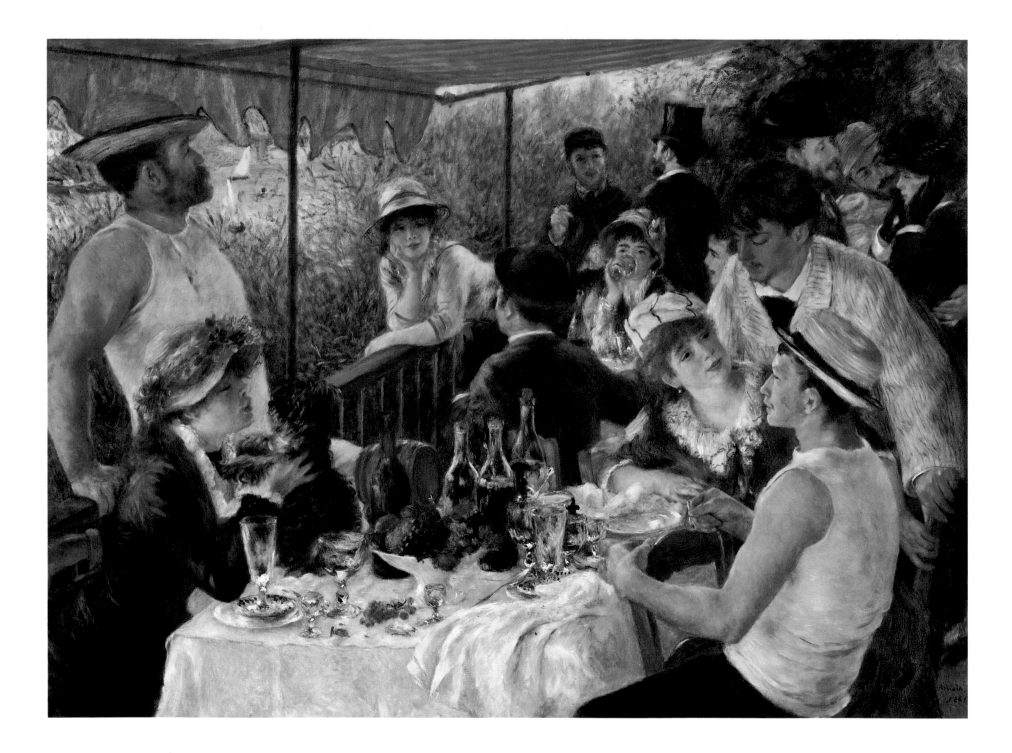

LUNCHEON OF THE BOATING PARTY, 1880–81

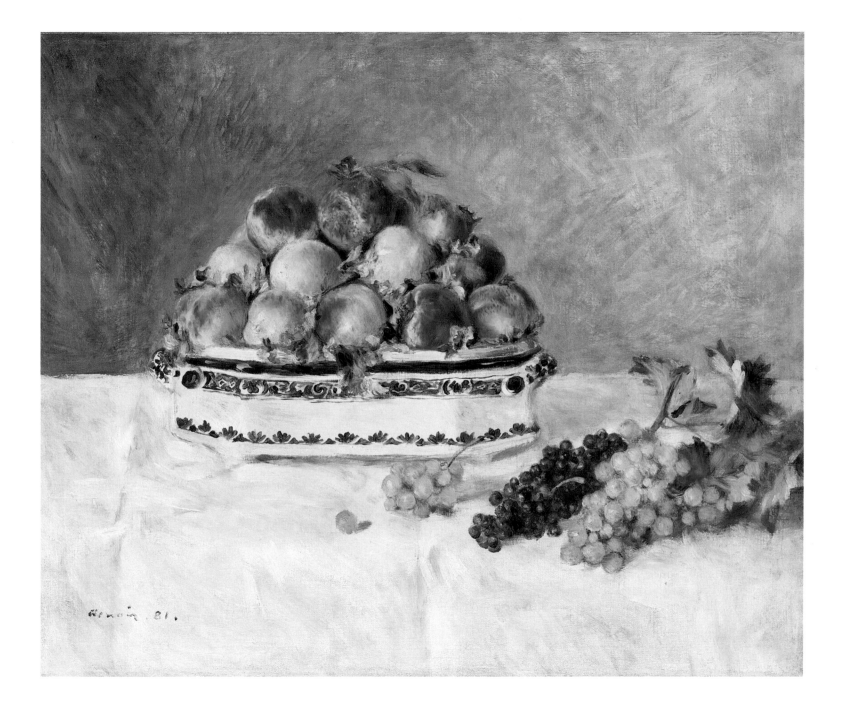

STILL LIFE WITH PEACHES AND GRAPES, 1881

Renoir 183

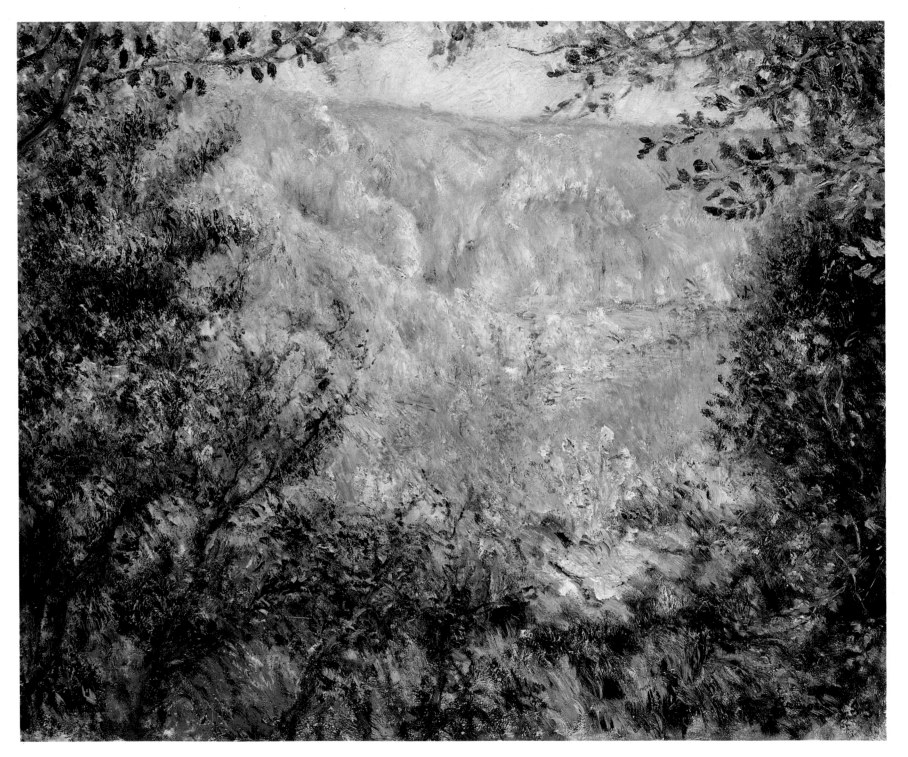

THE BAY OF MOULIN HUET, GUERNSEY, 1883

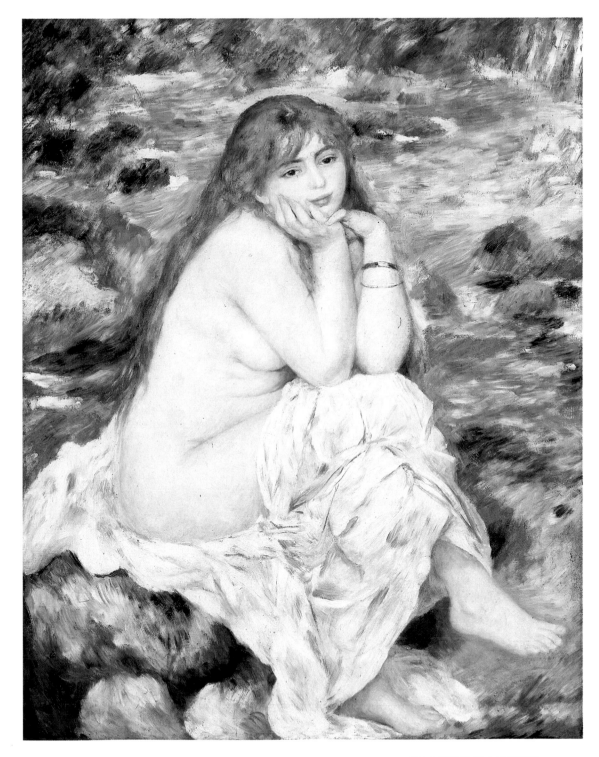

SEATED BATHER, c.1883

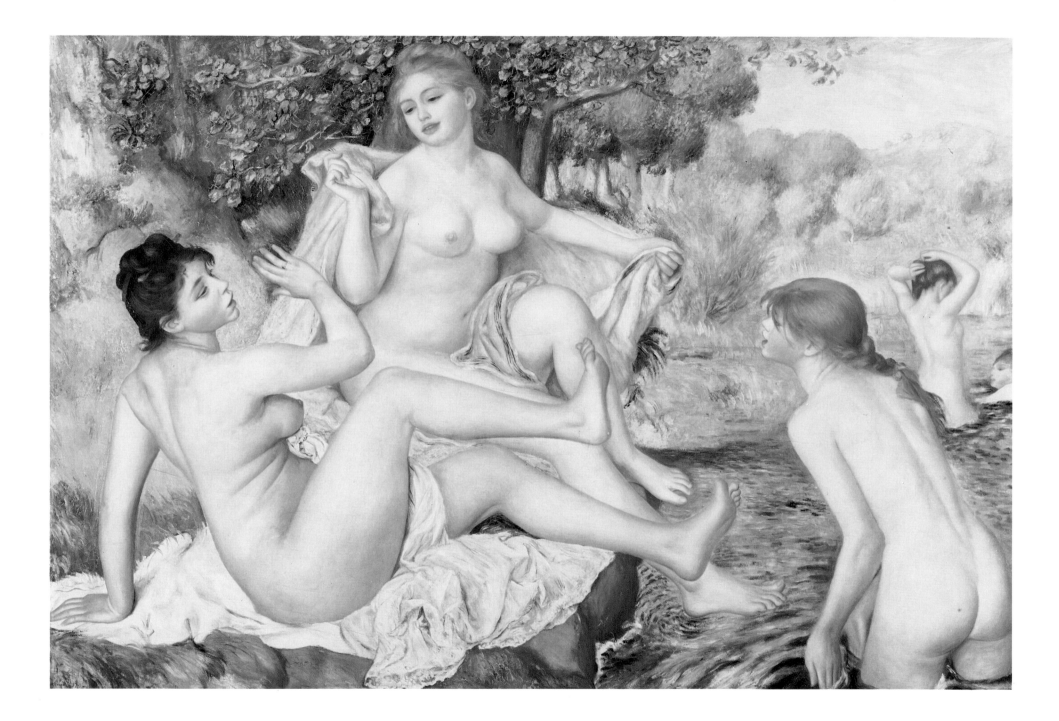

BATHERS, 1887

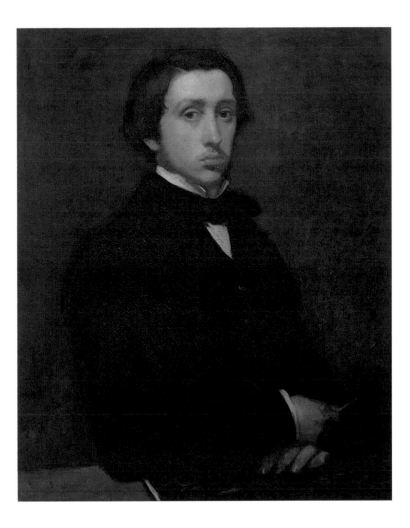

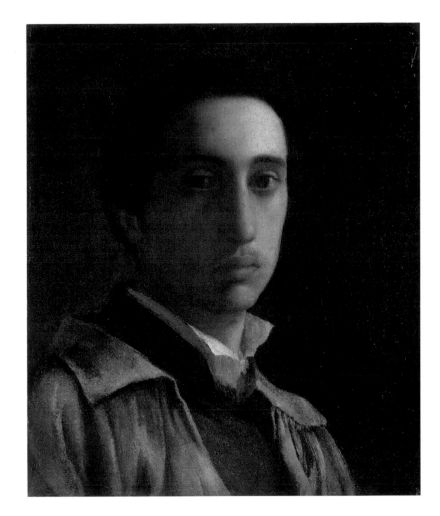

SELF-PORTRAIT IN FORMAL DRESS, c.1854

SELF-PORTRAIT IN WORKING CLOTHES, c.1856

DAVID AND GOLIATH, c.1864

WOMAN WITH CHRYSANTHEMUMS, 1858–65

Degas 189

HORSEMAN IN RED COAT, 1866–68

HORSE WALKING, c.1866–68

GENTLEMEN'S RACE: BEFORE THE START, 1862–80

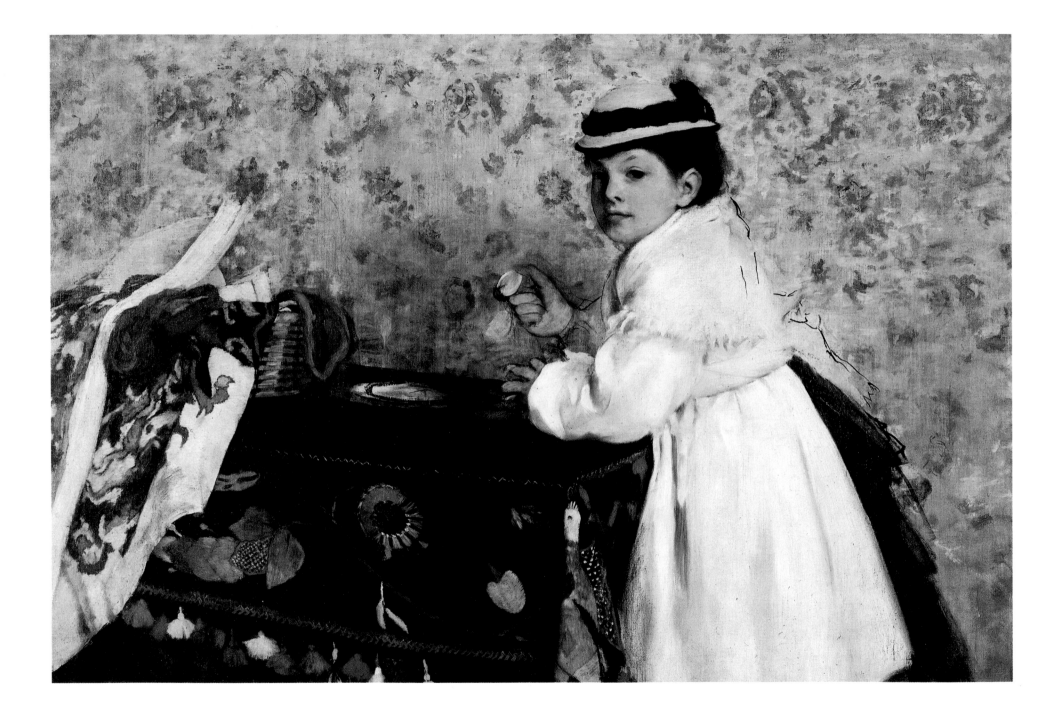

HORTENSE VALPINÇON AS A CHILD, 1869

EUGÈNE FIOCRE IN THE BALLET FROM LA SOURCE, 1866–68

Degas 193

MADAME RENÉ DE GAS, 1872–73

THE ORCHESTRA AT THE OPERA, 1868–69

INTERIOR, 1868–69

SULKING, 1873–75

BALLET REHEARSAL WITH SPIRAL STAIRCASE, c.1876

THE REHEARSAL, 1877

Degas 199

TWO WOMEN AT THE RACES, 1878

WOMEN IN FRONT OF A CAFÉ, 1877

THREE SEATED PROSTITUTES, c.1879

DANCERS IN REHEARSAL, 1878–80

TWO WOMEN IN A MUSEUM, 1877–80

DANCER AND WOMAN WITH UMBRELLA WAITING ON A BENCH, c. 1882

TWO LADIES AT THE MILLINERS, c.1883

COUNTRY LANE WITH TREES NEAR A SMALL TOWN, c. 1865

VILLAGE STREET OF MARLOTTE, 1866

A VENUE OF CHESTNUT TREES NEAR LA CELLE-SAINT-CLOUD, 1867

EARLY SNOW AT LOUVECIENNES, 1870

THE BRIDGE AT VILLENEUVE-LA-GARENNE, 1872

OUTSKIRTS OF LOUVECIENNES, 1872

MEADOW, 1875

Sisley 213

VIEW OF SAINT-MAMMES, c. 1880

A FARMYARD NEAR SABLONS, 1885

Sisley 215

THE BOULEVARD HÉLOÏSE, ARGENTEUIL, 1872

THE FORGE AT MARLY-LE-ROI, 1875

Sisley 217

VERSAILLES ROAD AT SAINT-GERMAIN, 1875

LANDSCAPE AT LOUVECIENNES, 1873

Sisley 219

THE CHEMIN DE BY THROUGH THE WOODS OF ROCHES-COURTANT—ST. MARTIN'S SUMMER, c.1880

THE TOWPATH, 1864

Pissarro 221

A SQUARE AT LA ROCHE-GUYON, 1867

222

STILL LIFE, 1867

Pissarro 223

THE CÔTE DU JALLAIS, PONTOISE, 1867–68

THE HILLSIDES OF L'HERMITAGE, PONTOISE, 1867–68

Pissarro 225

CHESTNUT TREES AT LOUVECIENNES, 1872

LANDSCAPE WITH FLOODED FIELDS, 1873

ORCHARD IN BLOOM, LOUVECIENNES, 1872

FACTORY NEAR PONTOISE, 1873

Pissarro 229

STILL LIFE: PEARS IN A BASKET, 1872

THE CLIMBING PATH, L'HERMITAGE, PONTOISE, 1875

THE BACKWOODS OF L'HERMITAGE, PONTOISE, 1879

RABBIT WARREN AT PONTOISE, SNOW, 1879

Pissarro 233

THE SHEPHERDESS

(YOUNG PEASANT GIRL WITH A STICK), 1881

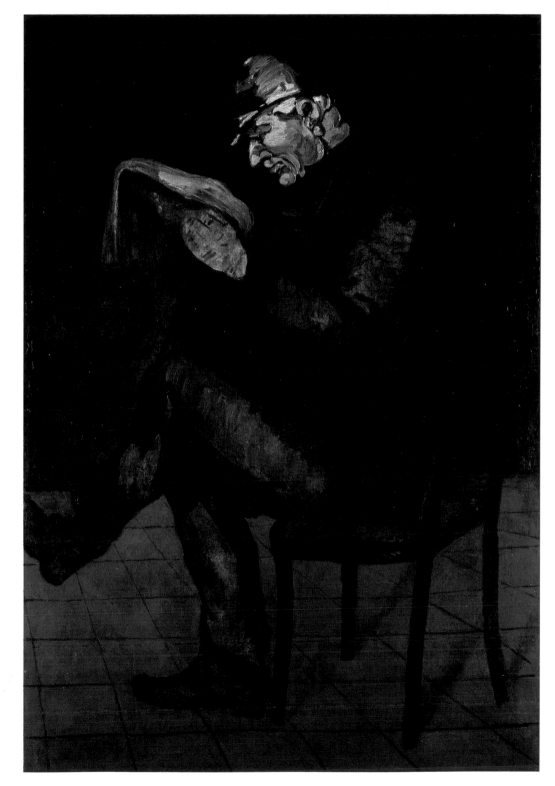

LOUIS-AUGUSTE CÉZANNE, 1860–65

THE ABDUCTION, 1867

A MURDER, 1867–70

Cézanne 237

GIRL AT THE PIANO, c.1866

THE BLACK CLOCK, 1869–70

Cézanne 221

THE RAILWAY CUTTING, 1869–71

JAR, COFFEE POT AND FRUIT, 1870–72

THE HOUSE OF THE HANGED MAN, 1872–73

THE SEINE AT BERCY, 1873–75

Cézanne 245

THE BUFFET, 1873–77

AUVERS, PANORAMIC VIEW, 1873–75

STILL LIFE WITH FRUIT, BOWL, CLOTH, APPLES AND BREAD, 1879–82

THE ETANG DES SOEURS AT OSNY, 1875–77

Cézanne 249

BIG TREES AT THE JAS DE BOUFFAN, 1885–87

THE BRIDGE AT MAINCY NEAR MELUN, c.1879–80

Cézanne 251

MOUTH OF THE SEINE AT HONFLEUR, 1865. *90 × 150 cm. Norton Simon Foundation, Pasadena, California*
The wind seems the main animating force in this coastal scene. The sailing boats and the clouds run before it and it has given the oarsmen a choppy sea to contend with. Monet here essays the traditional marine painting for which Eugène Isabey was well known at the time but the panorama is broader and the handling much freer, even though the young artist keeps firm control and shows a sound sense of structure. Although the feeling of being outdoors in a stiff breeze is strong, the painting was in fact executed in the studio. It was successful at the Salon of 1865, except with Manet who was not amused to be congratulated for work by a young upstart with a similar name.

THE CAPE OF LA HÈVE AT LOW TIDE, 1865. *90 × 150 cm. Kimball Art Museum, Fort Worth, Texas*
Monet shows us what he had learned from Courbet but with none of the latter's compulsive passion. The main interest lies in the shift in the centre from foreground to background with the horizon and breakwater leading the eye across the picture. Details like the sailing ship on the left and beached boats on the right arrest the horizontal sweep. The cloudy sky is well realised but essentially a backdrop to a beautifully organised scene.

THE BODMER OAK AT THE BAS-BRÉAU, FONTAINEBLEAU FOREST, 1865. *97 × 130 cm. Metropolitan Museum of Art, New York. Gift of Sam Salz and Bequest of Julia W. Emmons*
Our attention is effectively and evenly distributed in this powerful and pleasing Fontainebleau scene that is more freely and calmly painted than most Barbizon School pictures. Monet's assurance at the age of 24 has no equal among the Impressionist School.

WOMEN IN THE GARDEN, 1866. *256 × 208 cm. Musée d'Orsay, Paris*
This must be one of the largest paintings ever to be worked on out of doors. Camille was probably the model for all the figures and one may wonder how impressed she was by the scale of Monet's ambitions. If the picture just failed to match them it remains an eloquent tribute to Monet's remarkable skill in the handling of colour and light.

TERRACE AT SAINTE-ADRESSE, 1867. *98 × 130 cm. Metropolitan Museum of Art, New York. Purchased by Friends of the Museum*
Bright and hard with no concern for spatial illusion and with all the elements clearly separated, this pre-Impressionist Monet has a lot in common with some post-Impressionist pictures of the early 20th century, Marquet for instance. Monet's father is seated on the right. An informal scene has been rendered with an uncommon degree of compositional precision.

JEANNE-MARGUERITE LECADRE IN THE GARDEN, 1866. *80 × 99 cm. Hermitage Museum, Leningrad*
This is an archetypal image of Impressionism, like that on page 123, an image that outwardly looks idyllic but probably conceals more mixed feelings.

THE BEACH AT SAINTE-ADRESSE, 1867. *75 × 102 cm. Metropolitan Museum of Art, New York. Bequest of William Church Osborn*
Another well-balanced composition in a high colour key that surely must have made even Boudin blink. The transparency of the water and the reflected sky add an extra dimension to the foreground.

THE MAGPIE, 1869. *89 × 130 cm. Musée d'Orsay, Paris*
Begun during the winter at Etretat, Monet finished this wonderful snow-scene in Paris. It was rejected at the 1869 Salon by the famous orientalist painter Léon Gérôme who called Monet and his colleagues a 'band of madmen'. Monet showed the picture in a Paris dealer's window instead where it drew incredulous and hostile crowds.

BATHERS AT LA GRENOUILLÈRE, 1869. *73 × 92 cm. National Gallery, London*
The subject is a riverside bathing and boating retreat on the Seine to the north of Paris. Monet and Renoir worked at La Grenouillère together and, although Monet only intended his pictures as studies for a larger work to be completed in the studio, what the two men painted there has become a landmark of Impressionism. Monet here severs his last tenuous links with any clear tradition.

THE BEACH AT TROUVILLE, 1870. *38 × 46 cm. National Gallery, London*
Camille posed for the left-hand figure in this freely painted study during the summer of her marriage to Monet. Grains of sand from the beach have been found in the paint. With *Bathers at La Grenouillère*, it marked a new looser stage in the evolution of the Impressionist style.

MARINE VIEW — SUNSET, 1874. *49.5 × 65 cm. Philadelphia Museum of Art. Purchased, the W.P. Wilstach Collection*
This sunset scene is painted with a brisk overall directness that belies its poetic mood. The reeds in the foreground make the area beyond seem poignantly inaccessible however robust the application of the rich sunset colours.

LA PROMENADE (WOMAN WITH A PARASOL — MADAME MONET AND HER SON), 1875. *100 × 81 cm. National Gallery of Art, Washington, D.C. Collection of Mr. and Mrs. Paul Mellon*
'The painting creates an effect that is both singular and extremely accurate', wrote a critic, Pierre Dax, when it was shown at the Second Impressionist Exhibition. It is a picture that exhilarates with its freshness, energy and originality of viewpoint – a wonderful evocation of a breezy summer's day.

GARE ST. LAZARE, PARIS, 1877. *82 × 100 cm. Fogg Art Museum, Cambridge, Mass. Maurice Wertheim Collection*
In 1877 Monet was given permission to set up his easel at the Gare St. Lazare where he painted at least a dozen pictures both under the great canopy and just outside it. This one concentrates more on the representation of the locomotive and trucks than the others, which are concerned more with the atmospheric effects of smoke and steam.

PONT DE L'EUROPE (GARE ST. LAZARE), 1877. *64 × 80 cm. Musée Marmottan, Paris*
One of the most evocative of Monet's railway pictures. The paintings excited some derision when shown at the Third Impressionist Exhibition but provoked considerable interest as well. The bridge itself was a complex steel structure that captivated a number of other painters including Caillebotte and Norbert Goeneutte.

LANDSCAPE WITH ORCHARD AND FIGURES, 1879. *95 × 75 cm. Reader's Digest Collection*

The year in which Monet painted this picture at Vétheuil was already a year of disaster, but his wife Camille had not yet fallen ill and so he did not know what further misfortune was in store for him. The figures in the orchard seem almost submerged and barely able to see the sky for the profusion of blossom. Though the sun is not actually shining its handiwork is everywhere. The picture conveys a reckless generosity with the brush and a splendid unconcern for conventional compositional devices.

THE ARTIST'S GARDEN AT VÉTHEUIL, 1881. *150 × 120 cm. National Gallery of Art, Washington D.C.*

In 1881 Monet painted several upright landscapes, mostly of garden subjects. There are four versions of this bright and stimulating view which seems more lyrical than usual for Monet. It could be seen perhaps more as a picture about children experiencing the wonder of a summer's day than a simple feast for the eye alone.

APPLES AND GRAPES, 1879. *68 × 89 cm. Metropolitan Museum of Art, New York. Gift of Henry R. Luce, 1957*

A masterly still life with a commanding resonance produced by its great chord of colour and chiaroscuro. Monet again proves himself the most muscular virtuoso of basic Impressionism.

SUNFLOWERS, 1880. *100 × 81 cm. Metropolitan Museum of Art, New York*

In the summer and autumn of 1880 Monet painted several brilliant flower pieces which included asters, dahlias and chrysanthemums, as well as these sunflowers that seem to emit radiant energy. All the pictures were executed with tremendous brio. At Vétheuil Monet became interested in gardens again, but the great passion of Giverny still lay several years in the future. Van Gogh felt great admiration for Monet's flower pieces and he would later receive Monet's praise in return.

VÉTHEUIL IN SUMMER, 1880. *60 × 99.7 cm. Metropolitan Museum of Art, New York. Bequest of William Church Osborn*

This picture is one of many views of the small town where Monet lived for three and a half years. Together they constitute a preparation for the artist's work in series. None of the views of Vétheuil is identical though – Monet shifted his position constantly – but he recorded some rather similar views under different weather conditions. This canvas is surprising for its sparkling clarity and the absence of atmospheric effect, and it is also quite conventionally topographical.

FLOATING ICE ON THE SEINE, 1880. *61 × 100 cm. Kunstmuseum, Berne*

The winter after Camille's death was a particularly severe one and the Seine was completely frozen over. The pictures Monet painted of the breaking up of the ice were part of a great burst of creative activity around Vétheuil at the beginning of the year. One version was refused at the Salon in spite of Monet's curious reference to it as a 'prudent bourgeois thing'. But their simplicity and narrow colour range could well have seemed entirely vacuous to the jury, or anyone else.

CLIFFS NEAR POURVILLE, 1882. *60 × 81 cm. Rijksmuseum, Twenthe, Enschedé*

In 1882 Monet returned to the coast of Normandy where he had painted the great cliffs of Etretat 13 years previously, and in a great burst of activity, 'working like a madman', he produced many pictures of the cliffs and beach at Pourville and Varengeville. He was to occupy himself on the coast for four years in between trips to Holland and Italy, as well as work at home and near Giverny. This rarely reproduced painting is truly a stunning encounter of mass and space with a dramatic sense of the unyielding opposition of the battered cliffs to the storms which will surely resume their assault when the radiant truce that Monet depicts is over.

THE MANNEPORTE, ETRETAT, 1883. *65 × 81 cm. Metropolitan Museum of Art, New York. Bequest of William Church Osborn, 1951*

An exhilarating view of one of the great natural arches on the Normandy coast where Monet worked on and off so energetically during the early 1880s. This version is dramatically three-dimensional compared with the later version on page 22, with an unusually emphatic chiaroscuro, and the brushwork is notably varied. The cliffs in fact seem imposing enough without the two tiny figures silhouetted against the horizon on the left, no doubt introduced by Monet to establish scale.

RAVINE OF THE CREUSE, 1889. *65 × 81 cm. Museum of Fine Arts, Boston. Bequest of David P. Kimball in memory of his wife Clara Bertram Kimball*

Monet visited the valley of the Creuse in central France in early 1889 and was much stimulated by its 'stupefying and sombre beauty'. He endured as much physical discomfort there as he did on the Normandy coast in 1886. In the spring he found the bright weather almost too dazzling. He has made this picture a coruscating unity of mass, light and colour which relentlessly assaults our eye but never tires it.

YOUNG WOMAN RECLINING, IN SPANISH COSTUME, 1862. *94 × 113 cm. Yale University Art Gallery, New Haven. Bequest of Stephen Carlton Clark*

This superbly confident picture, with its inscription to the great photographer Nadar, was clearly inspired by Goya's famous *Maja Clothed*. Women in men's clothing carried an erotic charge during the 19th century, not least because the lower half of a woman's body was never ordinarily seen. The cat and the oranges, apart from being a compositional device, seem intended to disavow over-serious intention on Manet's part.

PORTRAIT OF JEANNE DUVAL, 1862. *90 × 113 cm. Szépmüvészeti Múzeum, Budapest*

Baudelaire's mistress was ageing and ill when she sat for Manet and a sense of unease on his part can be felt in this extraordinary picture which it seems Baudelaire did not like. Manet exhibited it in 1865, however, and it remains one of his most compelling portraits.

PORTRAIT OF VICTORINE MEURENT, 1862. *43 × 44 cm. Museum of Fine Arts, Boston. Gift of Richard C. Paine, in memory of his father Robert Treat Paine*

Manet's favourite model at 18 – painted in the year he met her. She posed for some of his most important pictures including *Luncheon on the Grass*, *Olympia* and *The Railroad*. She was not well educated but of strong character. After 1870 she began to paint and had a self-portrait accepted at the Salon of 1876. It might not be going too far to say that her colouring and character had a definite effect

on the course of Manet's art. Certainly his first attempt to paint her seems to have produced a masterpiece.

THE DEAD CHRIST WITH ANGELS, 1864. *179 × 150 cm. Metropolitan Museum of Art, New York. Bequest of Mrs. Horace Havemeyer, 1929*
'Do not miss Manet's Christ, or the poor miner raised from the coal mine . . .' wrote one critic of this work and it was generally dismissed with similar derision. Courbet ridiculed the idea of painting angels at all but Degas defended the picture, as had Zola and Baudelaire. It can still seem a little risible at first sight but its conviction and sheer bravura are genuinely moving and, as Zola wrote, '. . . the angels in the background with great blue wings . . . are so strangely elegant and gentle . . .'

BATTLE OF THE KEARSARGE AND THE ALABAMA, 1864. *134 × 127 cm. John G. Johnson Collection, Philadelphia*
Manet was here painting modern life with a vengeance. Most great paintings of naval battles have been made after an interval of time. Manet's was exhibited in the same year. He started work on his rendering of the Confederate *Alabama* being sunk by the US Navy *Kearsarge* straight away, most probably using written descriptions and photographs. The selected viewpoint provoked derisive comment but the idea of seeing the water as though from the deck of a ship was based on Manet's own personal experience as a young seaman.

STILL LIFE WITH MELON AND PEACHES, c.1886. *69 × 92 cm. National Gallery of Art, Washington D.C. Gift of Eugene and Agnes Meyer*
Manet here aims to paint the kind of still life that was a symbol of the good living enjoyed by the potential purchaser, but this intention does not overwhelm his extraordinary integrity as a painter. If a way of applying paint seemed right to him he could not do otherwise – much as he longed for universal approval. It is indeed a handsome picture, perhaps the greatest of his few still lifes in the established tradition as opposed to ones of simple objects disposed at random, or those incorporated into various subjects like *A Bar at the Folies-Bergère*.

YOUNG LADY IN 1866 (WOMAN WITH A PARROT), 1866. *185 × 129 cm. Metropolitan Museum of Art, New York. Gift of Erwin Davis 1889*
Zola praised this picture in his first article about Manet, seeing in it proof of the artist's innate stylishness arising from his characteristic economy of means. It was first shown in a private exhibition Manet organised after being passed over by the committee inviting contributions from painters for the Exposition Universelle in 1867. It was finally shown in the Salon of 1868 where it received a very mixed reception. It is not known what the picture was meant to say about the figure (posed for once again by Victorine Meurent). It has been suggested that the monocle and the flowers may have been given her by a man and that the parrot could be privy to their significance. It is at any rate a striking harmony in grey and pink which failed, according to another critic, '. . . because he does not know how to paint flesh'.

THE BURIAL, 1867–70(?). *73 × 90.5 cm. Metropolitan Museum of Art, New York*
This unfinished painting may well illustrate Baudelaire's funeral cortège, but this is not certain. The poet and critic (a champion of Manet) was buried in oppressive thundery weather on 2 September

1864. There is a curious vehemence in the brushwork that seems like a protest at a sore misfortune. The picture once belonged to Pissarro.

BOULOGNE HARBOUR BY MOONLIGHT, c.1869. *82 × 101 cm. Musée d'Orsay, Paris*
Painted on the basis of early morning observations from Manet's hotel window in Boulogne, this highly atmospheric painting shows women waiting to take the night's catch of fish to market. Seventeenth-century Dutch nocturnal painting has been noted as an influence and x-rays have revealed that the composition was considerably changed during its reworking in the studio.

READING, 1865–73. *61 × 74 cm. Musée d'Orsay, Paris*
Madame Manet posed for this portrait probably in 1865 and the figure behind from which it derives its title was probably added in 1873. This second figure is Madame Manet's son Léon, who can be seen in *Luncheon in the Studio* (opposite) five years younger than here. The picture was almost certainly influenced by Whistler's *White Girl* (National Gallery of Art, Washington D.C.), which scandalised the same public who were outraged by Manet's *Luncheon on the Grass*. If the addition of Léon's figure seems to have little point, the execution of the main figure is masterly and the sentiment one of affectionate admiration. Manet has emphasised his wife's hands: she was well known as an excellent pianist.

LUNCHEON IN THE STUDIO, 1868. *118 × 154 cm. Neue Pinakothek, Bayerische Staatsgemäldesammlung, Munich*
This painting has defied confident interpretation since it was first shown. The brief and perhaps little less than cordial communion of a shared lunch has evaporated and Manet seems to be scrutinising the figure of Léon (his son or stepson) in the foreground with a certain ambivalence. There are elaborate still lifes to left and right. The maid seems ready to set the domestic routine in motion once again and the cat wilfully ignores the whole company. This is one of Manet's most elaborate and puzzling inventions.

BOATING, 1874. *97 × 130 cm. Metropolitan Museum of Art, New York*
This remarkable canvas perhaps demonstrates Manet's resistance to orthodox Impressionist methods rather than their espousal when he was working in close contact with Monet at Argenteuil. It is essentially a portrait of a man in a boat rather than a scene of boating life, the composition having been radically flattened and simplified to concentrate attention on the main human subject who was the artist's brother-in-law – he can also be seen in Manet's famous *Argenteuil* (page 36). Although Manet considered sending the picture to the Salon of 1876, he did not in fact offer it until 1879. It underwent a rather hostile reception and what must have been galling incomprehension from Zola. The picture was an excursion into formal experimentation of a kind that few were ready for at this time and it is yet another testimony to Manet's unceasing urge to develop a new pictorial language of his own.

ON THE BEACH, 1873. *60 × 73 cm. Musée d'Orsay, Paris*
A seaside picture very different from Boudin's or Monet's in feeling, although the latter's beach scenes of 1870 might well have provoked it. It seems more concerned with the mood of the two reflective people (Madame Manet and the painter's brother Eugène) than in capturing an instantaneous visual impression, as was Monet's.

MASKED BALL AT THE OPERA, 1873. *60 × 73 cm. National Gallery of Art, Washington D.C. Gift of Mrs. Horace Havemeyer in memory of her mother-in-law Louisine W. Havemeyer*
This exhilarating glimpse of an annual event at the Opera was worked on for some months using friends in the studio as models. It seems a direct descendant of *Music in the Tuileries* (page 26) but there is here a much more positive sense of enjoyment and delight in stronger colour. Manet again finds pleasure in (this time at least 22) top hats. The legs entering the picture from above were a device repeated less prominently by the trapeze artist in the mirror of *A Bar at the Folies-Bergère* (page 52).

LADY WITH FANS (PORTRAIT OF NINA DE CALLIAS), 1873–74. *113.5 × 166.5 cm. Musée d'Orsay, Paris*
The lively character of an unconventional lady of means, who liked to entertain painters and writers and was herself a musician, is very sympathetically conveyed here by Manet with great vitality and freedom of handling. Her face immediately communicates her lively intelligence as well as her waywardness, just as the Japanese fans on the wall suggest a high-spirited ambiance.

MADAME MANET ON A BLUE COUCH, 1874. *65 × 61 cm. Pastel on paper, mounted on cloth. Musée du Louvre, Cabinet des Dessins, Paris.*
It is not known whether Degas was responsible for Manet's adoption of pastel though he may well have been. About 100 works in the medium have survived. In this portrait of his wife, dressed smartly for the street and curiously in the same pose as *Olympia*, Manet has found nothing very personal to say about her. He has made the picture more a striking essay in colour contrast and the unique qualities of his medium.

PORTRAIT OF BERTHE MORISOT WITH HAT, IN MOURNING, 1874. *62 × 50 cm. Private Collection*
Berthe Morisot was probably unwilling to pose for long for this alarmingly expressive portrait, and the rapidity of its execution has exposed both her and Manet's emotion with breathtaking clarity. Morisot was in mourning for her father whom she dearly loved and who had just died after a long and painful illness and Manet must have been deeply affected by her unhappiness. In all his portraits of his friend a melancholy anxiety always seems to threaten her and the pictures constitute a most sensitive account of a remarkable artist's character.

YOUNG WOMAN AMONG FLOWERS, c.1876. *126 × 175 cm. Reader's Digest Collection*
During the later 1870s Manet sometimes seemed to embrace the Impressionist style of Monet and Berthe Morisot with total commitment and this is one of the most extreme examples of his conversion before he reverted to his earlier preference for studio painting. This picture could be said to show signs of lack of practice in *plein-air* painting but it conveys Manet's determination to master the difficulties, which he does with considerable success.

PORTRAIT OF STÉPHANE MALLARMÉ, 1876. *27 × 36 cm. Musée d'Orsay, Paris*
This small picture is a product of the close friendship between the great Symbolist poet and Manet, who saw each other nearly every day for the ten years before the artist's death. Manet simply paints Mallarmé as if during one of their casual conversations, smoking one of the cigars he was so devoted to. It was always considered the best likeness of Mallarmé and personal rapport must have had a part in making it seem a great rather than just a good portrait.

THE ARTIST, 1875. *192 × 128 cm. Museu de Arte, São Paulo*
This portrait was rejected by the Salon jury of 1876 because, as one member put it: '... we have given Manet ten years to mend his ways; he will not mend his ways; on the contrary he digs in! Reject!' Manet then exhibited it with another rejected work at his own studio where it had a more favourable reception. The model, Marcellin Desboutin, was a printmaker and painter who etched the affecting portrait of Manet on page 23 and appears in *Absinthe* (page 71). He was by no means a major artist but he exhibited with the Impressionists and must have been admired and liked by Manet. This impressive picture continued Manet's unrelenting struggle to paint modern portraits in the tradition of Velázquez rather than that of David and Ingres.

THE WAITRESS, 1878 or 1879. *98 × 79 cm. National Gallery, London*
GIRL SERVING BEER, 1879. *77.5 × 65 cm. Musée d'Orsay, Paris*
It has not been precisely determined what the relationship between these two paintings is. *The Waitress* is certainly a reworked fragment of a horizontal picture whose left-hand, larger, fragment *At the Café* is now in the Oskar Reinhart Collection at Winterthur. But it is not certain whether the *Girl Serving Beer* is a study for the reworking of the severed piece or a final distillation of the subject. Manet found the waitress at the Brasserie de Reichshoffen on the Boulevard Rochechouart and she agreed to pose for him only on condition that her protector (the man she is serving) could come to the studio with her. Both pictures are certainly beautiful. Something is gained in the closer view at the expense of interesting background detail. One gives equal importance to the two figures, the other seems the best portrait of a waitress ever painted.

THE LEMON, 1880–81. *14 × 21 cm. Musée d'Orsay, Paris*
The lemon seemed to become a personal emblem for Manet during the 1860s, combining a simplicity of form and execution with a tribute to the Flemish and Spanish schools in which he found inspiration. He often incorporated a lemon into one of his major compositions. In the last years of his life Manet painted several small still lifes, often sent as gifts to his friends. This one was given by Suzanne Manet after her husband's death to Antonin Proust, an old friend of the artist's.

PORTRAIT OF MADEMOISELLE ROMAINE LECAUX, 1864. *81 × 65 cm. Cleveland Museum of Art. Gift of Hanna Fund*
This entirely delightful portrait is the first masterpiece among the many pictures of young girls that Renoir was to paint. The influence of Ingres in the pose, of Corot in the light-toned palette and of Velázquez in the more freely handled passages is apparent.

STILL LIFE, 1864. *130 × 98 cm. Kunsthalle, Hamburg*
STILL LIFE, ARUM AND FLOWERS, 1864. *130 × 96 cm. Oskar Reinhart Collection, 'Am Römerholz', Winterthur*
Despite Renoir's protestation that he painted flowers only for 'mental relaxation', both these artless arrangements of spring blooms in a greenhouse are serious and concentrated studies. They have a strong affinity with Monet's flower pieces of the time but are not so decoratively composed.

SPRING BOUQUET, 1866. *101 × 79 cm. Fogg Art Museum, Harvard, Massachusetts. Bequest of Grenville L. Winthrop*
This wonderful evocation certainly demonstrates Renoir's abiding affinity with French 18th-century painting but its execution makes it seem lighter and airier than any previous painting of flowers. Renoir seems to have captured their very scent.

THE PROMENADE, 1870. *80 × 64 cm. National Gallery of Scotland, Edinburgh*
This pleasant scene of dalliance marks a stage in Renoir's progress towards Impressionism. The figures and background are more closely integrated and the play of the brushstrokes is freer and more rhythmic. In spirit it has strong affinities with the shameless hedonism of 18th-century French artists like Boucher and Fragonard whom Renoir always considered his artistic forebears.

WATER NYMPH, c.1871. *67 × 123 cm. National Gallery, London*
This is the first of several long reclining nudes that Renoir was to paint. The artist's debt to Courbet is rapidly diminishing and Renoir's own artistic personality is emerging. It is the supremely gentle touch and the flesh tones combined with the unusual vulnerability of the model that lend this picture its special poignancy.

BATHER WITH A GRIFFON, 1870. *184 × 115 cm. Museu de Arte, São Paulo. Assis Chateaubriand*
This baigneuse is painted in a classical vein, partly no doubt for the sake of getting the picture admitted to the Salon of 1870, where it was, however, not particularly well received. It combines a posed figure with some realist props such as the griffon and the clothing. Lise Tréhot was almost certainly the model. Although Renoir was here honouring tradition, Courbet seems to have been his main inspiration.

STILL LIFE WITH A BOUQUET, 1871. *74 × 59 cm. Museum of Fine Arts, Houston*
This attractive picture is in fact a tribute to Manet. The etching on the wall is by him and the bouquet refers to the one in *Olympia* (page 28). The other objects are related to some of those in the background of Manet's portrait of Zola (page 29). The feathery grass obliquely echoes the quill in the writer's inkwell.

PORTRAIT OF RAPHA, 1871. *130 × 83 cm. Private Collection*
This portrait of a friend, Edouard Maître's mistress Rapha, was painted in Paris in April 1871 during the early days of the Commune. The height of the figure is accentuated by the elaborate full-length dress and the amount of descriptive detail makes it seem something of a genre painting.

A ROAD IN LOUVECIENNES, c.1872. *38 × 46 cm. Metropolitan Museum of Art, New York. Bequest of Emma A. Sheafer, 1974, Lesley and Emma Sheafer Collection*
Painted soon after the traumatic upheavals of 1870–71 this superb Impressionist landscape shows Renoir intent on conveying the pleasure of walking down a country lane *en famille* in the early summer. He was no doubt visiting his parents at Louveciennes where a few years before they had bought a house. Pissarro and Sisley both painted identical views of Louveciennes.

THE GUST OF WIND, c.1872. *52 × 82 cm. Fitzwilliam Museum, Cambridge*
Seldom, if ever, has the effect of wind on foliage been so wonderfully realised as in this picture. The contrasting use of thinly and thickly applied paint has an inspired aptness that makes it one of the great Impressionist landscapes.

ON THE SEINE, 1880. *46 × 55 cm. Art Institute of Chicago*
Some pictures do not become generally known even long after they are ripe for appreciation. Such a one is surely this brilliant small painting, much valued by its custodians but rarely if ever reproduced in colour before. This may be because apart from its modest dimensions, it has none of the extra landscape, still life or narrative interest of many of Renoir's works of this period. It may have been painted at Chatou at the same time as *The Seine at Chatou* (opposite). It suggests a Renoir exhilarated by his painterly fluency and freedom as well as, of course, his beautiful surroundings.

THE SEINE AT CHATOU, c.1881. *74 × 93 cm. Museum of Fine Arts, Boston. Gift of Arthur Bemmons, 1919*
This masterpiece of almost recklessly variegated brushwork is surely one of Renoir's most enjoyable landscapes, if not a miraculous one like *The Gust of Wind* (page 165). It was probably painted shortly after he finished *Luncheon of the Boating Party* (page 170) and may express some of Renoir's relief at his freedom from that protracted task. Renoir was quite soon to move towards a more uniform surface as Monet and Pissarro had before him.

JUGGLERS AT THE CIRQUE FERNANDO (TWO LITTLE CIRCUS GIRLS), 1879. *131.5 × 99.5 cm. Art Institute of Chicago. Potter Palmer Collection*
A curious composition which glows with a lyrical tenderness and the colour orange. The little girls were real jugglers and gymnasts in their father's circus in Montmartre but according to a critic in 1882 they 'were born with legs too short. To console them the artist has given them hands that are too long, full of great oranges.'

YOUNG WOMAN READING AN ILLUSTRATED JOURNAL, 1880–81. *46 × 81 cm. Museum of Art, Rhode Island School of Design*
An intriguing example of Renoir's small modern-life subjects painted around this time. It is carefully composed and executed with exactly the right amount of finish. As we cannot catch the girl's eye, we are obliged to try to read over her shoulder, which makes the 'impressionist' treatment of the magazine something of a deliberate joke.

PLACE CLICHY, c.1880. *65 × 54 cm. Anonymous loan to Fitzwilliam Museum, Cambridge*
This painting, particularly the cropped figure in the foreground, is comparable with contemporary photographs or illustrations. The spontaneity of the image, however, is deceptive, as the artist made several preparatory studies for it. The girl marks the introduction of Renoir's ideal doll-like type and the care with which she is defined in comparison with the background figures probably corresponds exactly with the attention Renoir would give such a girl if he spotted her by chance on the street.

LUNCHEON OF THE BOATING PARTY, 1880–81. *130 × 173 cm. Phillips Collection, Washington D.C.*
This is the second of Renoir's great figure compositions on the subject of collective recreation and it represents a considerable development both in conception and technique from *The Ball at the Moulin de la Galette* (page 54). Colour and tone play equal parts in the definition of form and all possible variations in thickness and texture of paint have been exploited to the full. It has been pointed out that the densely crowded parts of Veronese's *Marriage Feast at Cana* in the Louvre, which Renoir had studied closely, may have been influential in the conception of this work. In any event Renoir has turned a no doubt noisy and untidy occasion into an eternal image of the basic pleasures of life being openly and innocently enjoyed. It is surely *the* masterpiece of Impressionist hedonism, however much one may in the end prefer the artist's smaller, simpler works.

STILL LIFE WITH PEACHES AND GRAPES, 1881. *54 × 65 cm. Metropolitan Museum of Art, New York*
This is surely Renoir at the height of his seductive brilliance. It seems he only wished to communicate pleasure and his success is as resounding now as on the day it was painted. The dominance of blue in all but the peaches is a transparent but successful device to make them seem even more alluring. It seems clearer than ever that Renoir and Cézanne's friendship was one of opposites.

THE BAY OF MOULIN HUET, GUERNSEY, 1883. *46 × 55 cm. Fogg Art Museum, Cambridge, Massachusetts*
This brilliant landscape from Guernsey echoes Renoir's pictures of Algeria and the South painted in 1881. It radiates the same kind of consistent abstract vibrancy as later Monet and must have been the kind of achievement that curiously caused him to react so strongly against Impressionism two years later.

SEATED BATHER, c.1883. *121 × 91 cm. Fogg Art Museum, Cambridge, Massachusetts*
The model for this picture looks very like those who would pose 10 or 20 years later for the even more voluptuous images that followed Renoir's 'Ingres' period. This canvas also foreshadows that period itself in its perhaps rather uneasy separation of figure and background. The rocks behind the bather echo the marine subjects he had recently been painting in Guernsey where he had taken especial pleasure in watching the bathers. This *Bather* is somewhat of an exploratory painting but any reservations about individual parts are surely allayed by contemplation of the whole.

BATHERS, 1887. *115 × 170 cm. Philadelphia Museum of Fine Art. Mr. and Mrs. Carroll S. Tyson Collection*
This painting is the most ambitious work of the period following his declaration to the dealer Vollard that he had 'reached the end of Impressionism'. When first exhibited at Georges Petit's Exposition Internationale of 1887 it was subtitled *Trial for Decorative Painting*. Inspired by Raphael and Ingres the artist made numerous preparatory studies for this large picture. The style of the painting, with its emphasis on firm drawing and sharp outline, was the climax of Renoir's reaction against Impressionism.

SELF-PORTRAIT IN FORMAL DRESS, c.1854. *41 × 33 cm. Musée du Louvre, Paris*
Between 1854 and 1858 Degas painted 11 self-portraits which seem to convey melancholy reservations about their subject but also a determination to face the world with seriousness and dignity. Later on he tried a kind of defiant posturing but he never chose to examine himself in a painting after the age of 28. The earlier group are all indebted to Ingres and his study of the Italian masters. In hindsight they convey an impression of a man who would always be alone, who would feel disdain for much of the world, but whose eyes would miss nothing.

SELF-PORTRAIT IN WORKING CLOTHES, c.1856. *39 × 33 cm. Metropolitan Museum of Art, New York*
This picture, painted about two years later than its companion, seems earlier because of its more positive debt to Neo-Classicism. Who could have doubted Degas' enormous ability in his early twenties?

DAVID AND GOLIATH, c.1864. *85 × 65 cm. Fitzwilliam Museum, Cambridge*
This astonishing sketch, probably meant to be developed later, exhibits a range of original ideas typical of the more mature Degas. David has slung his stone and it has struck Goliath – blood is indicated on his forehead. The giant is also some distance away and any chance of dramatising his stature has been deliberately sacrificed. It is much more freely brushed than any of his other historical paintings of these years and reveals, perhaps for the first time, the extent of his artistic individuality.

WOMAN WITH CHRYSANTHEMUMS, 1858–65. *74 × 92 cm. Metropolitan Museum of Art, New York*
This remarkable portrait was started as a flower piece in 1858 and the figure was apparently an afterthought painted in 1865. It seems a curious essay in the uncertain connection of a human being with her immediate environment and although it might be partly mocking or ironic it is sumptuously beautiful. The integration of the portrait with the rest of the picture seems to have been surprisingly untroublesome as there is little evidence of reworking of the flowers and their background. Degas was probably inspired by Delacroix to paint the extraordinary floral explosion, but he never painted flowers again and even professed to dislike them.

HORSEMAN IN RED COAT, 1866–68. *44 × 28 cm. Musée du Louvre, Paris*
Degas used dried-out oil paint and turpentine on paper extensively early in his career as he enjoyed experimenting with unusual media. This striking study seems to have been made out of doors but it might well have been posed in the studio using a dummy horse.

HORSE WALKING, c.1866–68. *32 × 20.5 cm. Collection of Mr. and Mrs. Eugène Thaw, New York*
This lovely drawing – rare in that the horse is alone and unsaddled – may well have been derived from a painting or other work of art. It is one of the hundreds of drawings that Degas made for possible use in paintings or drawings not yet conceived.

GENTLEMEN'S RACE: BEFORE THE START, 1862–80. *48 × 61 cm. Musée d'Orsay, Paris*
Started in 1862, this picture was reworked in parts in 1880. Degas liked to portray moments of nervous tension both in racing and the dance when bodies and minds were taut with anticipation.

HORTENSE VALPINÇON AS A CHILD, 1869. *73 × 110 cm. Minneapolis Institute of Arts. John R. Van Devlin Fund*
The rich decoration that pervades the whole picture offsets the economy of delineation of the figure. The girl almost seems to be asserting an innocent superiority to the fussiness of her environment which Degas has acutely observed and enjoyed. The curious broken black line suggesting an alternative profile for her back seems to have taken on an abstract life of its own which Degas could apparently not bring himself to erase.

EUGÈNE FIOCRE IN THE BALLET FROM LA SOURCE, 1866–68. *130 × 145 cm. Brooklyn Museum. Gift of A. Augustus Healy, James H. Post and John T. Underwood*
Degas has here in a single scene combined two of the motifs that would later dominate his work. The actual performance of the ballet was designed to be spectacular since it employed a real horse and real water.

MADAME RENÉ DE GAS, 1872–73. *73 × 92 cm. National Gallery of Art, Washington D.C. Chester Dale Collection*
When in New Orleans Degas painted several portraits of members of his family of which this is surely the best and most interesting. His sister-in-law (*née* Estelle Musson) was blind and possibly pregnant. She was also musical and Degas may have taken his cue from seeing her listening to music. The picture is without doubt one of the artist's most subtle and sympathetic portraits. The subtle greys and pink remind one of Whistler though the picture is certainly not the work of an aesthete.

THE ORCHESTRA AT THE OPERA, 1868–69. *56.5 × 46 cm. Musée d'Orsay, Paris*
An extraordinarily successful example of Degas' compositional method dependent on drawings done from life. The artist, who knew several members of the orchestra, has freely shifted them around and pushed the stage too far into the background. In spite of all this it nonetheless makes one feel present in the stalls as no other picture does.

INTERIOR, 1868–69. *81 × 116 cm. Private Collection*
The real subject of this mysterious and beautiful picture has been debated inconclusively ever since it was painted, and it was once dramatically dubbed *The Rape*. A starting point was almost certainly Emile Zola's novel *Thérèse Raquin* in which a murderous couple find they cannot consummate their passion on their wedding night two years after their crime. Details which do not tally with the novel though suggest that Degas deliberately robbed the subject of any specific meaning.

SULKING, 1873–75. *32 × 46 cm. Metropolitan Museum of Art, New York. H.D. Havemeyer Collection*
This enigmatic narrative painting was made shortly after *Interior*. It defies interpretation or even the designation of a reasonably appropriate title. It has been suggested that the mise-en-scène is a bank or a bookmaker's office (the English sporting print is by Herring). The protagonists are the critic Duranty and a model, Emma Dobigny. They seem almost to be rehearsing a mysterious play that Degas is directing. *Sulking* was the last picture of this kind by the artist though he continued to infuse some of his pictures with unspoken psychological meaning. It is in any event a compelling and accomplished piece of painting and disturbingly memorable.

BALLET REHEARSAL WITH SPIRAL STAIRCASE, c.1876. *43 × 57 cm. Corcoran Museum, Washington D.C.*
The first of Degas' ballet rehearsal pictures involving a spiral staircase and although it is not as cunningly contrived a composition as in the painting opposite with which he followed it, the painting is an unusual and beautiful essay in illusionistic space achieved with subtle chiaroscuro rather than Degas' usual linear methods.

THE REHEARSAL, 1877. *66 × 100 cm. Glasgow Museums & Art Galleries, Burrell Collection*
Degas has here very carefully contrived a composition from his stock of studies of dancers seen in rehearsal and there is little that is conventional about it. The light is more gently ambient than usual and the sense of space created by the tall distant windows and the dancers' shadows is a masterly conception. The eye though is constantly led by the dancers in the background and the floorboards to the ballet master's figure with its strong red accent on the right. The eye also has to absorb the ingenious device of the staircase with the legs of a descending dancer on the left and the group of resting dancers at the bottom right from which the figure of the master emerges. The cunning void below the centre window also attracts the eye. One feels that Degas' regard for his 'rats', as they were known, was on this occasion benign as well as analytical.

TWO WOMEN AT THE RACES, 1878. *19 × 24 cm. Private Collection*
Degas depicted this subject two or three times during the late 1870s. It certainly appears to be unfinished, but was not abandoned by the artist. With its arbitrary-seeming pattern of flat colour it much resembles the work of Vuillard in the late 1890s. Degas is here once again exploring the theme of the observer observed.

WOMEN IN FRONT OF A CAFÉ, 1877. *41 × 60 cm. Musée du Louvre, Paris*
This remarkable piece of reportage, which reminds one so forcibly of the best of 20th-century street photography, is one of Degas' most vividly described scenes. The pillar which partly hides a figure is a very bold compositional device. The attitude of the central figure tells us of a person who certainly attracts but perhaps is better not to know. It may not be Degas' most beautiful pastel, but it has a most extraordinary sense of truthfulness.

THREE SEATED PROSTITUTES, c.1879. *18 × 22 cm. Monotype and pastel. Rijksmuseum, Amsterdam*
Degas made about 50 monotypes of brothel scenes in the late 1870s and early 1880s. The compositions were based on observations made at one or more of the hundreds of *maisons de tolérance* in Paris which Toulouse-Lautrec would also haunt and paint a decade later. Degas' curious combination of brutal realism with sympathy rendered with draughtsmanship of genius places these prints among his most memorable works.

DANCERS IN REHEARSAL, 1878–80. *74 × 60 cm. Art Institute of Chicago*
This gracefully posed group is distinguished by an especially delicate use of colour. Degas also enjoyed the humour of seeing only the lower legs and feet of the dancers revealed under the backdrops or cut-cloths. The edges of profiled flats were exploited quite frequently by Degas to provide the kind of purposefully wandering line that he enjoyed for its own sake. The picture seems to have a place among his most beautiful ballet subjects.

TWO WOMEN IN A MUSEUM, 1877–80. *81 × 75 cm. Museum of Fine Arts, Boston.*
Degas painted another similar picture, but his most famous related compositions are of *Mary Cassat in the Louvre* (page 72) made in pastel, mixed media and several prints. No doubt the artist herself posed for these images. Degas' equivocal attitude concerning the intellectual and artistic stature of women is expressed in his relationship with Mary Cassat (1845–1926). His often quoted derogatory comments about women, for instance, seem to be negated here by the pose struck by the standing figure, which

conveys intelligence and dignity.

DANCER AND WOMAN WITH UMBRELLA WAITING ON A BENCH, c.1882. *49 × 61 cm. J. Paul Getty Museum, Malibu*
One of Degas' more poignant vignettes of ballet life. The space as often recedes from left to right and provides a broadening and empty foreground which enhances the mood and emphasises the umbrella. The cut-off hat is another piece of Degas' 'photo-journalism' and the resting dancer is probably unrelated to the woman who may or may not have come to see if there is a place for her daughter in the ballet. Her wearing of mourning recalls Degas' earlier cryptic anecdotes. That we can never know *what* she is waiting for is of course part of the picture's sympathetic piquancy, though it would be well worth our attention without it.

TWO LADIES AT THE MILLINERS, c.1883. *76 × 85 cm. Thyssen Collection*
Around 1882 Degas discovered a new subject – the fashionable ladies' hat shop. His American friend and protégé, Mary Cassat, sometimes accompanied him and posed as a customer. Although he asserted that the 'red hands of the girl holding the pins' interested him more than anything else, he seems to have taken considerable pleasure in the hats themselves. This is the most robust and 'finished' example of the group of compositions that Degas devised during the 1880s. He greatly enjoyed watching people looking at themselves in mirrors and striking poses.

COUNTRY LANE WITH TREES NEAR A SMALL TOWN, c.1865. *45 × 59.5 cm. Kunsthalle, Bremen*
Although Sisley's principal debt is to the painters of the Barbizon school, he may well have been influenced here by his early study of Constable. Both the composition and the tonal manner are remarkably sophisticated for such an early work by the artist.

VILLAGE STREET OF MARLOTTE, 1866. *50 × 92 cm. Albright-Knox Art Gallery, Buffalo, New York*
This strong picture with its determined geometric simplicity both expresses Sisley's powerful individuality and shows several of the main influences on him at the age of 27. Courbet, Corot, Daubigny are his forerunners here. It is the schematic detachment which is perhaps most interesting in relation to Sisley's future work as an Impressionist. The picture was exhibited at the Salon with another similar view of Marlotte in 1866.

AVENUE OF CHESTNUT TREES NEAR LA CELLE-SAINT-CLOUD, 1867. *89 × 116 cm. Southampton Art Gallery*
This large and masterly picture, painted for the Salon of 1868, has a rigorous and impressively simple composition. The full-bodied brushwork comes close to the early style of Monet and Renoir, although the motif is clearly inspired by the Barbizon school.

EARLY SNOW AT LOUVECIENNES, 1870. *54 × 73 cm. Museum of Fine Arts, Boston. Bequest of John T. Spaulding*
Pissarro, who also lived at Louveciennes, painted a comparable view of this street at a different time of year. Sisley has rendered this scene with a characteristically subdued harmony of colour offset with stronger accents of salmon pink, blue and pure white.

THE BRIDGE AT VILLENEUVE-LA-GARENNE, 1872. *49.5 × 65.5 cm. Metropolitan Museum of Art, New York. Gift of Mr. and Mrs. Henry Ittleson Jr. 1964*
Monet's influence can be detected here, particularly in the bands of colour describing the reflective surface of the water. Yet the composition is of a kind that is Sisley's own. A strong geometric framework supports the glowing harmony of colour. Sisley enjoyed depicting bridges in general and painted a remarkable underview of one at Hampton Court in 1874 (Kunstmuseum, Winterthur).

OUTSKIRTS OF LOUVECIENNES, 1872. *54 × 80.5 cm. Private Collection*
This subtle composition encourages the eye to scan the whole picture. At first one avoids the centre, but gradually the foliage and the aqueduct become the focus of attention. It is Sisley at his most inimitable: quiet but affirmative. Pissarro and Renoir both painted similar views in Louveciennes.

MEADOW, 1875. *55 × 73 cm. National Gallery of Art, Washington D.C. Ailsa Mellon Bruce Collection*
This is another idyll of the Impressionist Arcadia that has found a permanent place in the Western imagination. It is an evocation of early summer that owes much to Monet and would not be shamed if hung beside his best work.

VIEW OF SAINT-MAMMES, c.1880. *54 × 73 cm. Walters Art Gallery, Baltimore*
Sisley came to place enormous importance on the skies in his paintings, however summary some of them might at first appear. He saw them not only as the all-important source of light but also as giving the picture depth through its successive planes which were of equal importance as those of its landscape beneath. 'It gives the movement . . .' he said, and this beautiful picture is a prime example of the dynamic role he often made the sky play. It entirely dominates the scene, giving colour to the water and making the river banks seem relatively passive and dependent on the energy bestowed on them from above.

A FARMYARD NEAR SABLONS, 1885. *54 × 73 cm. Aberdeen Art Gallery and Museum*
Sisley lived at Les Sablons from 1883 to 1889. It is near Moret-sur-Loing where he painted many of his best-known later works. This is an unusual subject for him in that it is an entirely enclosed space, but it makes a satisfying arrangement of verticals and horizontals. The couple seem rooted as if asked to pose in front of their farm. The sky looks casually brushed in, but it is in fact more precisely calculated than appears to be the case at first.

THE BOULEVARD HÉLOÏSE, ARGENTEUIL, 1872. *39 × 61 cm. National Gallery of Art, Washington D.C. Ailsa Mellon Bruce Collection*
This is probably Sisley's most vivid evocation of daily life in a small French town. The figures are much more than compositional devices and the atmosphere of street life is conveyed as convincingly as the attractive mistiness of the scene. Monet painted the same street in 1872.

THE FORGE AT MARLY-LE-ROI, 1875. *55 × 73.5 cm. Musée d'Orsay, Paris*
No doubt attracted by the haze of smoke and the fire, Sisley here made an interesting departure in subject-matter. He also appears to have been interested in the smithy's tackle for its own sake.

VERSAILLES ROAD AT SAINT-GERMAIN, 1875. *51 × 65 cm. Private Collection*
This is the kind of picture by Sisley that gives the purest pleasure. Topographically it is simpler than many works by Pissarro, but uses similar compositional devices. The area at top right saves the eye from losing itself down the lane on the left.

LANDSCAPE AT LOUVECIENNES, 1873. *53 × 73 cm. National Museum of Western Art, Tokyo*
Louveciennes was not as unpopulated as this picture suggests, but Sisley on the whole avoided people in his pictures. He conveys the solitude of the painter more than any of his friends. The two figures here seem poignantly remote and give the landscape a haunting quality.

THE CHEMIN DE BY THROUGH THE WOODS OF ROCHES-COURTANT — ST. MARTIN'S SUMMER, c.1880. *60 × 81 cm. Museum of Fine Arts, Montreal. John W. Tempest Bequest*
Sisley eventually rejected the homogenous surface so often favoured by Monet and Pissarro in particular. Here once again he varies his brushwork throughout, apart from the matching of water and sky. The powerful harmony of reds, yellow/orange and blue creates a strong visual impact and the far bank directs the eye to the imagined destination of the path. It is Sisley pure and simple.

THE TOWPATH, 1864. *82 × 108 cm. Glasgow Art Gallery and Museum*
This was painted for the Salon where it was shown in 1864. It is a powerful composition which shows Pissarro beginning to use the simple but effective device of the curving path to indicate space and natural contour and also to interest the viewer in what is out of sight. The figure introduces a sense of scale. Courbet's influence can be felt perhaps more than the artist's mentor Corot in this work.

A SQUARE AT LA ROCHE-GUYON, 1867. *50 × 61 cm. Nationalgalerie, Berlin*
With this astonishingly fluent statement in paint, Pissarro shows himself to have more in common with Cézanne's use of the palette knife than Courbet's. He seems to have been strongly influenced by his friend's defiantly summary technique and to have proved himself equally audacious.

STILL LIFE, 1867. *81.2 × 100.3 cm. Toledo Museum of Art, Toledo. Gift of Edward Drummond Libbey*
This still life, like the *Square at La Roche-Guyon*, has much in common with Cézanne's work at the time. There is a strong horizontal emphasis in the table and wood panelling which is countered by the vertical objects and strokes of the palette knife. The loaf and knife in the dish emphasise the depth not fully realised in the painting of the table top.

THE CÔTE DU JALLAIS, PONTOISE, 1867. *87 × 115 cm. Metropolitan Museum of Art, New York. Bequest of William Church Osborn, 1951*
Here Pissarro demonstrates his own kind of subtle complexity in composition. The eye is offered the rival attractions of viewing the sloping hill in the left background or of following the course of the path to the right. The buildings in the middle distance stabilise this tension. The painting was exhibited at the Salon of 1868.

THE HILLSIDES OF L'HERMITAGE, PONTOISE, 1867–68. *151.5 × 200.5 cm. Solomon R. Guggenheim Museum, New York. Justin K. Thannhauser*
This is the climax to, and also perhaps an amalgam of, the group of paintings to which the *Côte du Jallais* (opposite) belongs. Cézanne was certainly very seriously influenced by their type of simple but powerful composition. This picture was most probably accepted for the Salon, but it may have been another of the group.

CHESTNUT TREES AT LOUVECIENNES, 1872. *41 × 54 cm. Mr. and Mrs. Alex Lewyt Collection, New York*
A dramatic composition which exploits a leaning and a broken tree with a network of strongly coloured shadows. It was painted in the park at Louveciennes in the same area where Sisley worked and lived. Sometimes spring days are lit with a hard bright light with no idyllic vernal undertones and Pissarro has admirably recorded just such a day.

LANDSCAPE WITH FLOODED FIELDS, 1873. *65 × 81 cm. Wadsworth Atheneum, Hartford. Sumner Collection Purchase Fund 1966*
Pissarro was not often attracted to painting water, as Monet and Sisley were, but he here renders its reflective qualities with masterly precision. The general spaciousness is achieved by the clever positioning of the trees.

ORCHARD IN BLOOM, LOUVECIENNES, 1872. *45 × 55 cm. National Gallery of Art, Washington D.C. Ailsa Mellon Bruce Collection*
An unassuming and satisfying scene using the simplest compositional devices. It represents the pleasure in the most ordinary view not conspicuously pursued in painting before the Impressionists and which Pissarro and Sisley provided perhaps better than anyone. The critic Jules Castagnary wrote of this: 'He has a deplorable predilection for market-gardens and does not hesitate to paint cabbage or any other domestic vegetable. But these errors of logic or vulgarities of taste do not alter his beautiful qualities of execution.'

FACTORY NEAR PONTOISE, 1873. *48 × 60 cm. Museum of Fine Arts, Springfield. James Philip Gray Collection*
It has recently been established that Pissarro took considerable liberties when painting such scenes. The factory can be identified as one built at Pontoise to distil alcohol from sugar beet. It still stands today and it is apparent that Pissarro altered some of the architectural features. Industrial motifs are relatively rare in Impressionist painting but this one has an almost emblematic quality.

STILL LIFE: PEARS IN A BASKET, 1872. *46 × 55 cm. Mrs. Marge Scheuer, New York*
This still life forms an interesting comparison with that of 1867 (page 211). The basket has been deliberately tilted forwards. The concern for the shape of the pears set against the flat, almost abstract pattern of the wallpaper behind and the cloth covering the table make it a very modern picture for its time. The deliberate tonal manner of the painting is also remarkable.

THE CLIMBING PATH, L'HERMITAGE, PONTOISE, 1875. *54 × 65 cm. Brooklyn Museum, New York. Gift of Dikran K. Kelekian*
The mutual indebtedness of Pissarro and Cézanne continues with this very interesting painting. It is contemporary with Cézanne's pictures at Auvers-sur-Oise in the late 1870s and early 1880s when he compared the roofs of Auvers (page 235) to playing cards laid on one another. Such a description could well be applied to the roofs of Pontoise seen here through the trees. The whole picture has a weightless feeling and the steep path has been relieved of any arduous solidity. Most of the subtle expressiveness of the forms is achieved with a much more varied use of the palette knife than hitherto.

THE BACKWOODS OF L'HERMITAGE, PONTOISE, 1879. *126 × 162 cm. Cleveland Museum of Art, Cleveland*
It is possible that this painting's size indicates that Pissarro intended to offer it to the Salon of 1879. It emphasises the important influence of the Barbizon painters on the artist and shows affinities with Cézanne in the screen-like character of the foliage. It seems to embody all Pissarro's long experience with *sous-bois* subjects.

RABBIT WARREN AT PONTOISE, SNOW, 1879. *60 × 73 cm. Art Institute of Chicago*
The artist has here seized upon a bleak, untidy-looking subject and turned it into a compelling picture. One can feel that although Pissarro has observed everything very clearly and in detail he has nonetheless felt no need to spell it all out to us. It was indeed central to his art that an impression should convey the essence of a total observation. The painter also much enjoyed offsetting different levels of the terrain in a composition.

THE SHEPHERDESS (YOUNG PEASANT GIRL WITH A STICK), 1881. *81 × 65 cm. Musée d'Orsay, Paris*
This is surely the most poignant and memorable image amongst Pissarro's figure paintings of the 1880s. Most of his pictures in the Seventh Impressionist Exhibition of 1882 involved the human figure. The style may owe something to Renoir, but it is Pissarro's feeling for humanity that gives it a timeless quality. The integration of the figure with the background was the artist's principal concern in these pictures of the early 1880s.

LOUIS-AUGUSTE CÉZANNE, 1860–65. *68 × 114 cm. National Gallery, London*
Cézanne was said to have lived in dread of his father, but his early portraits of him reading a newspaper seem to convey something more like an appreciation of a strong character. The primitive perspective, draughtsmanship and application of paint in this portrait are jarring, but the style is so robust and knowing that it proclaims Cézanne's forceful talent as much as his immaturity at this time.

THE ABDUCTION, 1867. *90.5 × 117 cm. Fitzwilliam Museum, Cambridge*
Influenced by Delacroix and bringing Daumier to mind, this picture with its strong rhythmical brushwork and powerful characterisation seems as fluently executed as *A Murder*. Scholars have suggested a possible connection between the mountain background and the Mont Sainte Victoire that Cézanne was to paint so many times later in his life.

A MURDER, 1867–70. *64 × 81 cm. Walker Art Gallery, Liverpool*
This picture and the one opposite attest Cézanne's erotic and sanguinary preoccupations as he approached the age of 30. His application of paint may again seem crude but the composition is realised with purposeful accuracy. If Cézanne was ever clumsy, it was a little later when coming to terms with the influence of the Impressionists.

PORTRAIT OF ACHILLE EMPERAIRE, 1867. *200 × 122 cm. Musée d'Orsay, Paris*
Nobody would dare to title a painting so ostentatiously again until the Cubists and the whole picture is a striking example of Cézanne's wilful eccentricity during his twenties. Emperaire was a painter from Aix-en-Provence who was a dwarf and painted interesting erotic pictures. Cézanne also made notable drawings of him.

THE TEMPTATION OF SAINT ANTHONY, 1867–69. *54 × 73 cm. E.G. Bührle Foundation, Zurich*
Cézanne's youthful fascination with the female form here seems not only ambivalent but also somewhat morbid. The figure of sickly hue on the right seems wilfully gross while the lady paying attention to St. Anthony seems much more likely to repel than to tempt him. The ambiguities of this traditional religious subject are vividly exposed and turned to advantage by Cézanne.

GIRL AT THE PIANO, c.1866. *57 × 92 cm. Hermitage, Leningrad*
Cézanne's mother and his sister, Marie, probably posed for this balanced and orderly composition. Cézanne's interest in the abstract patterning of the wallpaper and the chair cover is striking. He would incorporate such motifs, fabrics in particular, into his still lifes and portraits for the rest of his career.

THE BLACK CLOCK, 1869–70. *54 × 73 cm. Stavros Niarchos Collection*
Cézanne's still lifes bring a monumental unity and grandeur to humble man-made objects. As with his still lifes of fruit, it is the shapes and forms combining strength and simplicity that attracted the painter to this motif. Chardin is perhaps Cézanne's only predecessor who could invest still life with such transcendental significance. This famous early example preceded some more tentative and uncertain ones before the emergence of his mature style. Although fruit (except for the half-concealed lemon) or plants are absent, this painting was the first to announce his lifelong pursuit of immutability on his studio tables.

THE RAILWAY CUTTING, 1869–71. *86 × 129 cm. Bayerische Staatsgemäldesammlung, Munich*
Mont Sainte Victoire announces itself explicitly for the first time in this summary but assured early landscape. The horizontal emphasis seems aimed at establishing the kind of dispassionate geometric order that Cézanne would pursue after the baroque animation of his early figure paintings and the influence of the romantic Provençal painter Monticelli on his landscapes.

JAR, COFFEE POT AND FRUIT, 1870–72. *63 × 80 cm. Musée d'Orsay, Paris*
This still life seems to owe quite a lot to Manet in its hard separation of the constituent elements and the application of paint. It conveys a sense of masterly completeness and finality – a knowingness which he would soon be ceaselessly questioning.

THE HOUSE OF THE HANGED MAN, 1872–73. *55 × 66 cm. Musée d'Orsay, Paris*
This is an early result of Cézanne's contact with the Impressionists and it was shown at the First Impressionist Exhibition in 1874, where it provoked considerable, mostly unfavourable, comment.

In a sense it shows Cézanne rebelling against Impressionism from the very start. It glows with diffused light, but nevertheless remains obstinately solid.

THE SEINE AT BERCY, 1873–75. *60 × 73 cm. Kunsthalle, Hamburg*

A rare example of Cézanne painting an urban industrial landscape. It was executed not long after *A Modern Olympia*, during a period when he was concerned with complex figure compositions, flower pieces and still lifes, as well as his landscapes at Auvers (pages 232 and 235). Pictures like this would influence certain Post-Impressionists of the next generation much more than Cézanne's late work.

THE BUFFET, 1873–77. *75 × 81 cm. Szépmüvészeti Múzeum, Budapest*

Cézanne here demonstrates his growing urge to make painting more purely architectural than it had ever been before. His concern is not with fine literal detail but with the absolute relative correctness of the surfaces of the wall and sideboard in relation to the various objects he has assembled and, even more importantly, of the whole to the picture plane. It is not surprising that his passionate concentration on every square inch of the canvas went unappreciated for so long.

AUVERS, PANORAMIC VIEW, 1873–75. *65 × 81 cm. Art Institute of Chicago*

Cézanne has here depicted the attractive town of Auvers-sur-Oise without any of its distinguishing features and without the river Oise, almost as if such picturesque elements would be irrelevant to a simple exercise in painting. The picture has much in common with Pissarro's painting of Pontoise (page 219) and is another testimony to the very close association of the two painters. Cézanne's geometric approach is very much in evidence, although he has not yet developed the diagonal 'constructive' stroke that simplifies and unifies his pictures, effectively removing his art from the Impressionist ethos.

STILL LIFE WITH FRUIT BOWL, CLOTH, APPLES AND BREAD, 1879–82. *55 × 75 cm. Collection Oskar Reinhart, Winterthur*

Cézanne is here approaching the style of his later still lifes when the pictures seem almost hymns to the natural harmony that an artist can achieve between nature, represented by fruit or plants, and ordinary domestic furnishings. But here there is a spiky angularity in the folds of the cloth and a somewhat leaden density about the fruit which would eventually give way to classical order and severity. It is similar to a more famous painting (whereabouts unknown) by Gauguin in one of his own pictures and also by Maurice Denis in his *Homage to Cézanne*.

THE ETANG DES SOEURS AT OSNY, 1875–77. *55 × 71 cm. Courtauld Institute Galleries, London. Home House Trustees*

Although this is an 'Impressionist' painting by Cézanne with dynamic expressive qualities achieved by the almost vehement strokes of the palette knife that reminds us as much of Courbet as anyone, the abstract architectural character of the 'constructive' period beginning two years later is clearly foreshadowed in it.

BIG TREES AT THE JAS DE BOUFFAN, 1885–87. *65 × 81 cm. Courtauld Institute Galleries, London. Home House Trustees*

This picture is distinguished by its spacious grandeur offset by the almost dance-like movement of the branches and foliage. It is one of many strong tree pictures dating from the late 1880s.

THE BRIDGE AT MAINCY NEAR MELUN, c.1879–80. *59 × 72 cm. Musée d'Orsay, Paris*

Cézanne was never interested in recording the particular characteristics of a place and had none of Pissarro's interest in the random complexity of nature. Trees, roads, houses, bridges for Cézanne all became abstract pictorial qualities with which he could develop general statements about the nature of perception and the ideal. His purpose was the immutable reduction of the visible world onto a flat surface. He has in this picture developed a diagonal brushstroke possibly derived from the draughtsman's hatching. The technique, however, is not simply mechanical, but full of nuances derived from the close observation of a particular motif. He has organised this scene into a beautifully balanced geometrical structure modified by modulations of colour suggesting the nature of the forms with no regard whatever for illusion or 'Impressionist' sensation.

MONT SAINTE-VICTOIRE (THE GREAT PINE), 1885–87. *67 × 92 cm. Courtauld Institute Galleries, London. Home House Trustees*

Cézanne made of Mont Sainte-Victoire a symbol of his highest aspirations and he continued to paint it until the end of his life. Between 1882 and 1889 14 canvases of the mountain and its approaches survive. In them Cézanne achieves a marvellous sense of remote grandeur. This example has a classical serenity while the tree and branches in the foreground echo and counterpoint the contours of the horizon. All other pictures of the subject fail to match those of Cézanne and, as visitors to Aix will know, he achieved a true likeness.

INDEX

Figures in *italics* refer to illustrations

Nicholas Mirzoeff, a graduate of Balliol College, Oxford, has a special interest in the social and historical background to art movements in 19th-century France.

Kathleen Adler, author of *Camille Pissarro: A Biography* and co-author with Tamar Garb of *Berthe Morisot*, to be published by Phaidon in 1987.

Richard Kendall, a leading authority on the life and works of Degas. He is a senior lecturer at Manchester Polytechnic and the author of *Degas 1834–1884*.

Christopher Lloyd, Assistant Keeper of the Department of Western Art at the Ashmolean Museum, Oxford. He has written extensively on art historical subjects and is at present involved in organising the exhibition of the work of Alfred Sisley to be held at the Royal Academy, London in 1988. He is also a specialist in the work of Pissarro.

Charles Harrison, a graduate of King's College, Cambridge, studied at the Courtauld Institute in London and is now Reader in Art History at the Open University.